W9-CMA-292

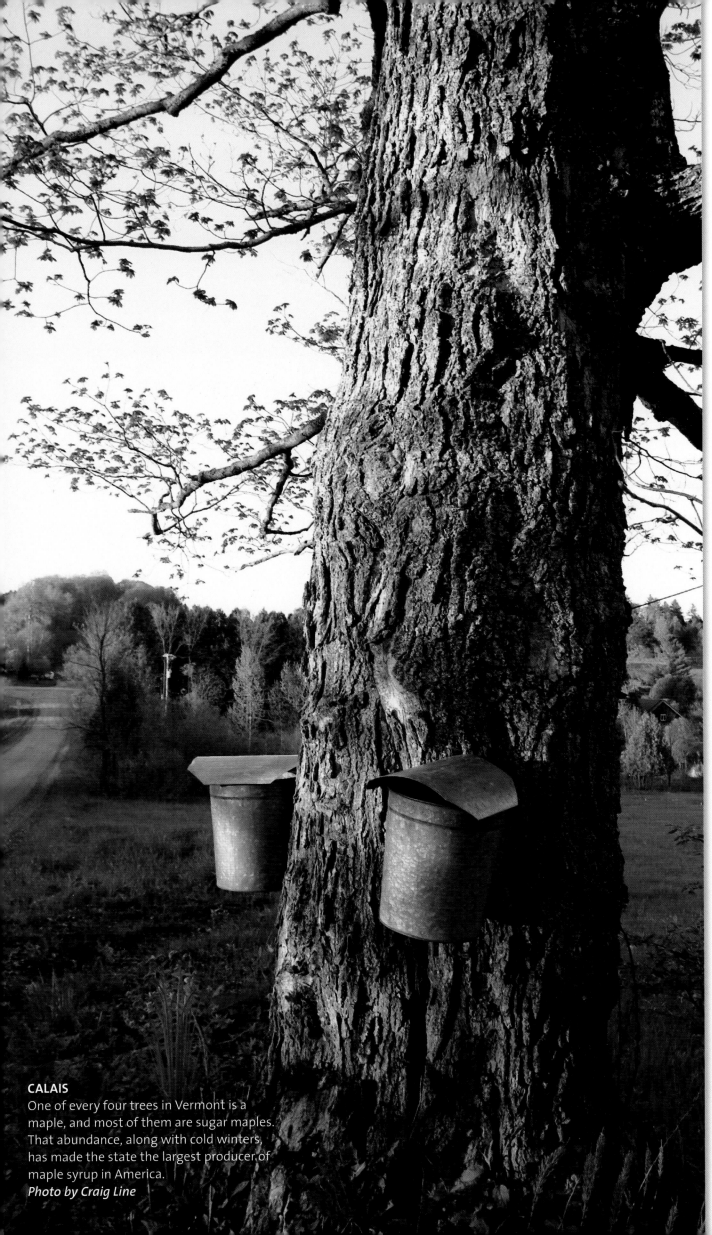

CALAIS
One of every four trees in Vermont is a maple, and most of them are sugar maples. That abundance, along with cold winters, has made the state the largest producer of maple syrup in America.
Photo by Craig Line

Vermont 24/7 is the sequel to *The New York Times* bestseller *America 24/7* shot by tens of thousands of digital photographers across America over the course of a single week. We would like to thank the following sponsors, the wonderful people of Vermont, and the talented photojournalists who made this book possible.

LONDON, NEW YORK, MUNICH, MELBOURNE, and DELHI

Created by Rick Smolan and David Elliot Cohen

24/7 Media, LLC
PO Box 1189
Sausalito, CA 94966-1189
www.america24-7.com

First Edition, 2004
04 05 06 07 08 10 9 8 7 6 5 4 3 2 1

Published in the United States by
DK Publishing, Inc.
375 Hudson Street
New York, NY 10014

DK Publishing, Inc. offers special discounts for bulk purchases for sales promo-
tions or premiums. Specific, large-quantity needs can be met with special
editions, personalized covers, excerpts of existing guides, and corporate
imprints. For more information, contact:

Special Markets Department
DK Publishing, Inc.
375 Hudson Street
New York, NY 10014
Fax: 212-689-5254

Cataloging-in-Publication data is available
from the Library of Congress
ISBN 0-7566-0086-3

Printed in the UK by Butler & Tanner Limited

First printing, October 2004

SHELBURNE
The shores of Lake Champlain lie in Vermont,
New York, and Quebec. The sixth-largest
lake in America, it was discovered by French
explorer Samuel de Champlain in 1609, and
even has its own Loch Ness–style monster.
"Champ" has reportedly been sighted 300
times.
Photo by Paul O. Boisvert

VERMONT 24/7

24 Hours. 7 Days.
Extraordinary Images of
One Week in Vermont.

Created by Rick Smolan and David Elliot Cohen

DK Publishing

About the America 24/7 Project

A hundred years hence, historians may pose questions such as: What was America like at the beginning of the third millennium? How did life change after 9/11 and the ensuing war on terrorism? How was America affected by its corporate scandals and the high-tech boom and bust? Could Americans still express themselves freely?

To address these questions, we created *America 24/7*, the largest collaborative photography event in history. We invited Americans to tell their stories with digital pictures. We asked them to shoot a visual memoir of their lives, families, and communities.

During one week in May 2003, more than 25,000 professionals and amateurs shot more than a million pictures. These images, sent to us via the Internet, compose a panoramic yet highly intimate view of Americans in celebration and sadness; in action and contemplation; at work, home, and school. The best of these photographs, more than 6,000, are collected in 51 volumes that make up the *America 24/7* series: the landmark national volume *America 24/7*, published to critical acclaim in 2003, and the 50 state books published in 2004.

Our decision to make *America 24/7* an all-digital project was prompted by the fact that in 2003 digital camera sales overtook film camera sales. This techno-logical evolution allowed us to extend the project to a huge pool of photographers. We were thrilled by the response to our challenge and moved by the insight offered into American life. Sometimes, the amateurs outshot the pros—even the Pulitzer Prize winners.

The exuberant democracy of images visible throughout these books is a revela-tion. The message that emerges is that now, more than ever, America is a supersized idea. A dreamspace, where individuals and families from around the world are free to govern themselves, worship, read, and speak as they wish. Within its wide margins, the polyglot American nation manages to encompass an inexplicably complex yet workable whole. The pictures in this book are dedicated to that idea.

—*Rick Smolan and David Elliot Cohen*

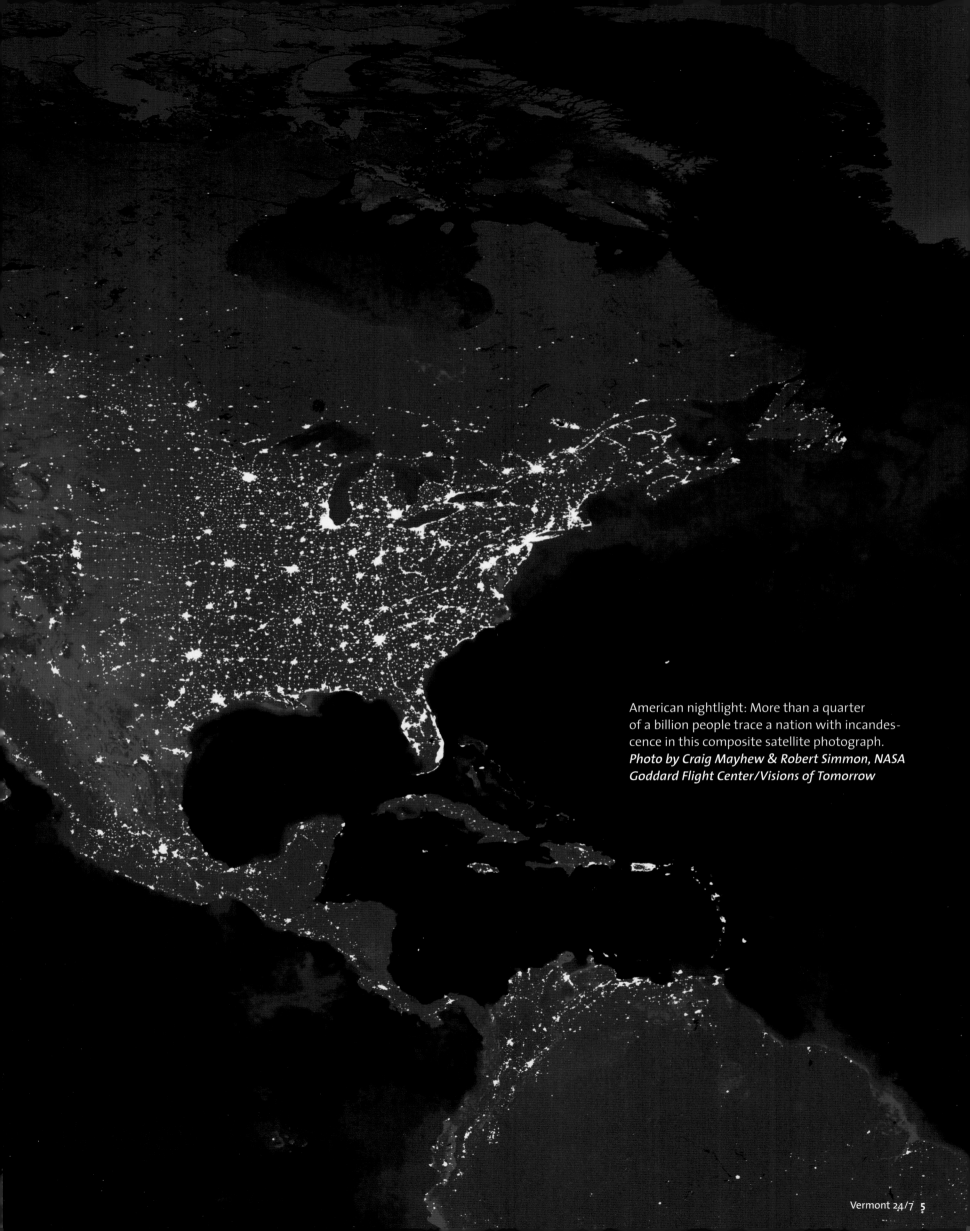

American nightlight: More than a quarter of a billion people trace a nation with incandescence in this composite satellite photograph.
Photo by Craig Mayhew & Robert Simmon, NASA Goddard Flight Center/Visions of Tomorrow

The Idea of Vermont

By Stephen Kiernan

Vermont is an idea as much as it is a place. Every July 4 this idea goes on parade in the one-stoplight town of Bristol. From surrounding Addison County, crowds throng the streets to watch aging veterans trooping proudly, tie-dyed dancers leaping to the sounds of African drums, Revolutionary War reenactors firing muskets, an armada of tractors from little old ladies navigating lawn mowers to sunburned farmers captaining two-story John Deeres, purple-wearing hippies on stilts, five local fire departments, toddlers on a horse-drawn wagon, and, finally, rowdy boys on ATVs dousing the crowd with giant water guns. Like a hayfield with thistles, the parade is prickled with Republican, Democratic, Independent, Progressive, Libertarian, Natural Law, and grassroots politicians. But there is no booing, or conflict. Culture and counterculture are neighbors in Vermont. Even in a state just beginning to learn about race, differences are welcomed.

The origins of the Vermont idea are historical. For 14 years this territory was an independent republic, joining the 13 United States only when Congress agreed to accept a state constitution that prohibited slavery. Idealistic iconoclasm persists, from U.S. Senator Ralph Flanders, who first challenged Joseph McCarthy, and U.S. Senator George Aiken, who said the solution to Vietnam was to declare victory and get out, to today's political crop: James Jeffords, Patrick Leahy, Bernie Sanders, Howard Dean—whose independence is famous or infamous, depending on whom you ask.

The old values persist: Vermonters feel patriotic about their towns. They mistrust institutions, outsiders, and fads. They love independence of thought and character. Each mud season, they govern themselves in tedious

CHITTENDON COUNTY
Abanaki Indians named this prominent elevation *moziozagan,* or "moose's shoulder." It's been called Camel's Hump since about 1830—an improvement on the 18th-century name: Camel's Rump. The 4,083-foot peak in

but neighborly form on Town Meeting Day. They labor together on school boards, historical societies, volunteer rescue squads, and much more to sustain their precious heritage of community.

The idea of Vermont was also written by the landscape, which is beautiful from the stony-chinned ridge of Mount Mansfield to the glacier-carved belly of Lake Champlain, but whose grandeur is on a human scale. Vermonters twice denuded their state of trees, once for potash, once for lumber. Later generations learned to appreciate what the land requires to thrive. Now that people outnumber livestock, it is Vermonters' ongoing challenge to balance the appetites of commerce with the nourishment of nature.

The idea of Vermont's future rises from its small towns, struggling against the bland uniformity of mass marketing. Like apple trees in a frigid February orchard, they insist on surviving. The restoration of old theaters in Rutland, Bellows Falls, and Vergennes promises light. The recovery of historic storefronts in Randolph and Saint Johnsbury promises life. The repair of aging steeples all across the state promises spirit.

Should any of the millions of visitors drawn each year to the idea of Vermont happen by one of those sanctuaries at the right moment, they may hear old hymns about how land is generous to those who treat it with re-spect, about the gratification of hard work, about sharing in community by pitching in when it's needed and accepting help when it's offered.

The idea of Vermont endures because the human spirit needs to know that this kind of life, in one place at least, remains possible.

STEPHEN KIERNAN *came to Vermont in 1978. He is senior investigative reporter and former opinion editor for* The Burlington Free Press.

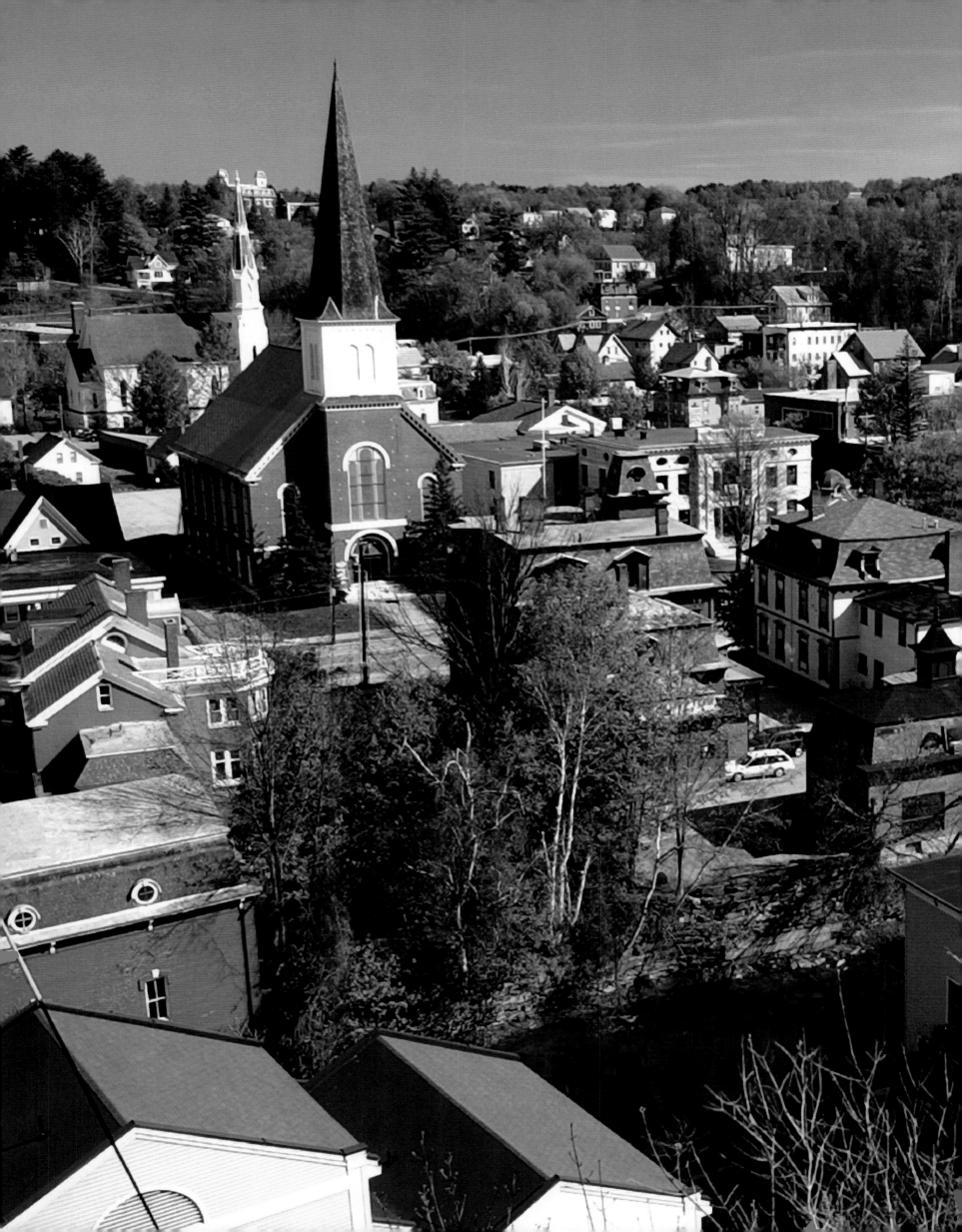

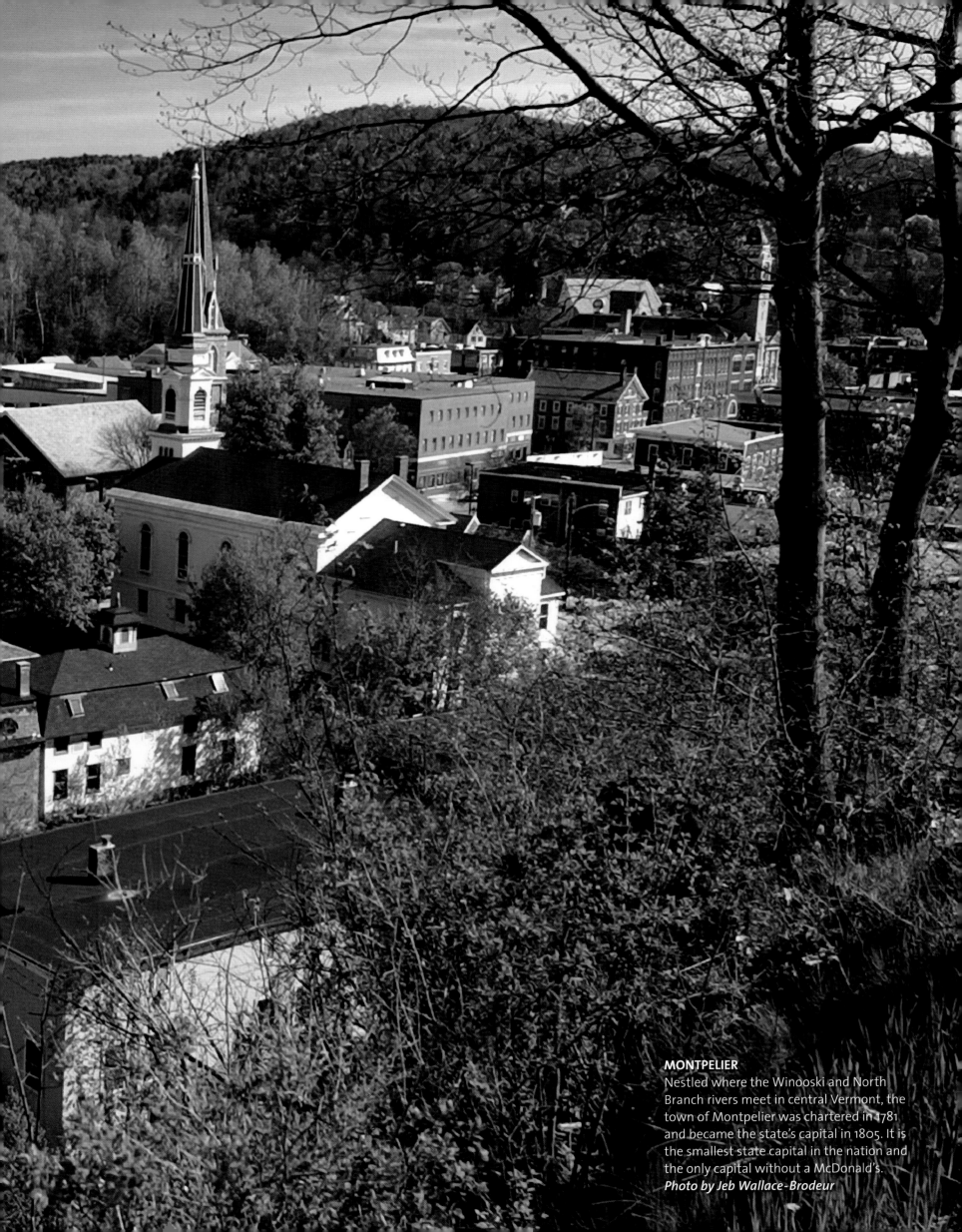

MONTPELIER
Nestled where the Winooski and North Branch rivers meet in central Vermont, the town of Montpelier was chartered in 1781 and became the state's capital in 1805. It is the smallest state capital in the nation and the only capital without a McDonald's.
Photo by Jeb Wallace-Brodeur

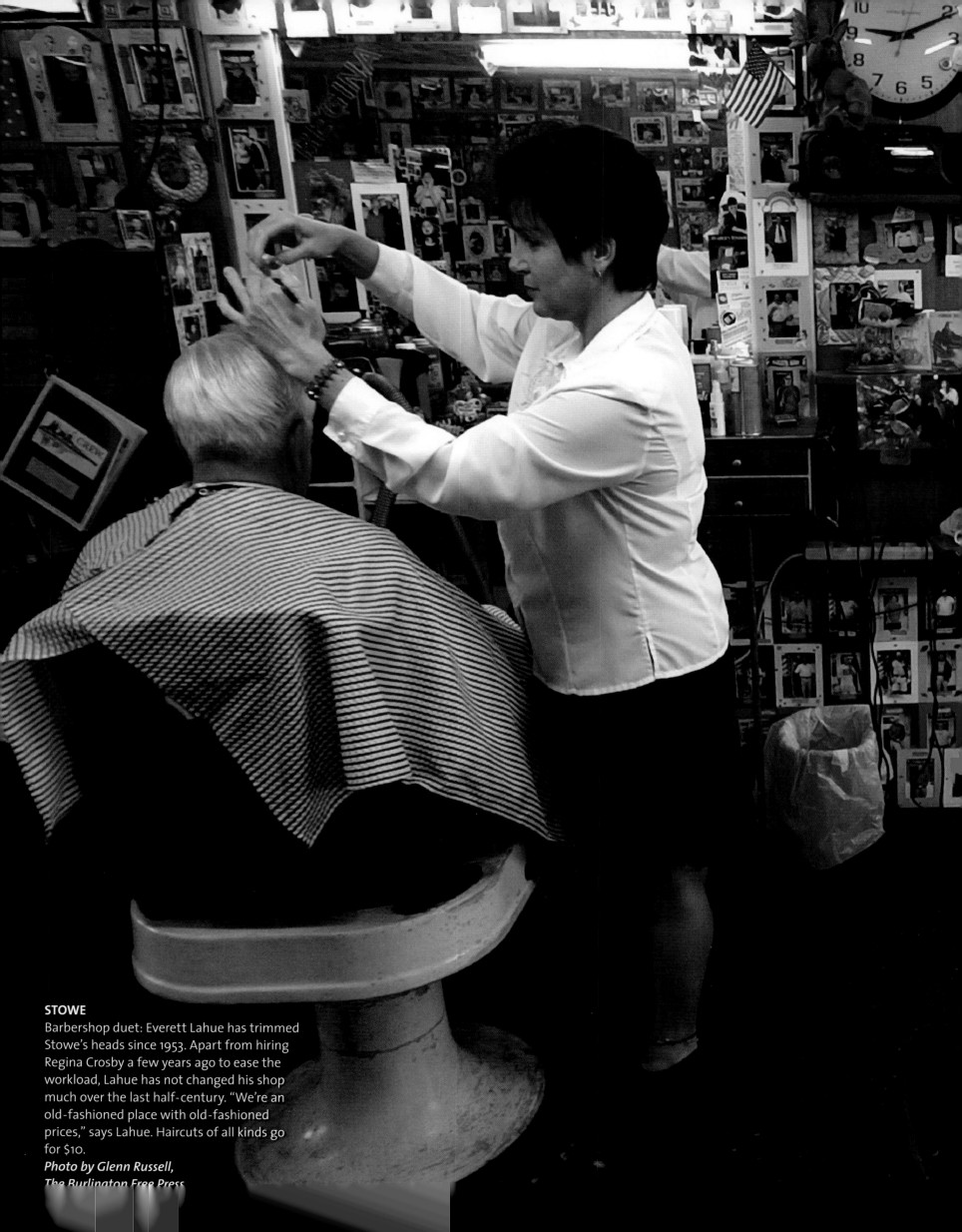

STOWE

Barbershop duet: Everett Lahue has trimmed Stowe's heads since 1953. Apart from hiring Regina Crosby a few years ago to ease the workload, Lahue has not changed his shop much over the last half-century. "We're an old-fashioned place with old-fashioned prices," says Lahue. Haircuts of all kinds go for $10.

Photo by Glenn Russell,
The Burlington Free Press

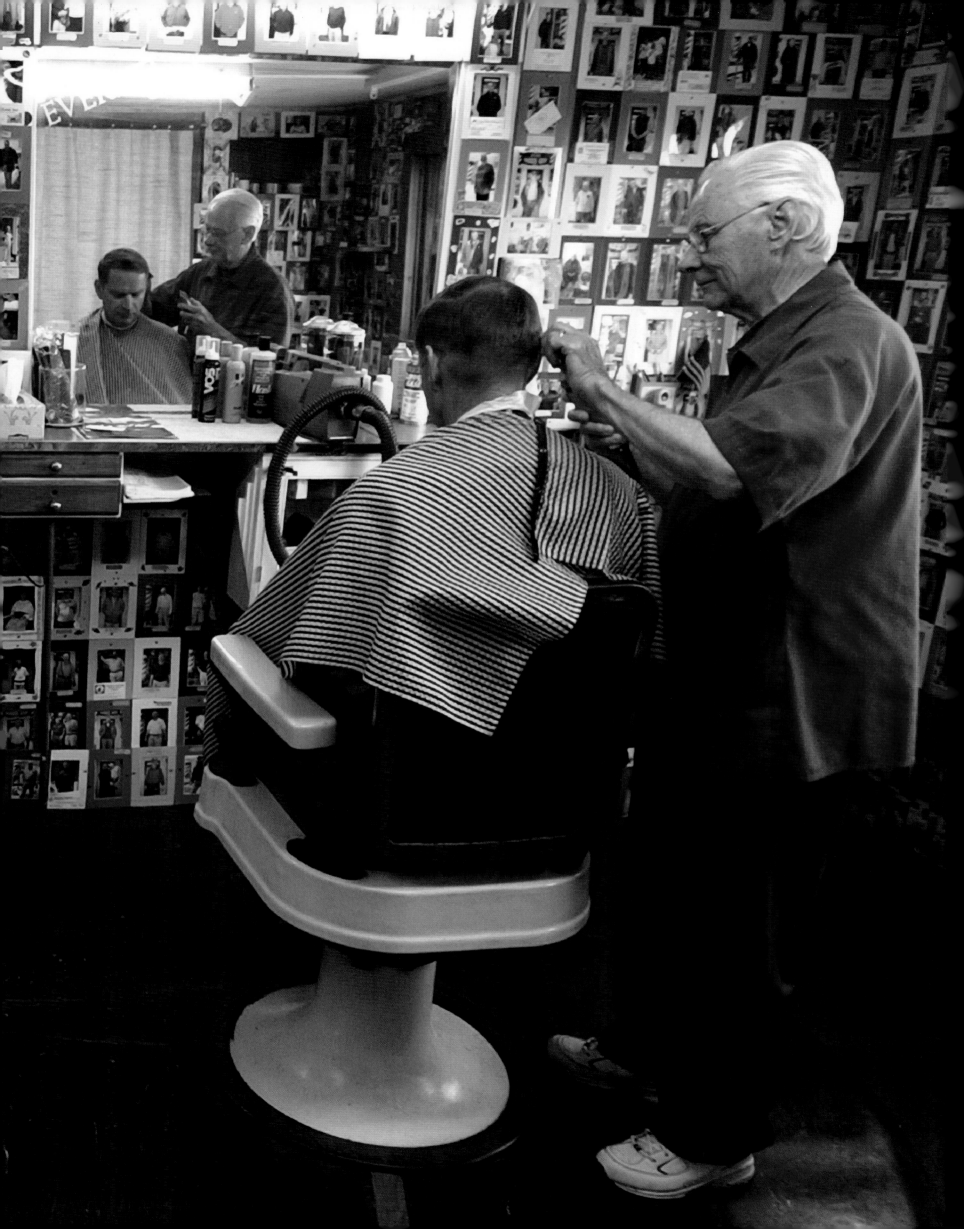

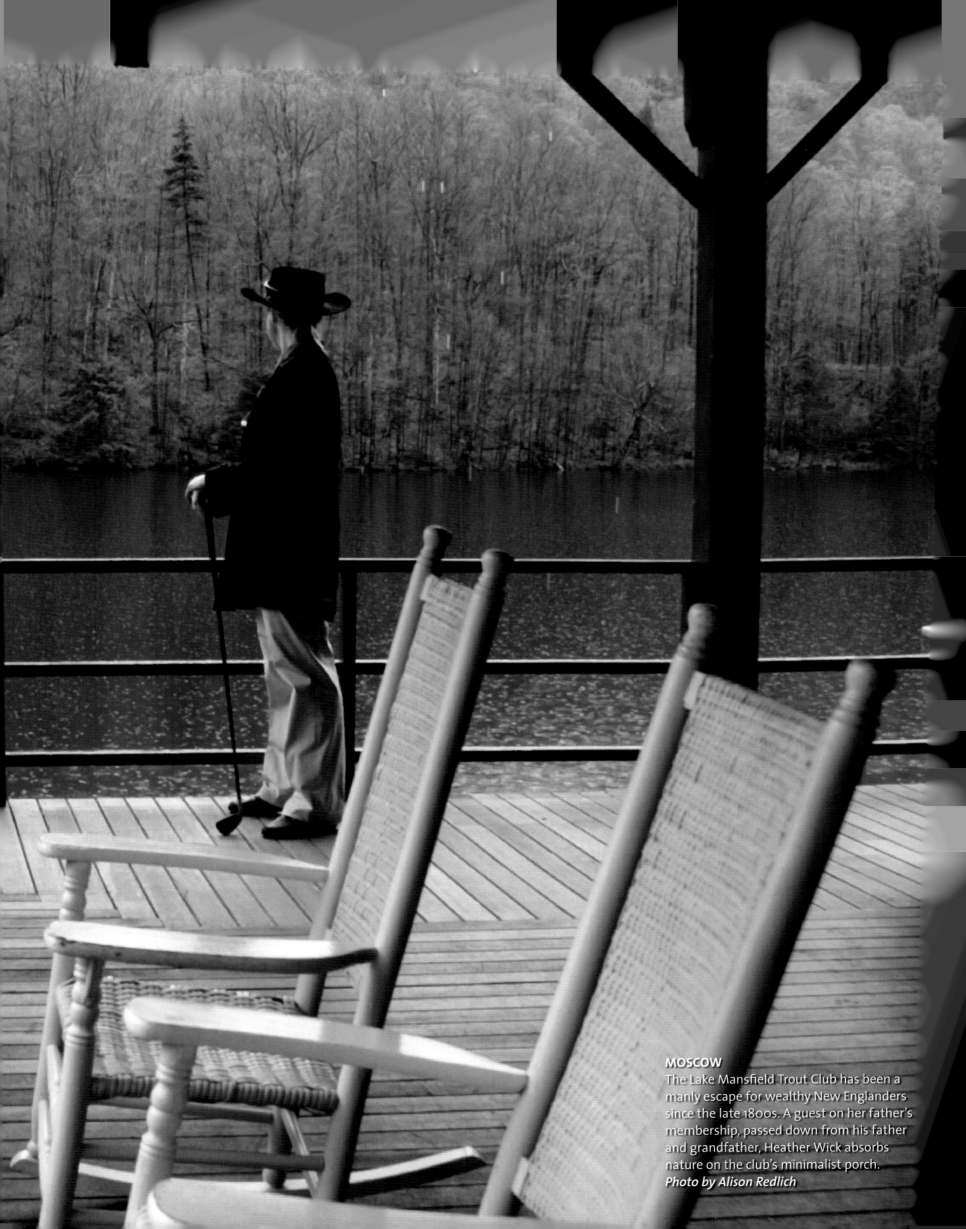

MOSCOW
The Lake Mansfield Trout Club has been a
manly escape for wealthy New Englanders
since the late 1800s. A guest on her father's
membership, passed down from his father
and grandfather, Heather Wick absorbs
nature on the club's minimalist porch.
Photo by Alison Redlich

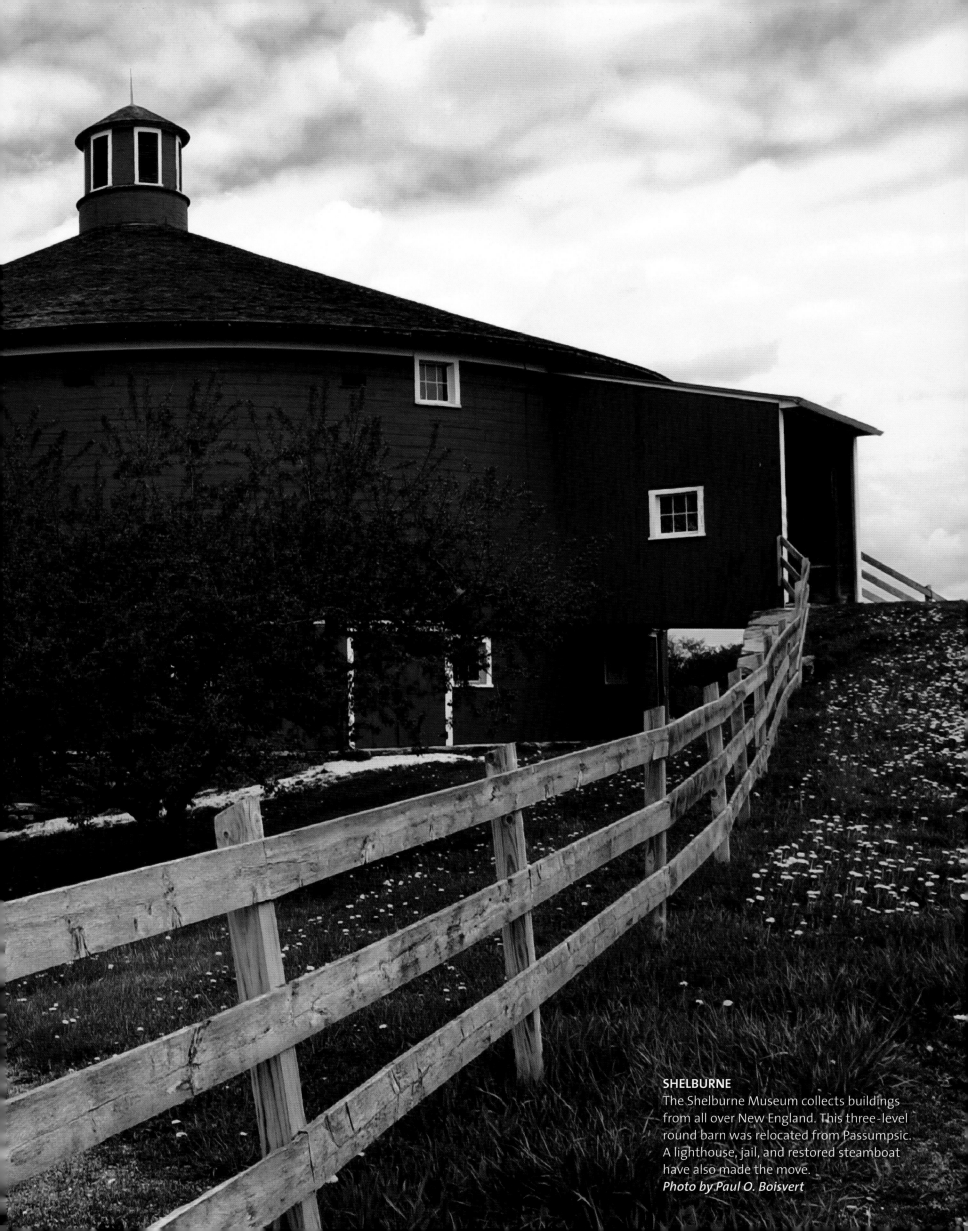

SHELBURNE
The Shelburne Museum collects buildings from all over New England. This three-level round barn was relocated from Passumpsic. A lighthouse, jail, and restored steamboat have also made the move.
Photo by Paul O. Boisvert

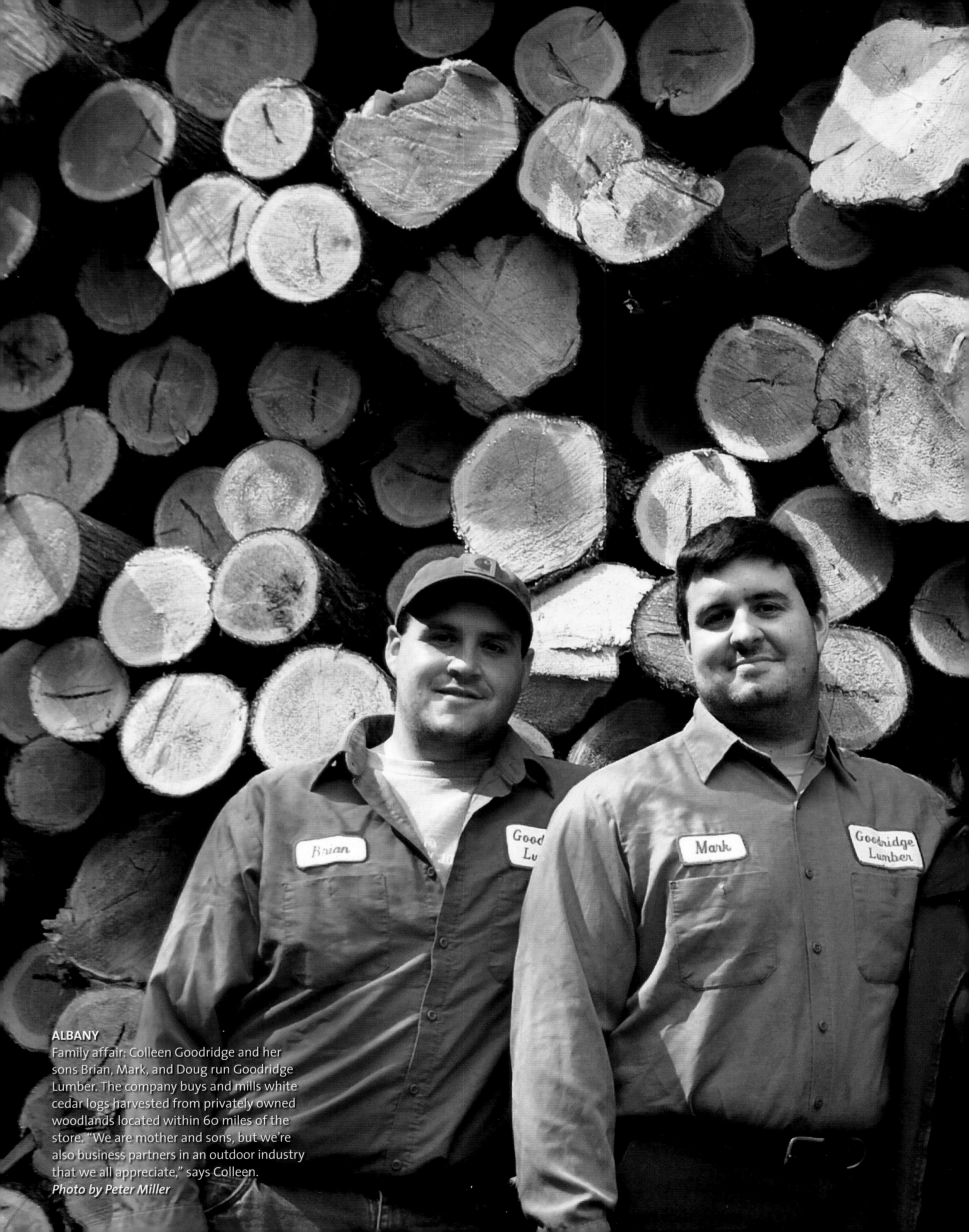

ALBANY
Family affair: Colleen Goodridge and her sons Brian, Mark, and Doug run Goodridge Lumber. The company buys and mills white cedar logs harvested from privately owned woodlands located within 60 miles of the store. "We are mother and sons, but we're also business partners in an outdoor industry that we all appreciate," says Colleen.
Photo by Peter Miller

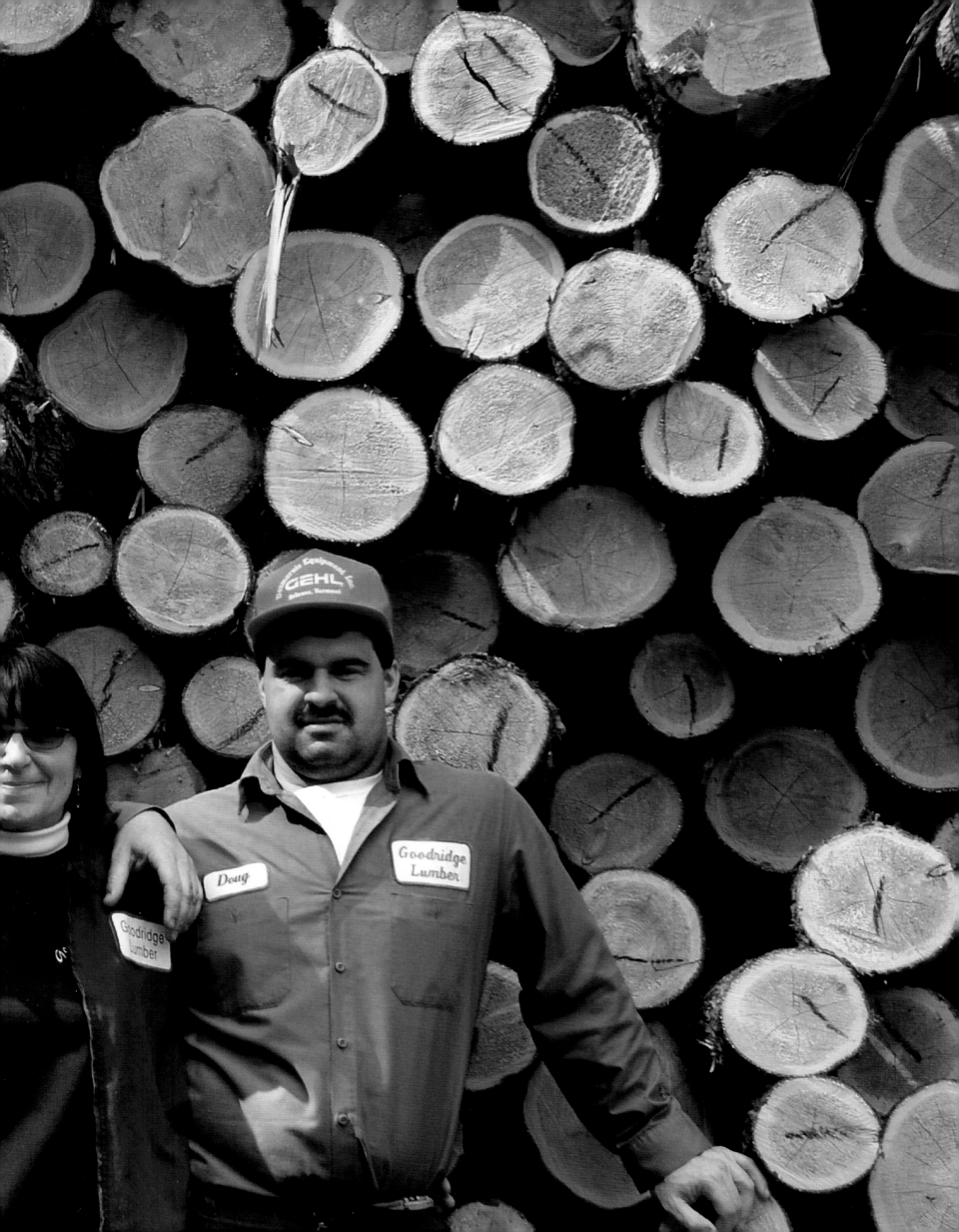

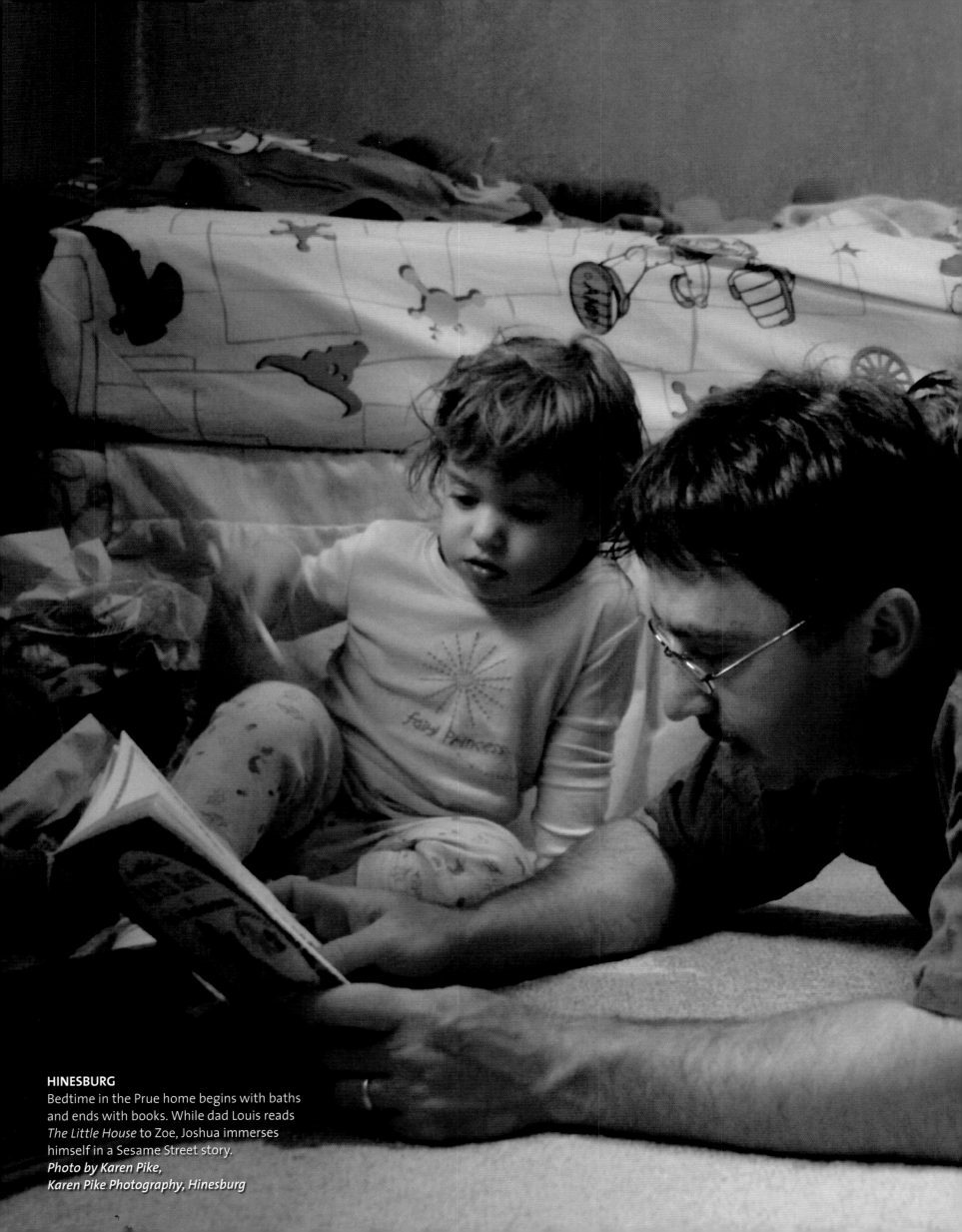

HINESBURG
Bedtime in the Prue home begins with baths and ends with books. While dad Louis reads *The Little House* to Zoe, Joshua immerses himself in a Sesame Street story.
Photo by Karen Pike,
Karen Pike Photography, Hinesburg

Hearth & Home

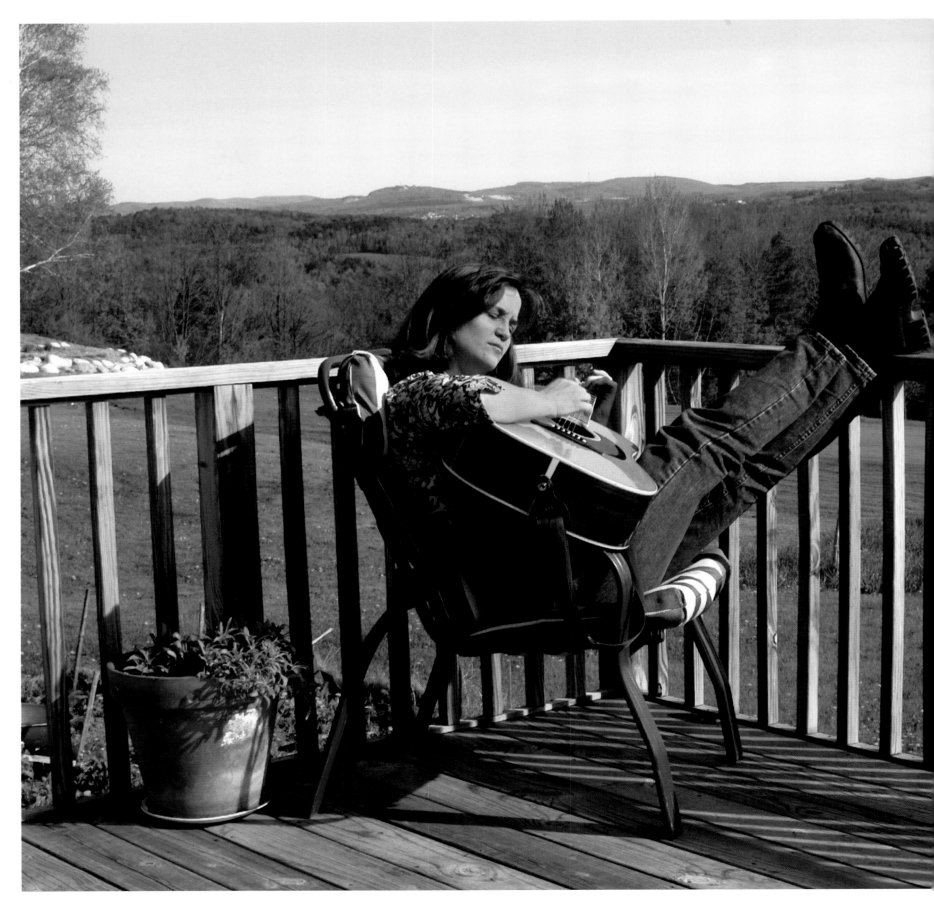

MONTPELIER

"This is the place that I call a holy land / It's calling me back with the words / and the ways I understand." In songs like "These Are the Roots," folk singer Diane Ziegler serenades her beloved native Vermont. Inspired by the vista, Ziegler composes ballads on her back deck and recorded her latest album, *Paintbrush*, just inside her house.

Photos by Karen Pike,
Karen Pike Photography, Hinesburg

WILLISTON

Since Jane St. Hillare's husband Roger painted their barn in 1990, it's been a landmark for drivers traveling between the northwestern towns of Hinesburg and Williston. "It's due for a new coat," Jane says.

MONTPELIER

Friends since birth, Nell Sather and Sally Aldrich make dandelion crowns for their mothers in Nell's backyard.

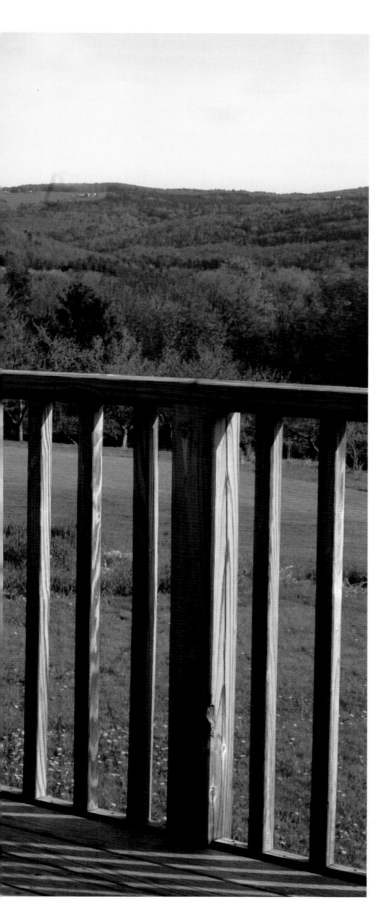

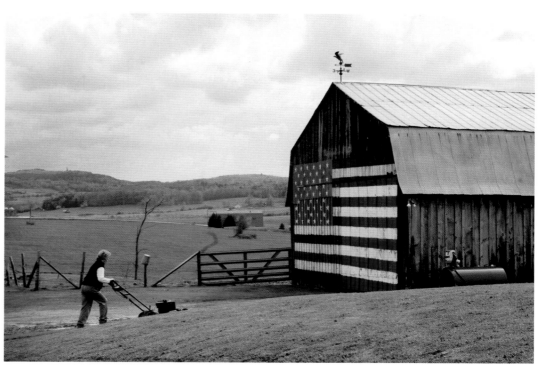

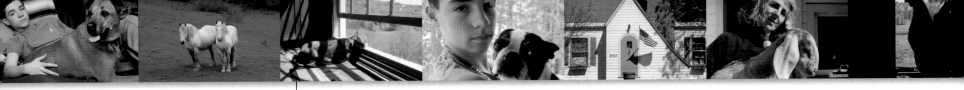

ST. JOHNSBURY
From Stephen Huneck's studio, Molly looks out at the rolling hills...of Dog Mountain. No kidding. Huneck, a dog-inspired folk artist best known for his children's books, named his 150-acre mountaintop farm in honor of his favorite subject.
Photo by Karen Pike,
Karen Pike Photography, Hinesburg

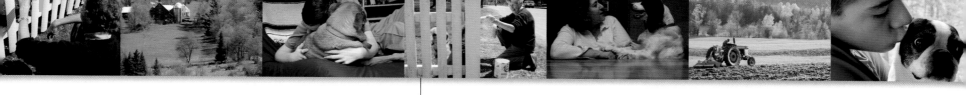

NORWICH

Alison May takes advantage of one of the first sunny days to paint her fence at the corner of Main and Hazen streets. "It was a nice day to get something done and visit with neighbors who passed by. I got a lot of Tom Sawyer comments," says May, a retired stockbroker.
Photo by Jon Gilbert Fox

Zachary Starinskas dreams while Woody keeps an
eye on the 8-year-old.
Photo by Vyto Starinskas, Rutland Herald

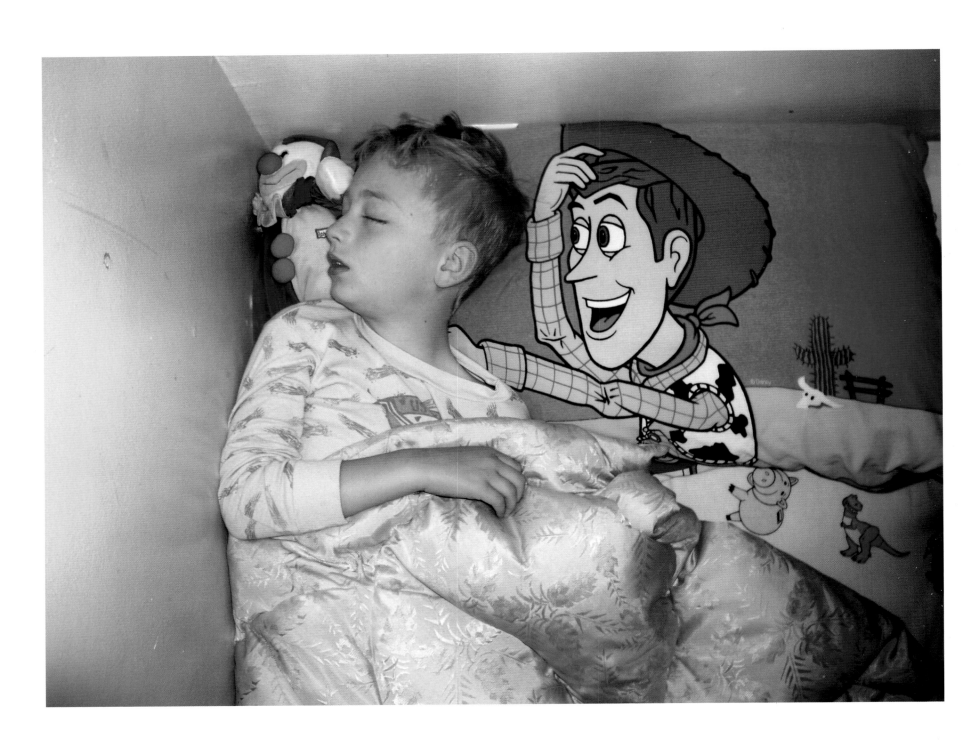

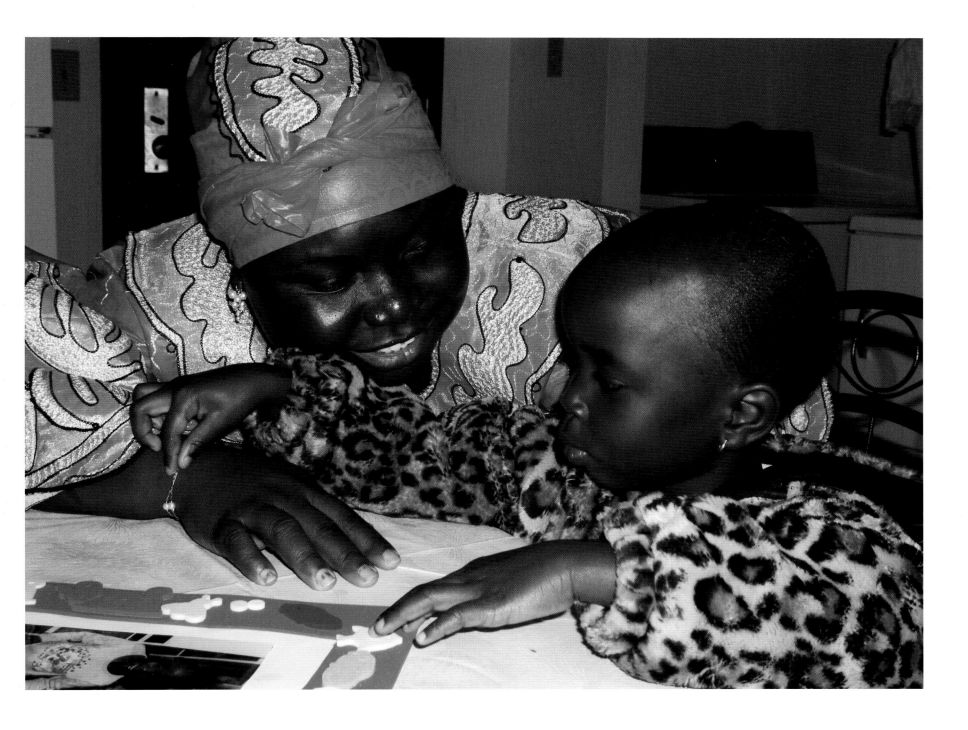

WINOOSKI

Originally from war-ravaged Sudan, Lomo Alfred lived in a refugee camp in Kenya for six years before she and her two children (4-year-old daughter Stella is shown here) could resettle in America in 2001. One of 60 Sudanese living in the Burlington-Winooski area, Alfred works nights as a custodian and is studying to be a paralegal.

Photo by Natalie Stultz,
Location Photography, Burlington, VT

GLOVER

Brittany Marsh cuddles up to grandpa Manville Powers outside Currier's Market. Powers, abused as a child, has made it his mission to help mistreated children. Over the past 22 years, he and wife Gloria have taken in nearly 300 foster children. On weekends, the couple cares for several of their 14 grandchildren, many of whose parents have foster kids of their own.

Photo by Jack Rowell

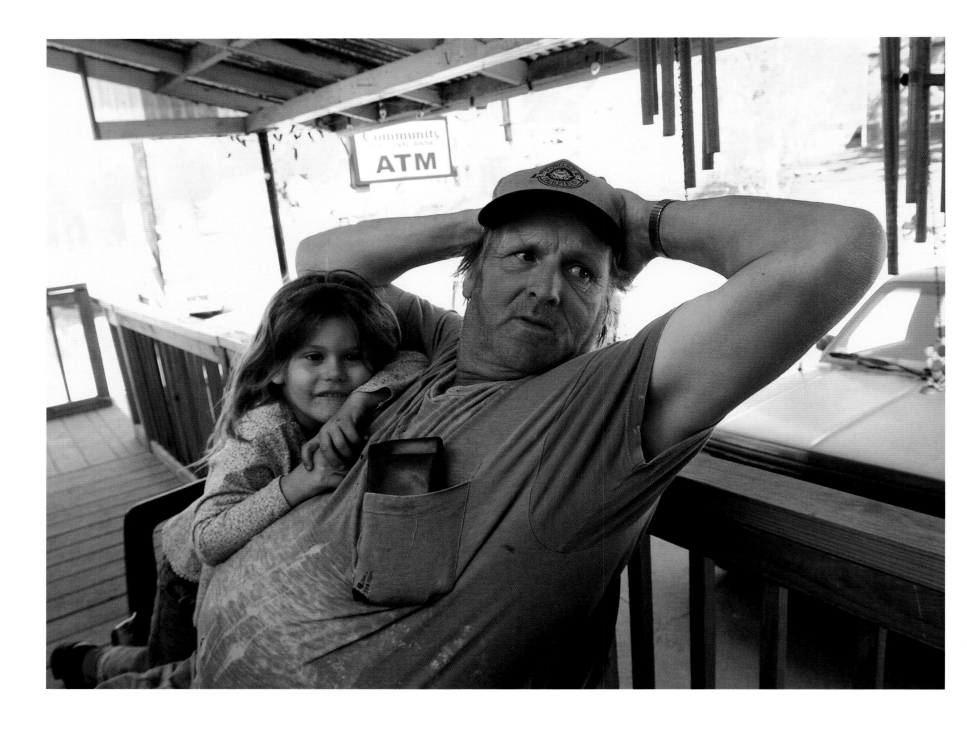

WHITE RIVER JUNCTION

The Upper Valley Haven Shelter helps families like Kim Lewis and daughter Felicia, who need a home base while they look for housing and work. The shelter can supply four families with food, clothing, and counseling for up to three months.
Photo by Jon Gilbert Fox

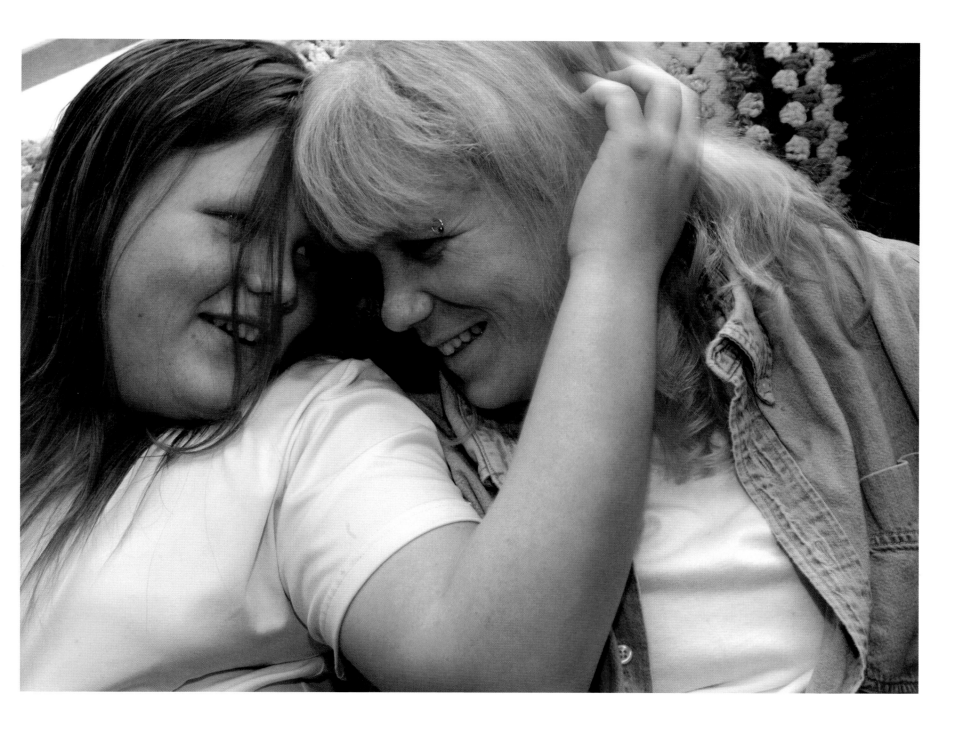

CABOT

Susan Carpenter and her 4-year-old son Sam grab breakfast and a little morning sun in front of their 1830s farmhouse. To support the family, Carpenter and her mother sell homemade maple syrup and organic milk from their herd of Jersey cows.

Photos by Craig Line

CABOT

Conditions have been tough for many dairy farmers in Vermont; wholesale milk prices dropped 21 cents a gallon between December 2001 and January 2003. The Carpenter farm is on firmer footing, though—the market for organic dairy products continues to grow.

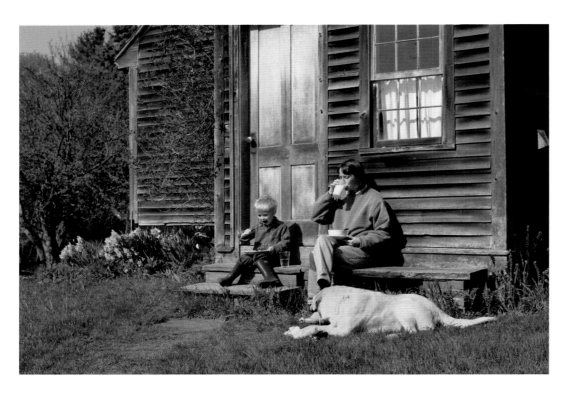

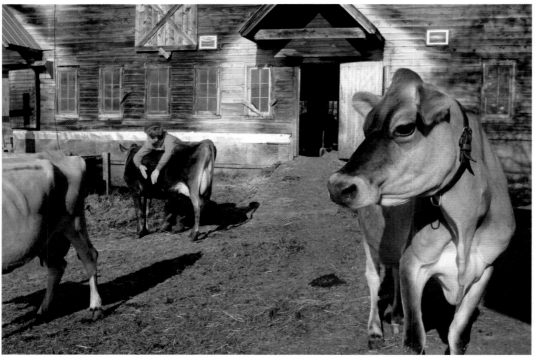

CABOT

Barbara Carpenter, sweeping an out building, discovered Vermont as a teenager on summer visits from New York. In 1950, she bought the 325-acre property where she and her daughter Susan live and work.

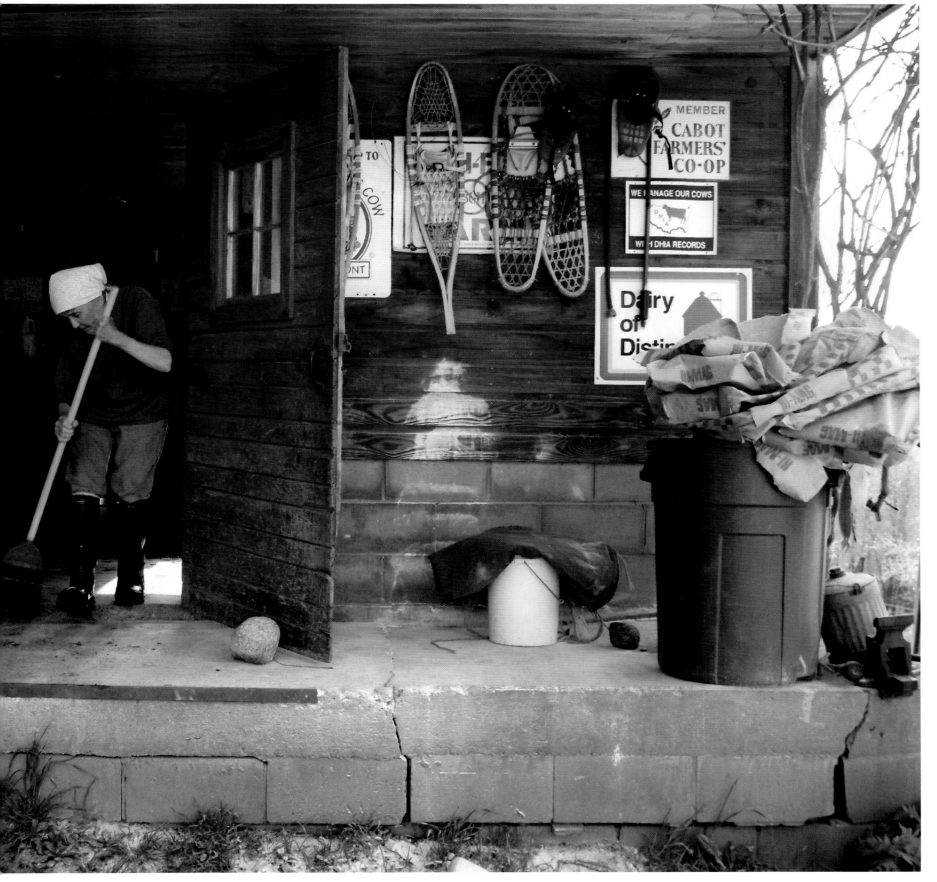

BRISTOL

Midwife Carol Gibson Warnock and new mother Hilary Payne-Vinick measure 2-day-old Gabriel, who was born at home. In Vermont, health insurance companies cover home births. "Vermont's a small place, and there's a good rapport between doctors and midwives," says Warnock. One of 16 licensed midwives in the state, she has delivered 1,000 babies in 29 years of practice.
Photo by Alison Redlich

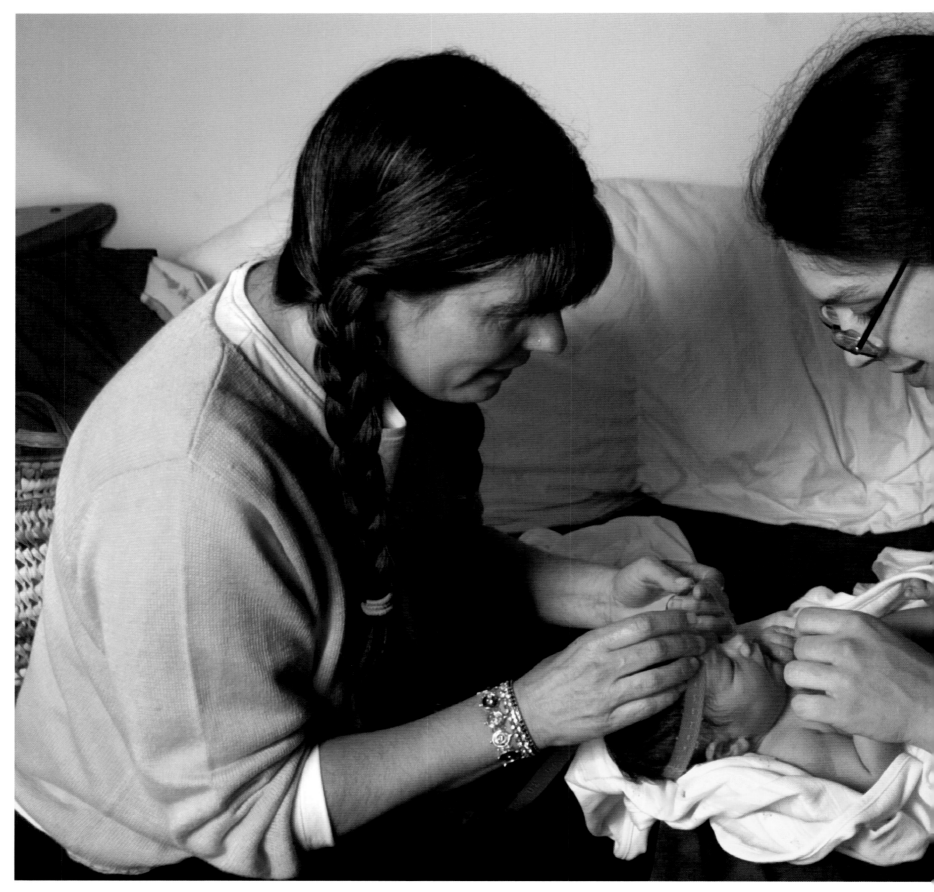

BURLINGTON

The Neonatal Intensive Care Unit at Fletcher Allen Health Care—the only one of its kind in Vermont—cares for babies weighing as little as one pound. Parents are often hesitant to hold their delicate newborns, but doctors say all infants need a human touch to reduce stress and help brain development.
Photo by Adam Riesner

BURLINGTON

Lisa Bilowith and Sue Schmidt adopted both of their African-American sons. Bilowith says the two-mom, multiracial family could exist only in a progressive state like Vermont, the first in the country to grant same-sex unions the full rights and privileges of marriage, in 1999. The first state to allow full joint adoption for lesbians and gays? Alaska, in 1985.
Photo by Karen Pike,
Karen Pike Photography, Hinesburg

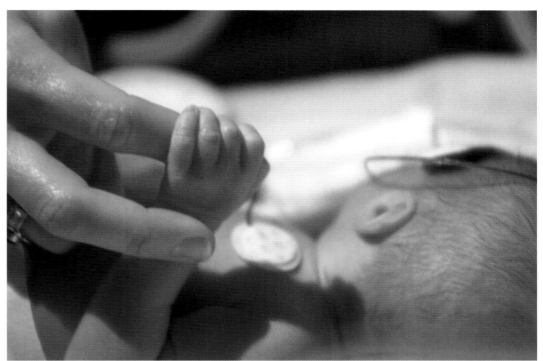

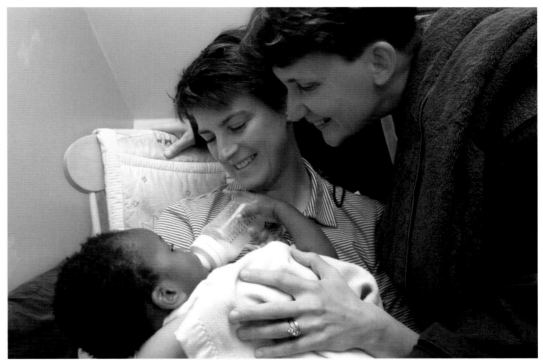

The year 2003 marked a turning point in the history of photography: It was the first year that digital cameras outsold film cameras. To celebrate this unprecedented sea change, the *America 24/7* project invited amateur photographers—along with students and professionals—to shoot and, via the Internet, submit digital images. Think of it as audience participation. Their visions of community are interspersed with the professional frames throughout this book. On the following four pages, however, we present a gallery produced exclusively by amateur photographers.

STOWE A Pintair family outing to climb Smuggler's Notch took a detour when they spied an abandoned barn. "Sometimes cows and sheep live in barns, but unicorns live in my barn," says Olivia Pintair. *Photo by Kathy Pintair*

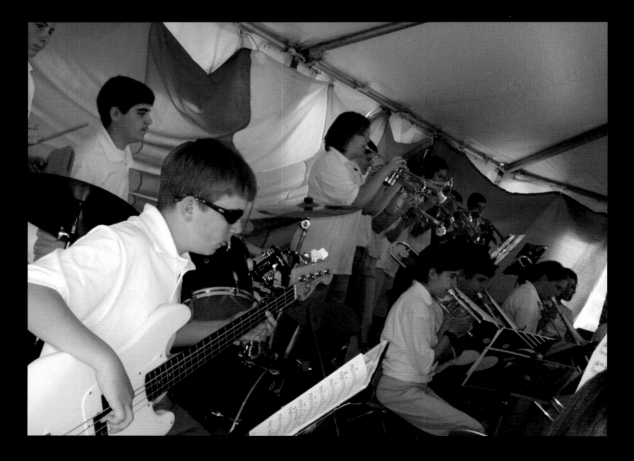

BURLINGTON Riffing on Carlos Santana's "Oye Como Va," Aidan Zebertavage and members of the Williston Central School Jazz Band supply the tunes for Burlington's annual Kids' Day festival. *Photo by S Mease*

CHARLOTTE Tristan Fulford wrestles with Cappoosh, while Michael Rubin introduces his puppy Mookie to the neighborhood. *Photo by Sarah Montgomery*

CHARLOTTE After hours of racing around, 3-month-old Mookie was content to curl up with his playmates. *Photo by Sarah Montgomery*

UNDERHILL "I came to a dead stop in the middle of the road—you can get away with that here," says photographer Sara Riley, who snapped this shot of Mt. Mansfield. *Photo by Sara Riley*

BARRE Melissa Ann Lafayette has been working at McDonald's for four years. The 20-year-old hopes to advance to assistant manager. *Photo by Chas Weaver*

BRATTLEBORO Creamery Bridge is the only covered bridge visible from Route 9, the main east-west route across southern Vermont. The Towne Lattice–style bridge spans Whetstone Brook. *Photo by Mark Tafoya*

UNDERHILL In the farmlands and woods west of Underhill Center, spring's first full flush of green marks what Vermonters call their "second foliage season." *Photo by Sara Riley*

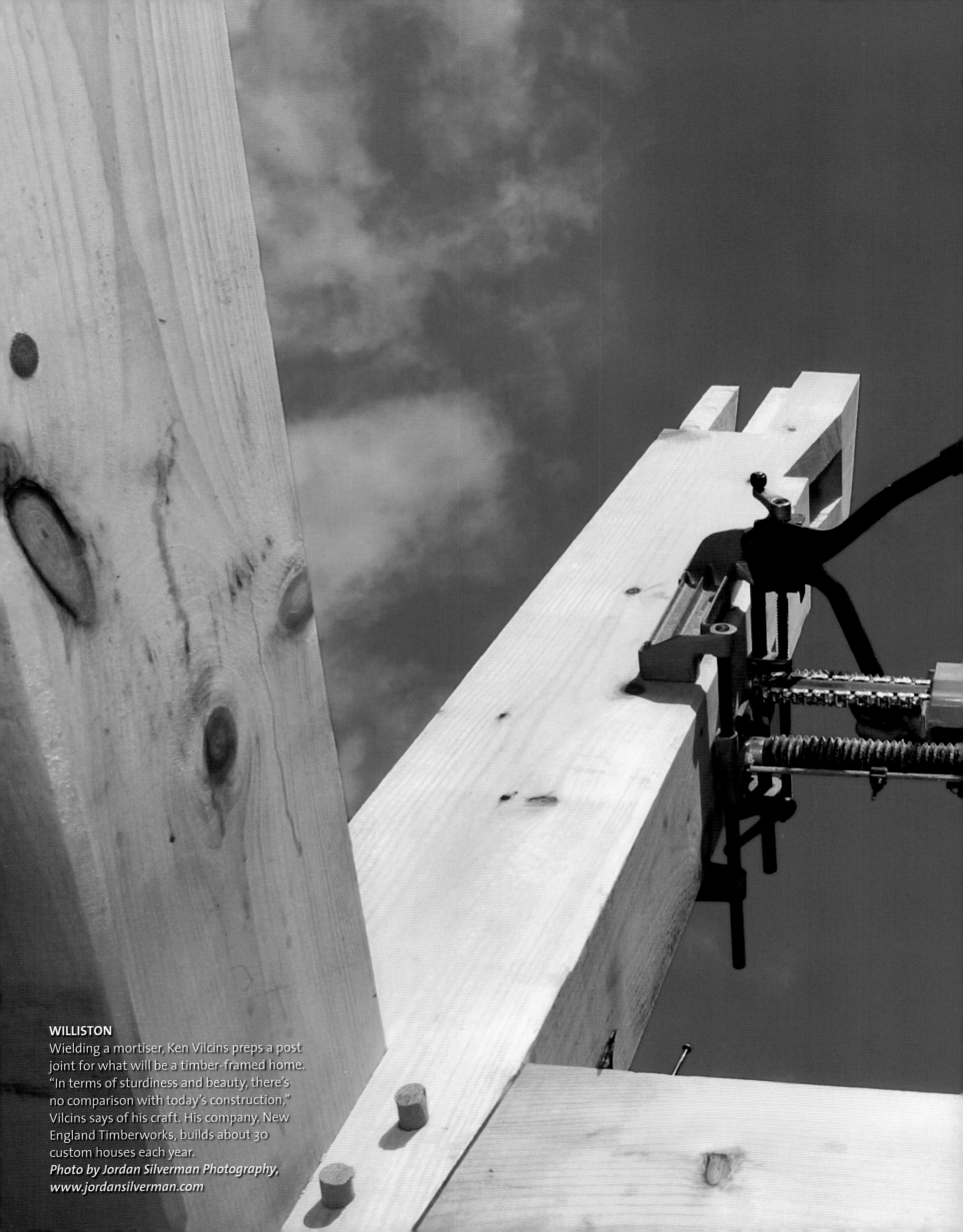

WILLISTON
Wielding a mortiser, Ken Vilcins preps a post joint for what will be a timber-framed home. "In terms of sturdiness and beauty, there's no comparison with today's construction," Vilcins says of his craft. His company, New England Timberworks, builds about 30 custom houses each year.
Photo by Jordan Silverman Photography,
www.jordansilverman.com

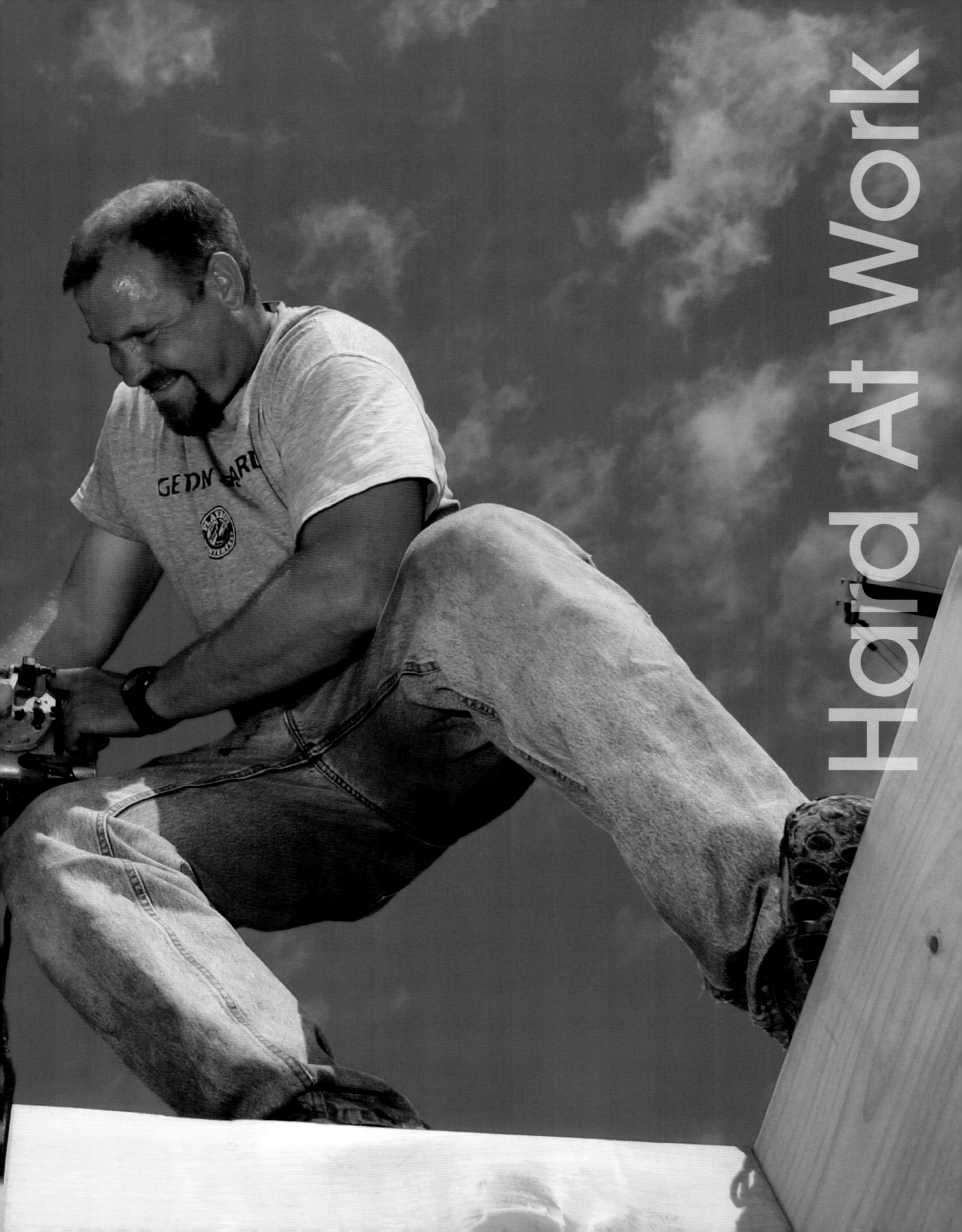

Hard At Work

SOUTH HERO

Like most rural towns, South Hero (pop. 1,696) can't afford its own fire department, but residents step up to get the job done. Volunteers Christina LaBarge and Christine Bourque practice laying hoses, hauling ladders, and maneuvering fire engines at a weekly training session.

Photos by Rob Swanson

SOUTH HERO

Retired safety engineer Al Hilliker has been a member of the volunteer fire service for most of his adult life. In the past year, he's responded to 54 calls for fires and automobile accidents. "I like being able to serve my community," he says.

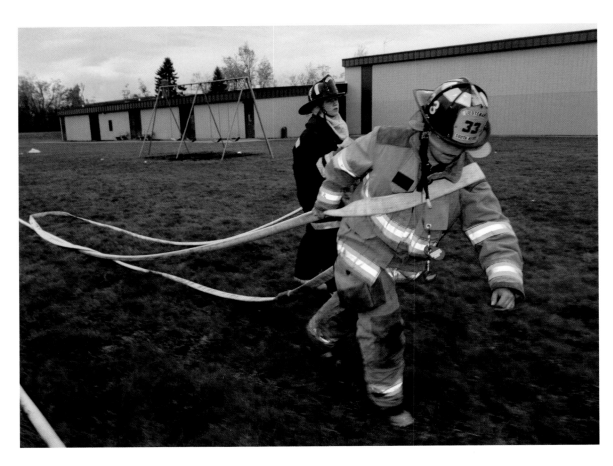

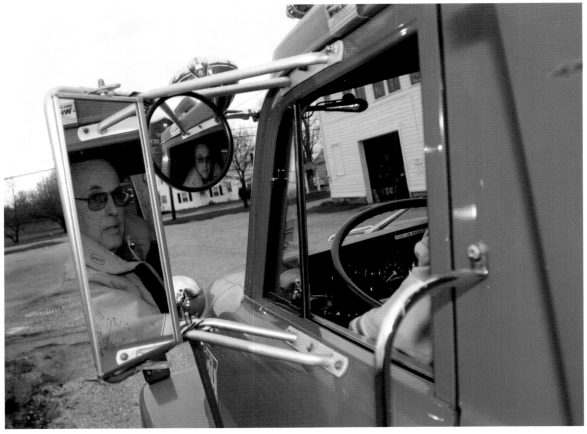

SOUTH HERO

For a 115-pound teenager, wearing a 40-pound fire suit and hauling a 28-foot ladder can be a daunting task. But Christina LaBarge held her own during training drills. The 17-year-old decided to join the department after her boyfriend and best friend were rescued from a car crash by volunteer firefighters.

SOUTH HERO

Middle school social worker by day and firefighter training officer by night, Christine Bourque directs recruits in hose charging drills. The South Hero Fire Department has 18 volunteers who respond to traffic accidents and fires in the Champlain Islands area.

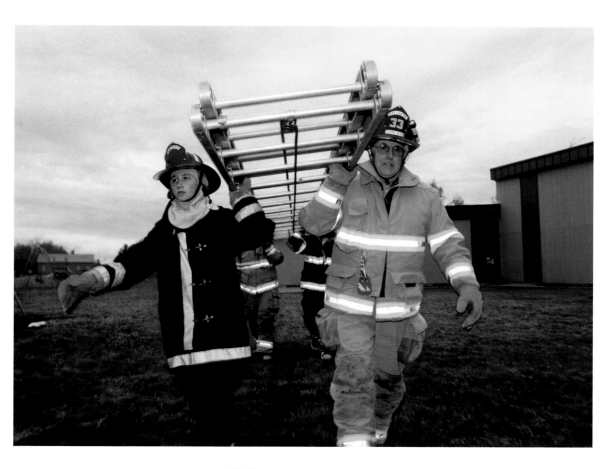

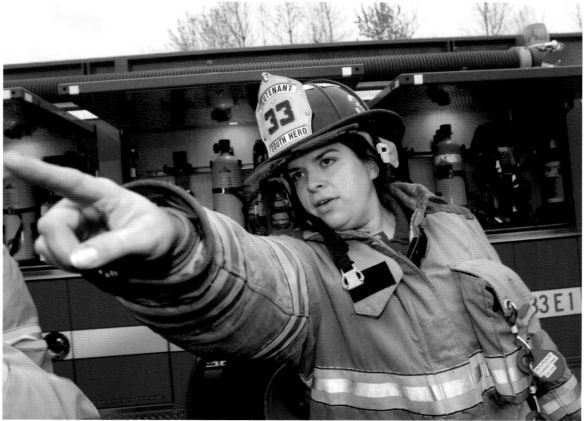

BURLINGTON

Douglas Kempner finds that Church Street Marketplace is a good venue for attracting a paying audience. "I like playing the cello, and I like making money," he says. Douglas, 13, who plays in the Vermont Youth Philharmonia, donates part of the $200-plus he earns each week during the summer to local charities.

Photo by Alison Redlich

BURLINGTON

Jon Lines, owner and cook of the Oasis Diner—started by his grandfather in 1954—has put a few Greek and vegetarian dishes on the classic diner's menu.

Photo by Alison Redlich

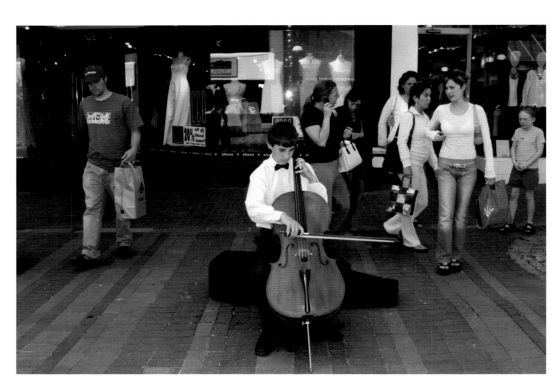

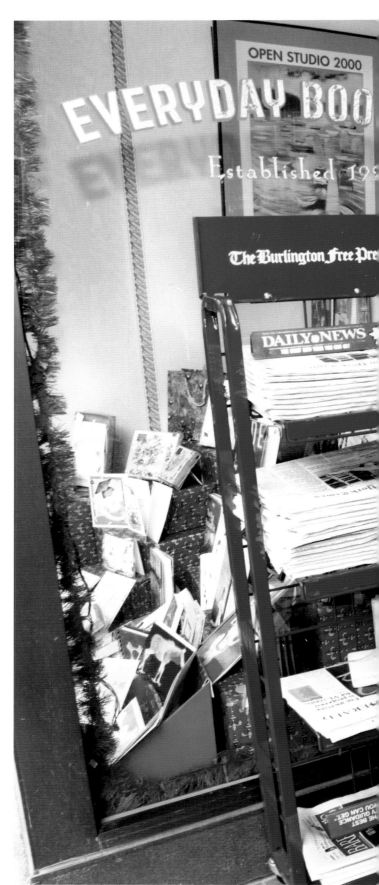

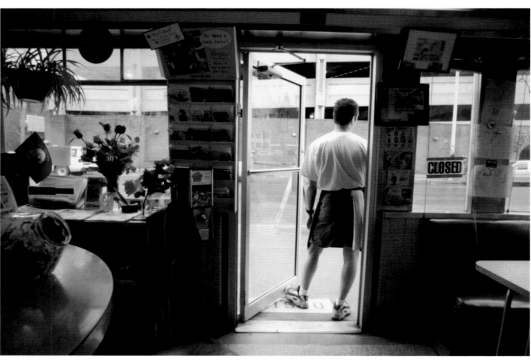

Elizabeth Orr's love of books led her to open her own store, Everyday Book Shop, in 1967. These days she hardly has time to read. Discount stores are undercutting her prices and the downturn in the economy has made Vermonters cautious about spending. "I've laid off all of my staff and downsized to a smaller building," says Orr.
Photo by Paul Hansen

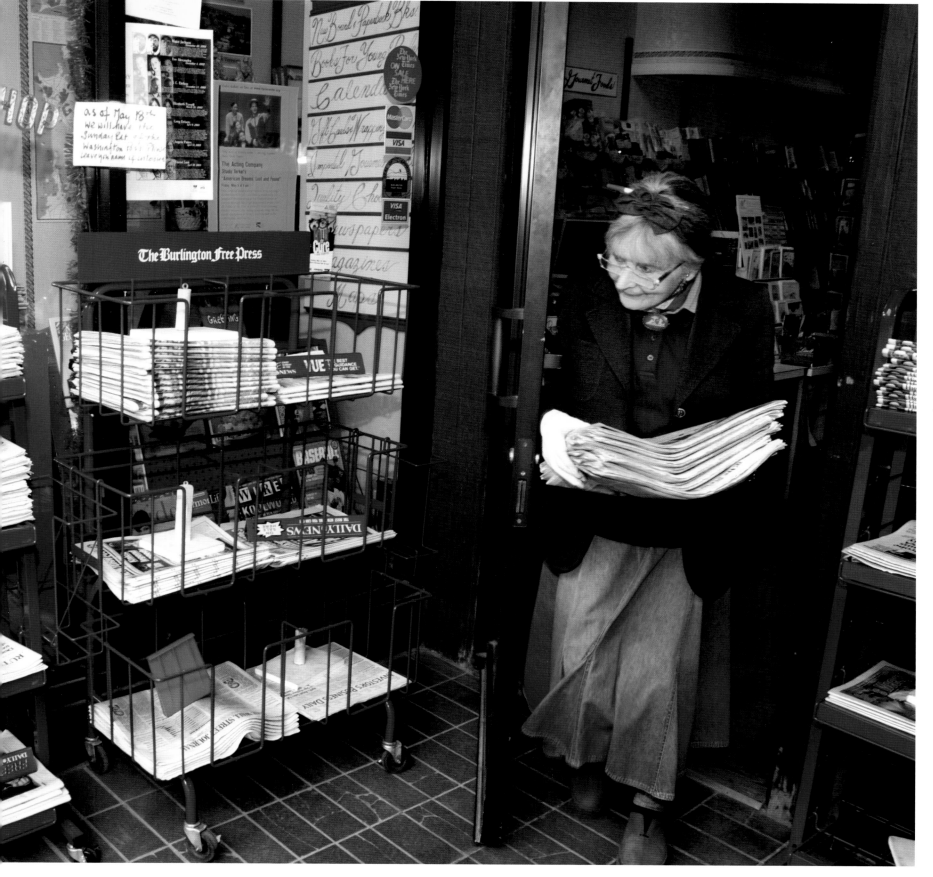

NORWICH

Riley and Hollis Westling know that their house on Main Street is a good place to snag customers. Their entrepreneurial schemes change with the seasons: This time of year, they sell hot chocolate. Come summer, it's lemonade, of course.

Photo by Jon Gilbert Fox

BURLINGTON

During a lull in business at their Overlook Park lemonade stand, Tyler Bradley samples the product while his brother Connor continues advertising. The boys sold 40 lemonades to the crowd gathered to watch the sun set over Lake Champlain.

Photo by Adam Riesner

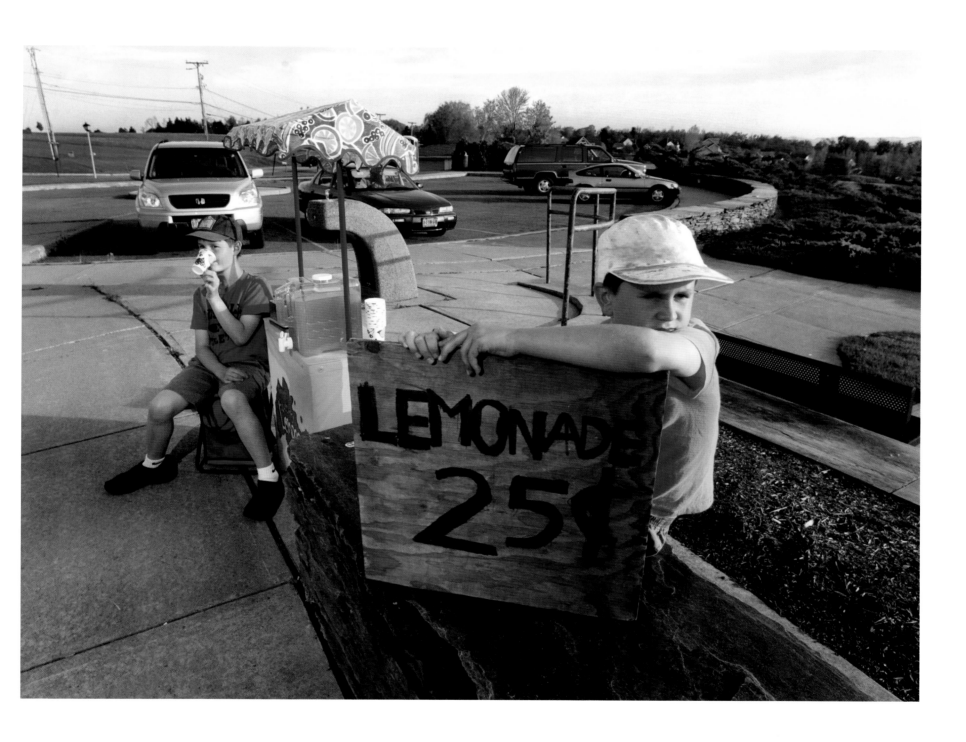

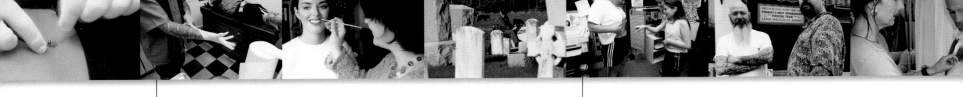

BURLINGTON

At Yankee Tattoo, Vermont's first legal body art parlor, Robert Dix prepares to repierce Amanda Tatro's lower lip. A regular customer at the shop, Tatro has several tattoos. Her previous piercing closed up when she left her hoop out too long.
Photos by Adam Riesner

BURLINGTON

After losing 27 pounds, Cindy Ploof treated herself to a belly button piercing. A bold move she never would have considered before, it's "way cool" according to daughter Rachael (foreground) and her friend Connie Ceril.

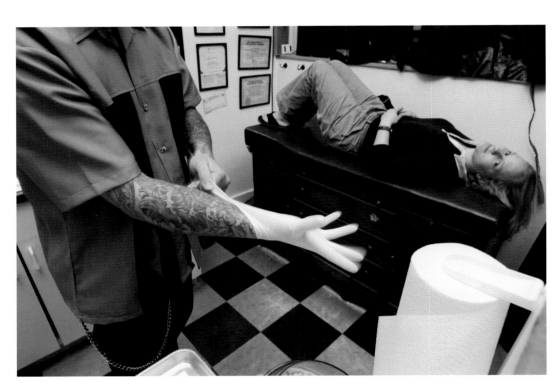

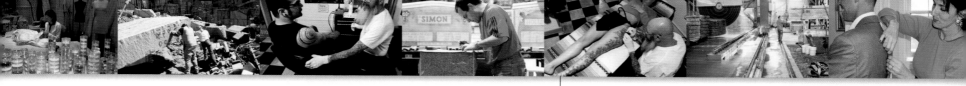

After failing high school art class because of his Vietnam War protest drawings, Bald Bill Henshaw spent 20 years traveling America as a tattooist. In 1996, the proud bearer of 30 tattoos (by 30 different artists) settled in Burlington to cofound Yankee Tattoo, where he practices his indelible craft on Patty Day.

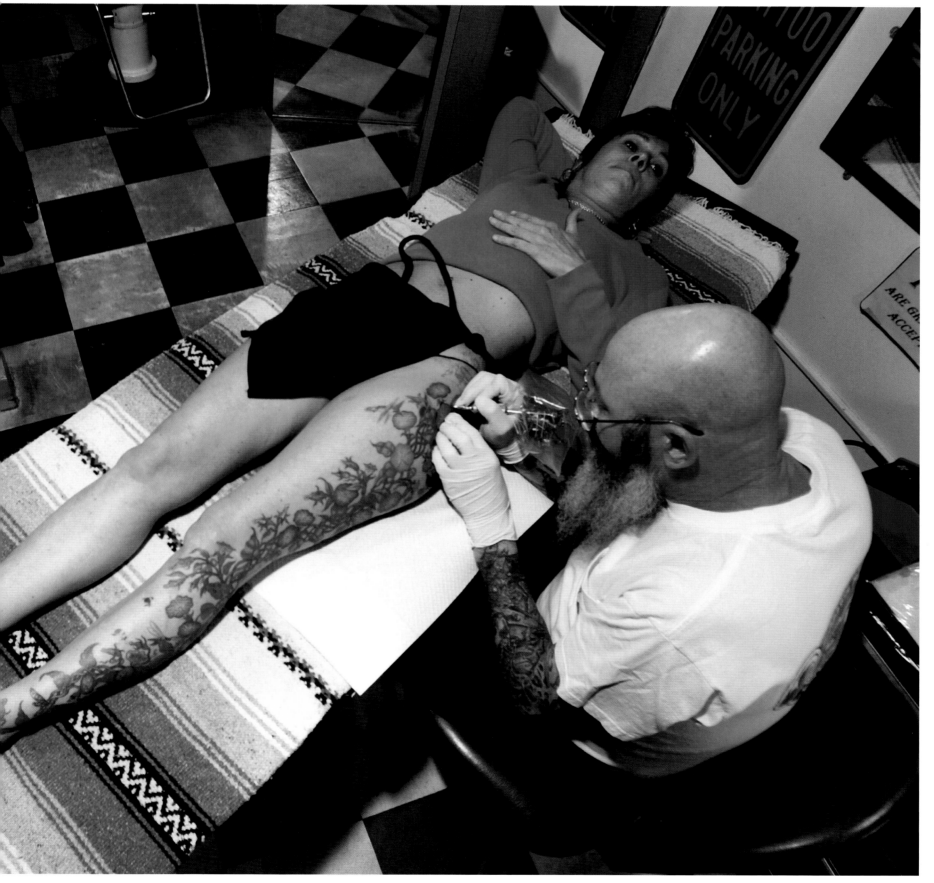

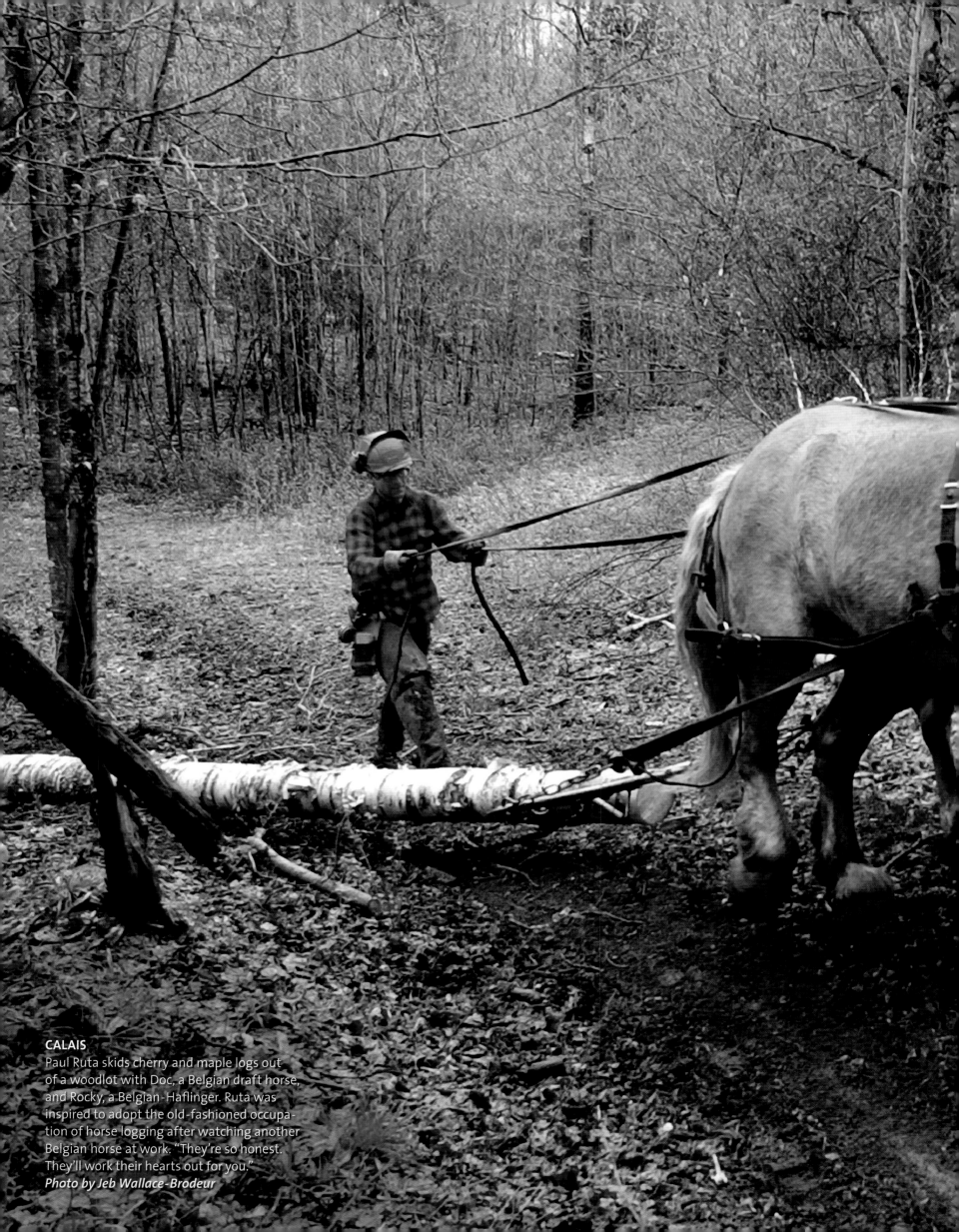

CALAIS

Paul Ruta skids cherry and maple logs out of a woodlot with Doc, a Belgian draft horse, and Rocky, a Belgian-Haflinger. Ruta was inspired to adopt the old-fashioned occupation of horse logging after watching another Belgian horse at work. "They're so honest. They'll work their hearts out for you."

Photo by Jeb Wallace-Brodeur

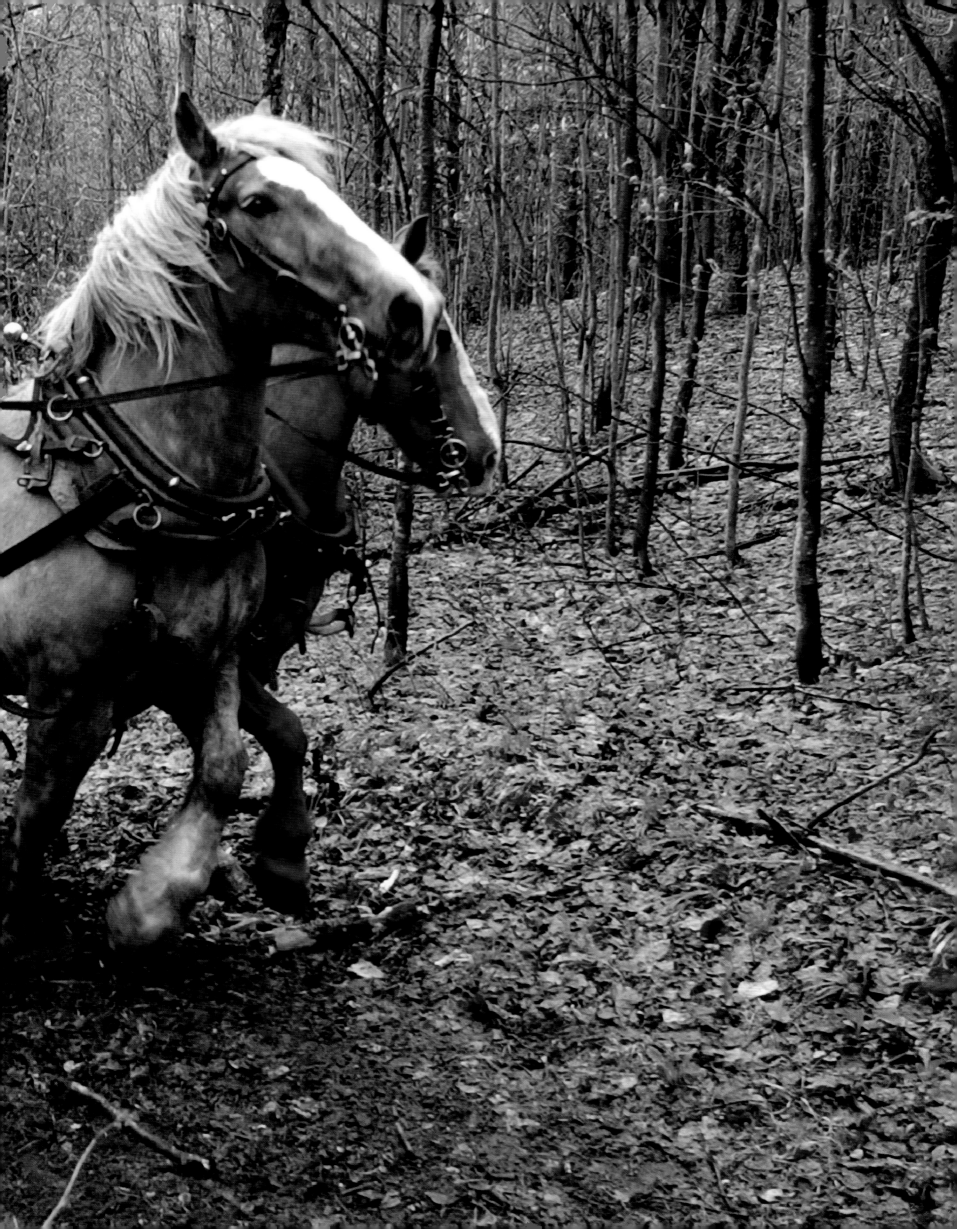

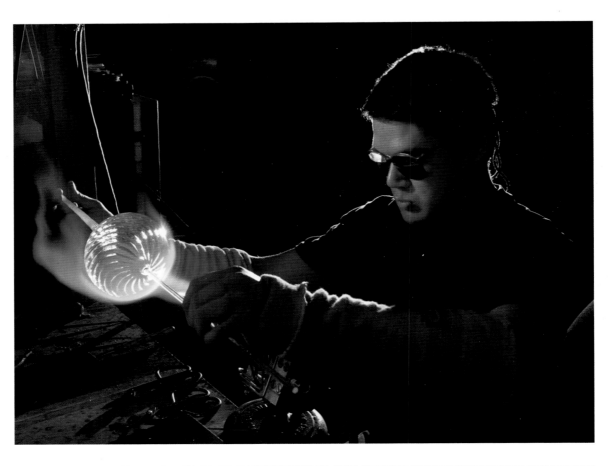

BURLINGTON

Using the Venetian "flamework" style of glass blowing, Jonathan Van Hecke can whip up a candy dish out of borosilicate in just over an hour. But, he says, "I'm burnt out on small production work. I want to do fine-art glass sculptures."
Photo by Peter Huoppi

TUNBRIDGE

Robin Mix cools and shapes a bubble of molten glass with wet newspapers to form a vase, while his assistant Mark Barreda blows into the rod to keep the bubble inflated. Mix uses *murrini*, an Italian mosaic technique, to make the pieces he sells to high-end shops like Tiffany's and Barney's.
Photo by Jon Gilbert Fox

WEYBRIDGE

Have tools, will travel: Lee Beckwith, a farrier, hauls out a propane forge, heats up a horseshoe, and then uses it to burn a mark on the bottom of a horse's hoof. The impression indicates whether the fit is good. If it's not, he files the hoof to make the shoe fit and nails it on.
Photo by Natalie Stultz,
Location Photography, Burlington, VT

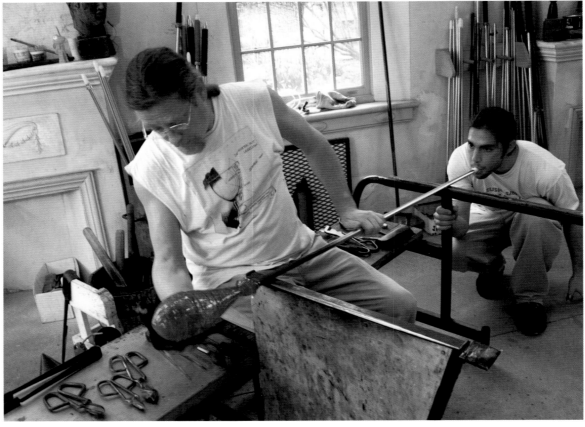

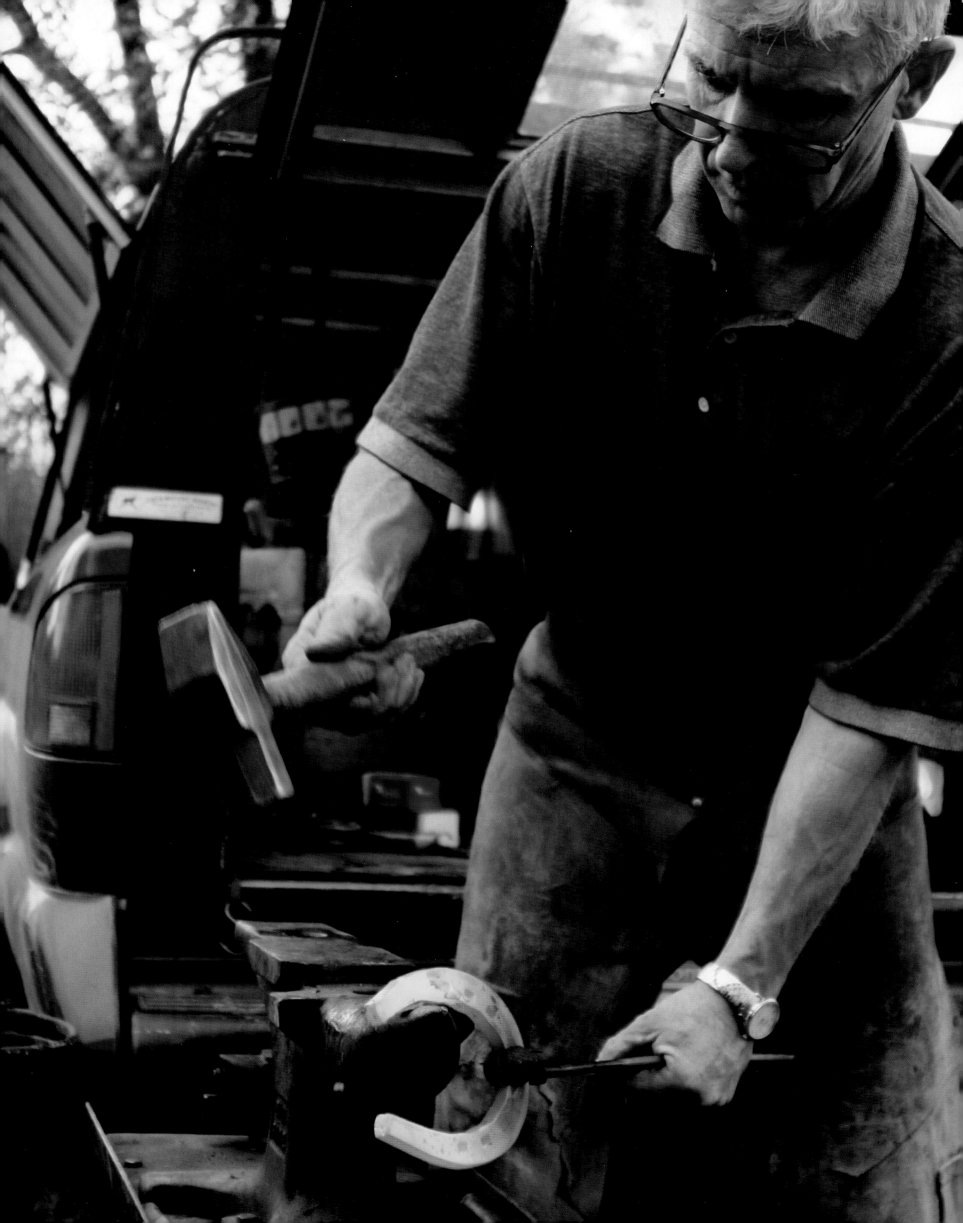

ALBURG

Vermont's first cheese factory opened in 1864. Today, the state produces 70 million pounds thanks to two dozen companies, most of them small, family-run operations such as Joanne James's Lakes End Cheese. Started in 1996 after James received some excess goat milk from a friend, Lakes End turns out artisanal cheeses from her herd of Jersey cows and dairy goats.
Photos by Paul O. Boisvert

SHELBURNE

Marisa Mauro and Jamie Miller stack cheese at Shelburne Farms. After being heated, the raw ingredients—milk, bacterial culture, and rennet—form solid curds. Raked into slabs, the curds are stacked and restacked to reduce moisture. The cheese is then aged for up to three years, becoming some of the 125,000 pounds of cheddar the company produces each year.

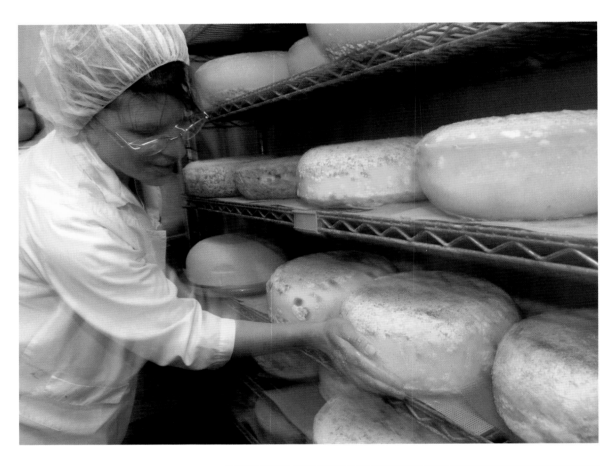

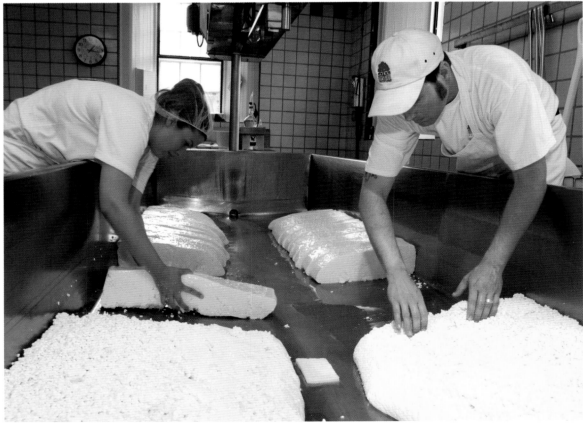

FERRISBURGH

Robert Lavallee rolls ham out of the smoker at Dakin Farm. Founded in 1792, the company still smokes its meats over corn cobs. Not to be stuck in the past, Dakin went high tech and started selling its products online in 1995. Since then, annual revenues have soared from $2.5 million to $4.5 million in 2003.

BURLINGTON

Rhino Foods made its mark by whipping up the chocolate chip cookie dough used in Ben & Jerry's ice cream. The firm now has a line of desserts, including a 6-inch cheesecake that Steve Cheever and Samira Talic top off with chocolate swirls.

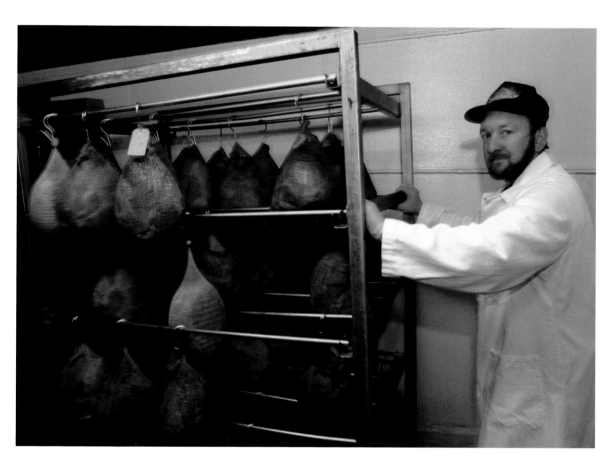

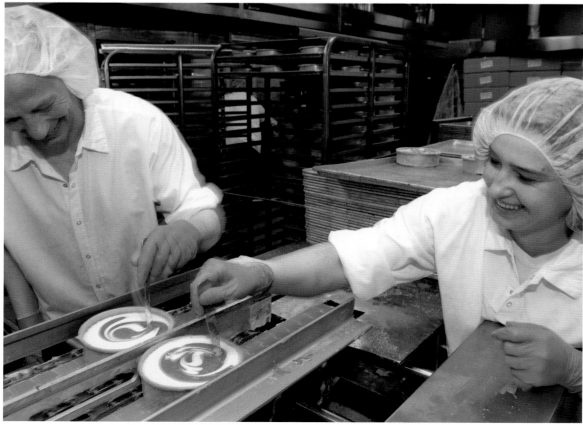

BERLIN

While friends hold and comfort her, veterinarian Tom Stuwe (in front) assesses Fire's condition at Craggy Lea Farm. The purebred Arabian had foaled earlier that morning, but the birth did not go well. The colt died and Fire suffered paralysis in her hindquarters. The 18-year-old mare, a beloved favorite of owners James and Holly Gavin, was euthanized a few hours later.

Photo by Craig Line

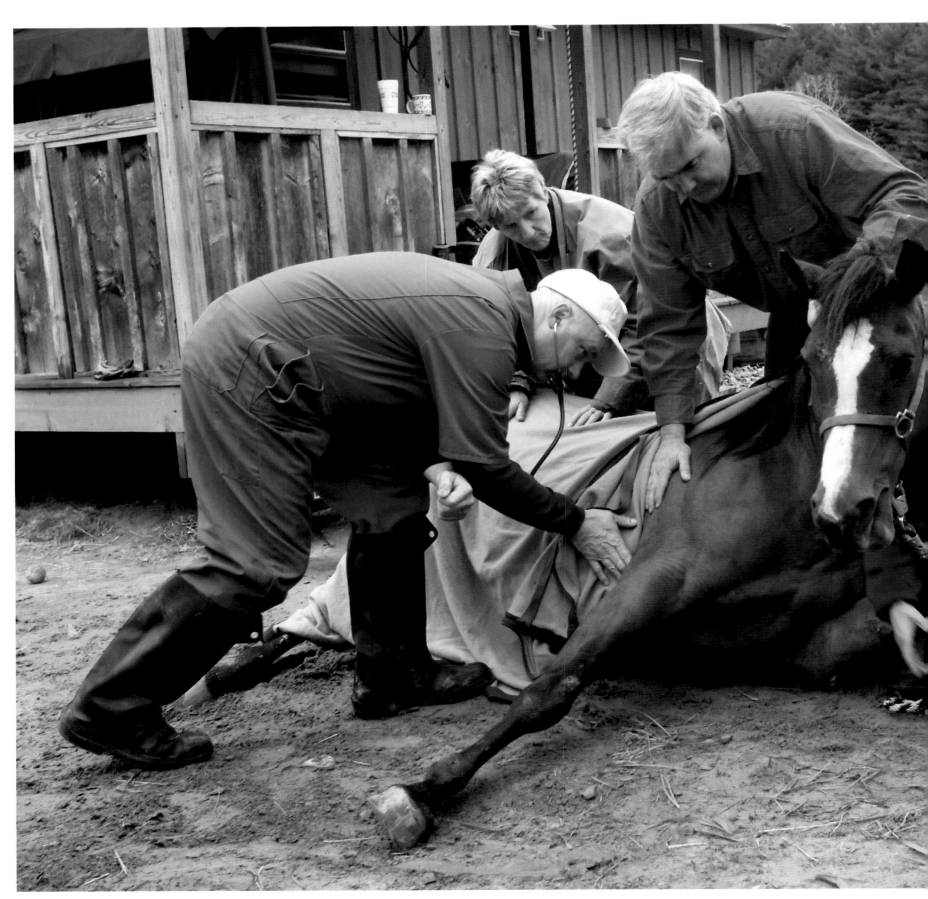

BURLINGTON

Dr. Lewis First, chief of pediatrics at Fletcher Allen Health Care, examines new patient Ashley Warren, who was recently diagnosed with Type 1 diabetes. Ashley's life now includes daily insulin shots and regular checkups on her blood sugar level. According to her father Todd, the smile on the 5-year-old's face says it all. "She's been really terrific with accepting this."
Photo by Adam Riesner

WELLS RIVER

Dr. Harry Rowe, 90, still sees patients like Timothy Larabee four days a week. Rowe opened his family practice in 1946, when house calls were very common. "I liked seeing where people lived, what kind of beds they slept in," Rowe says. "But it's an inefficient way of doing modern medicine."
Photo by Jon Gilbert Fox

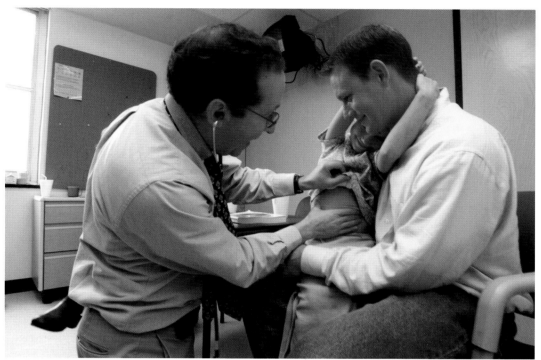

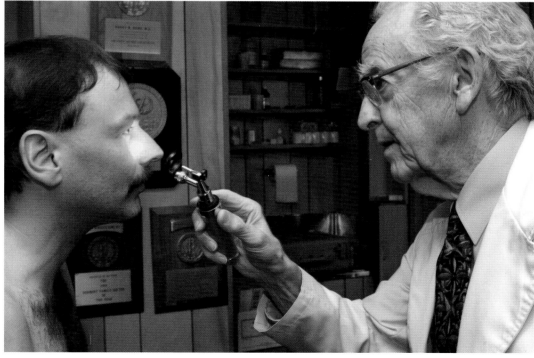

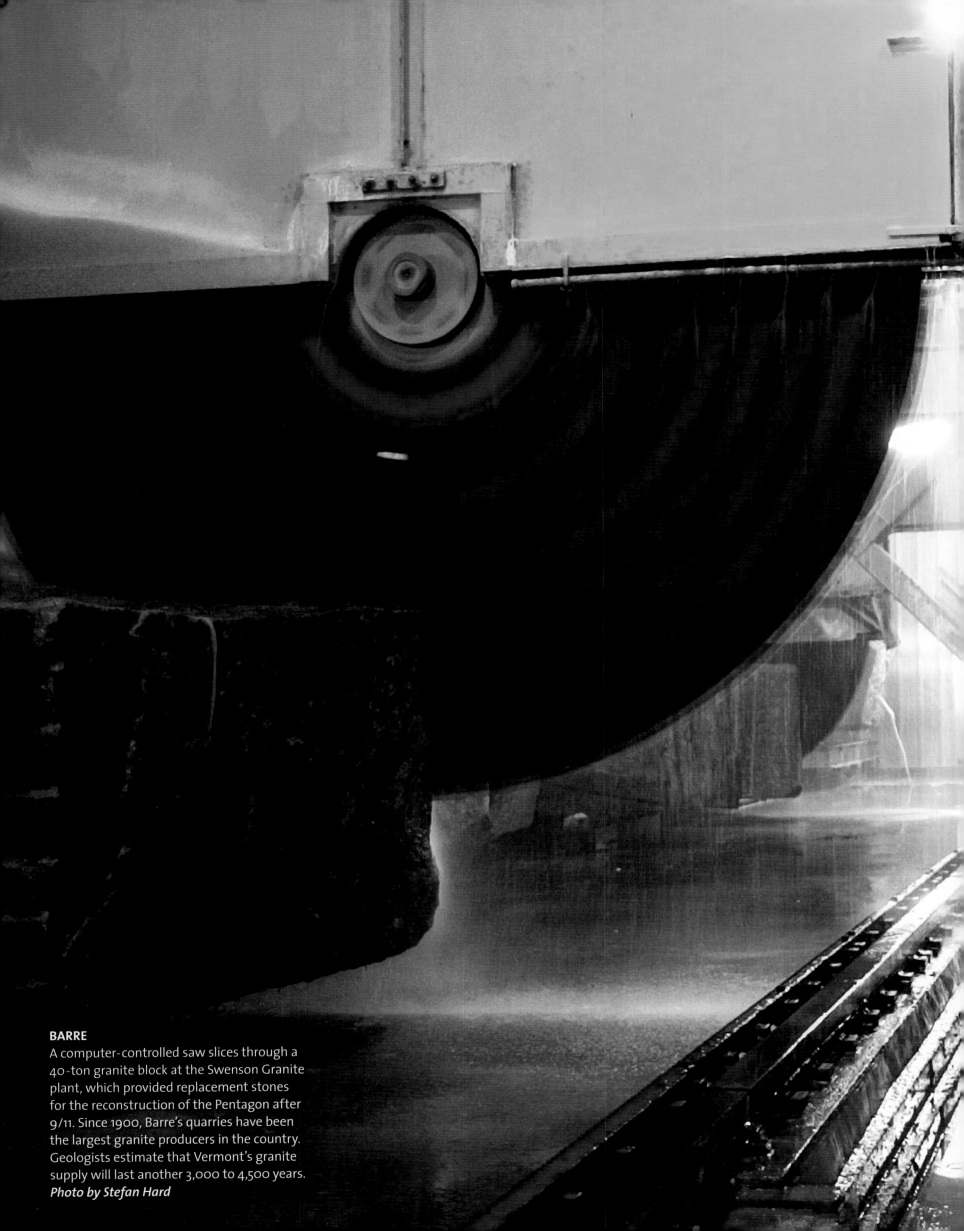

BARRE
A computer-controlled saw slices through a 40-ton granite block at the Swenson Granite plant, which provided replacement stones for the reconstruction of the Pentagon after 9/11. Since 1900, Barre's quarries have been the largest granite producers in the country. Geologists estimate that Vermont's granite supply will last another 3,000 to 4,500 years.
Photo by Stefan Hard

MONTPELIER

Before the Vermont House of Representatives convenes, Rep. Mary Morrissey (R-Bennington) discusses a transportation bill with Rep. Frank Mazur (R-South Burlington). Getting things done can be a challenge for lawmakers—Republicans dominate the House, Democrats rule the Senate, and the legislature meets for only five months of the year.

Photos by Glenn Russell, The Burlington Free Press

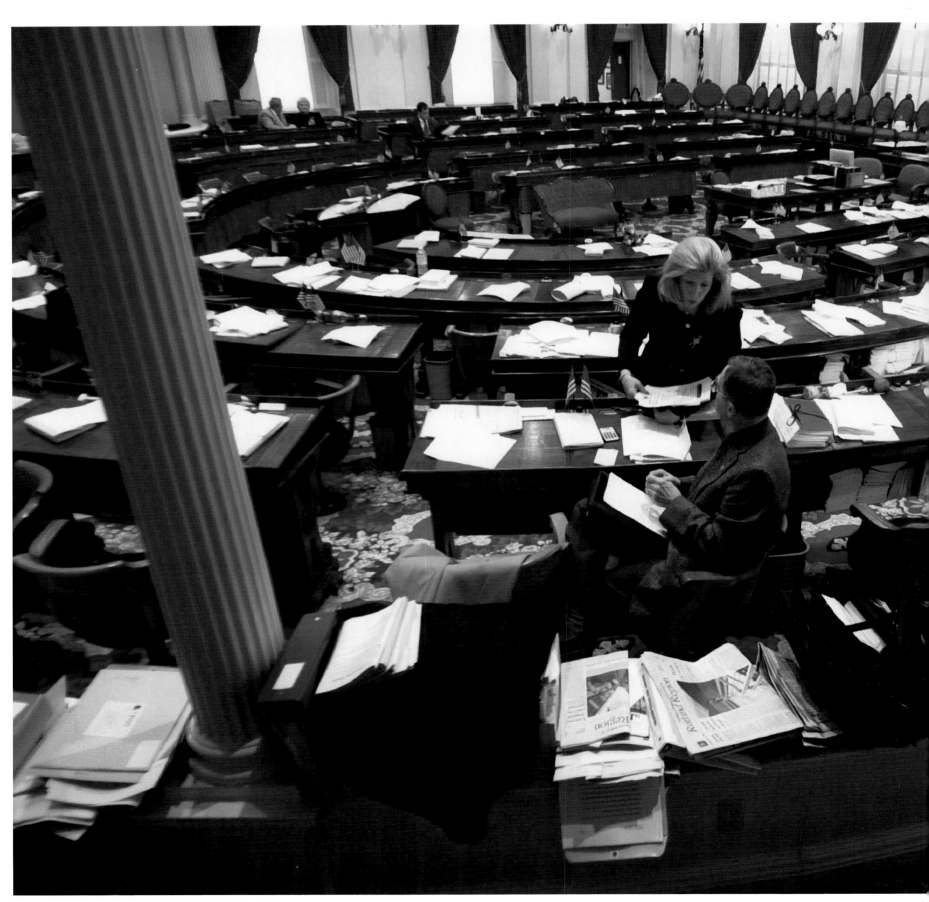

MONTPELIER

Sen. Vince Illuzzi (R–Essex-Orleans) sizes up an argument made by Rep. Bob Wood (R-Brandon) during negotiations on a capital construction bill. Sen. Illuzzi, a personal injury lawyer from Derby, was first elected in 1980 and is now the second longest serving member of the state legislature.

MONTPELIER

Rep. George Cross (D-Winooski) retreats to an alcove in the State House to make a phone call. Legislators don't have offices or support staff and most hold full-time jobs in their districts. "It's a citizen's legislature," says Cross. "It's considered a public service, not a prestigious position."

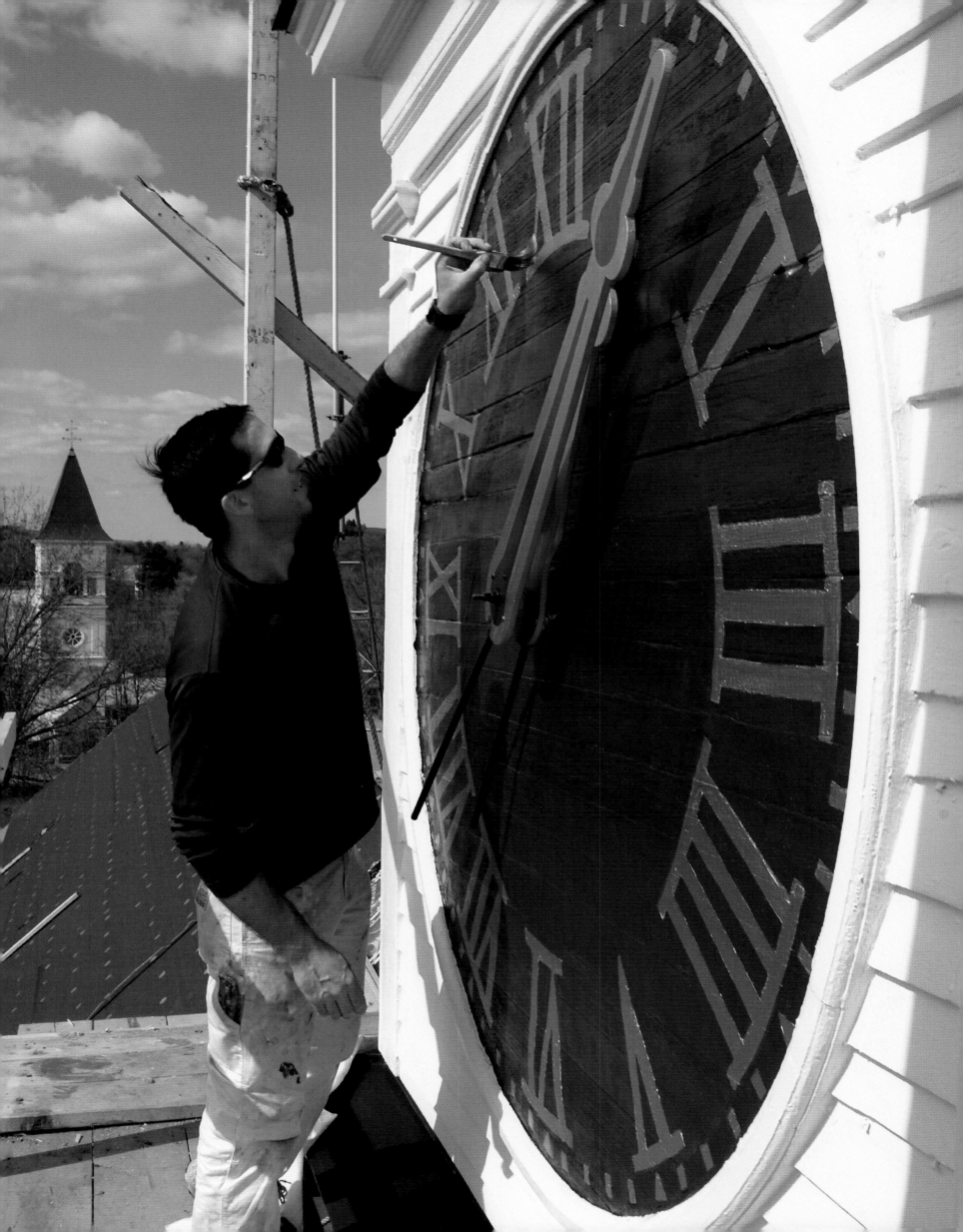

DANVILLE

Steady-handed Stephen Sanchez applies gold-leaf paint to the town hall clock. Sanchez has repainted the tower and all three clock faces as part of the building's restoration. Built in 1889, the hall is the central landmark in this town of 2,200 people.

Photo by Craig Line

GREENSBORO BEND

Although Phil Pike, aka Kangi Tanka ("raven" in Lakota), has no Native American blood in him, he is fascinated with the culture. Selling and repairing furnaces by day, Pike spends his summer evenings in a tepee and his weekends tanning and beading buckskin clothing and constructing watercraft, like this Inuit-style cedar kayak.

Photo by Jack Rowell

BRISTOL

Six years ago, Pat Palmer wanted to give his two Percherons, Spud and Chief, something to do, so he bid on a contract to collect Bristol's garbage and recyclables. Palmer won a 300-house route, which takes the team six hours. "We've only missed one day," Palmer says proudly. "And that's because they hadn't cleared the roads."
Photo by Jordan Silverman Photography,
www.jordansilverman.com

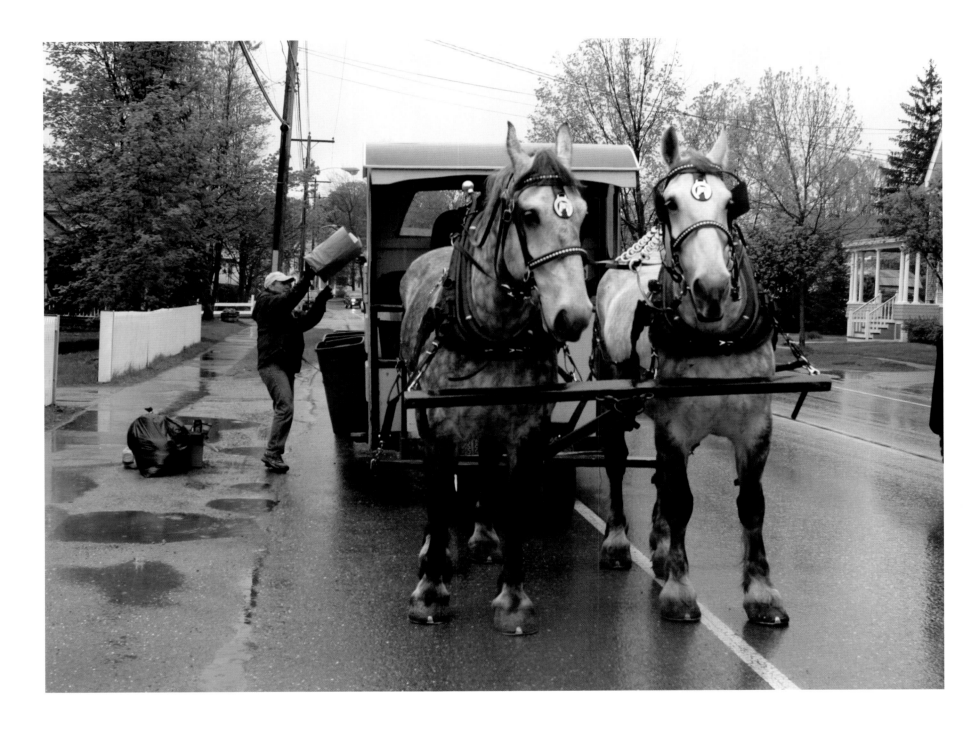

BURLINGTON

In 1988, the Intervale Foundation and Winooski Valley Park District began the ecological restoration of an old dump on the edge of Burlington. The 700-acre site now supports 12 organic farms that produce a half-million pounds of food each year. Kelli Bundgard of Full Moon Farm plants corn from the back of a sowing tractor.

Photo by Natalie Stultz,
Location Photography, Burlington, VT

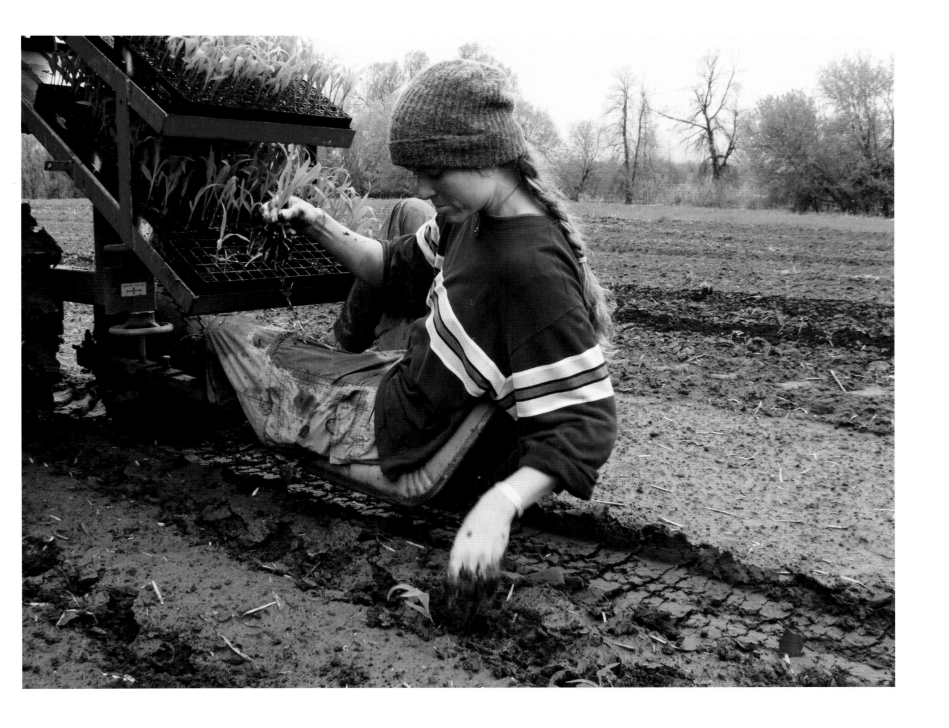

BERLIN

Self-described water witch Anne Burke teaches her granddaughter Becky Burke how to divine the location of subterranean water. Dowsers like Anne use a pronged stick to detect water hundreds of feet below the surface and to determine the direction of its flow. Scientific research may not support dowsing, but Anne's talent has earned her regular paid assignments with the Manosh Drilling Company.

Photo by Peter Miller

WATERBURY

After clearing manure from the gutter of her tractor, Rosina Wallace loads it with more and fertilizes her pasture with the nutrient-rich muck. The Vermont native runs the 225-acre dairy farm that her great-grandparents started in 1866.

Photo by Peter Miller

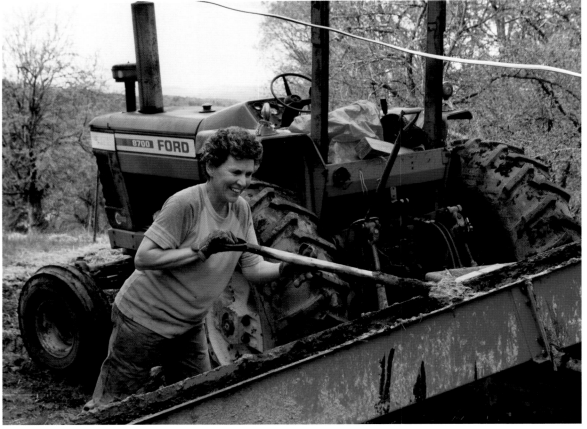

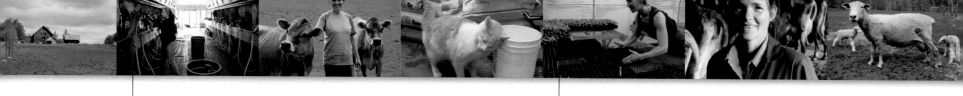

EAST BROOKFIELD

Morgan Greenwood, 21, who just got her degree in agricultural business, milks Holstein cows at Sprague Ranch. Built in 2000, the 24-stall, computerized milking parlor enables Greenwood to milk 400 cows in four hours, versus the 12 it takes manually. Sprague Ranch cows live in barns and are injected with the controversial bovine growth hormone BST, which stimulates milk production.
Photo by Jack Rowell

BURLINGTON

Jennifer Woodworth slides flats of lettuce, pepper, and tomato seedlings into the greenhouse at the Intervale Community Farm, an organic cooperative. Most crops in Vermont are harvested from late May through mid-November, although a few hardy salad greens continue to grow in the greenhouse through the winter.
Photo by Natalie Stultz,
Location Photography, Burlington, VT

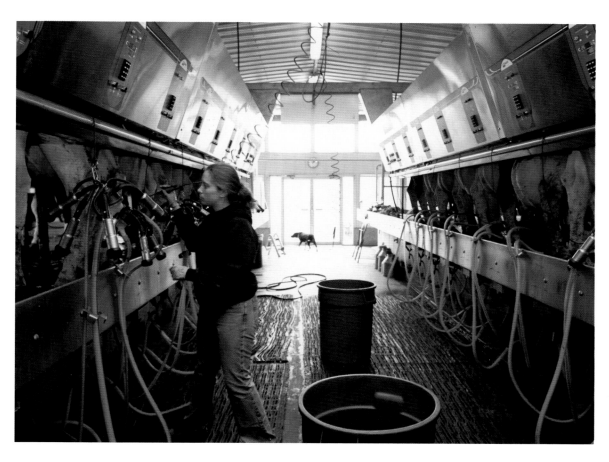

BURLINGTON

Adrianne Masterson performs a visual check of an F-16 "Fighting Falcon" preparing for takeoff. Assigned to the 158th Mission Support Squadron of the Vermont Air National Guard, Masterson is one of six female crew chiefs based at Burlington International Airport. Members of the Vermont Guard, though, are still known as "The Green Mountain Boys."

Photos by Stefan Hard

BURLINGTON

Pilots with the 134th Fighter Squadron of the Vermont Air National Guard take notes during a briefing. The 1,000-member unit set a U.S. Air Force record after 9/11 by flying combat missions for 122 consecutive days. Their assignment was to monitor the skies and provide air support over major northeastern cities.

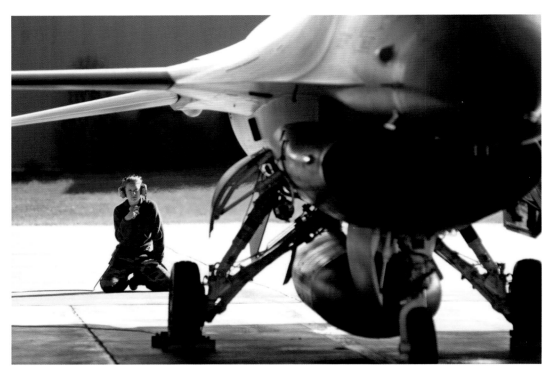

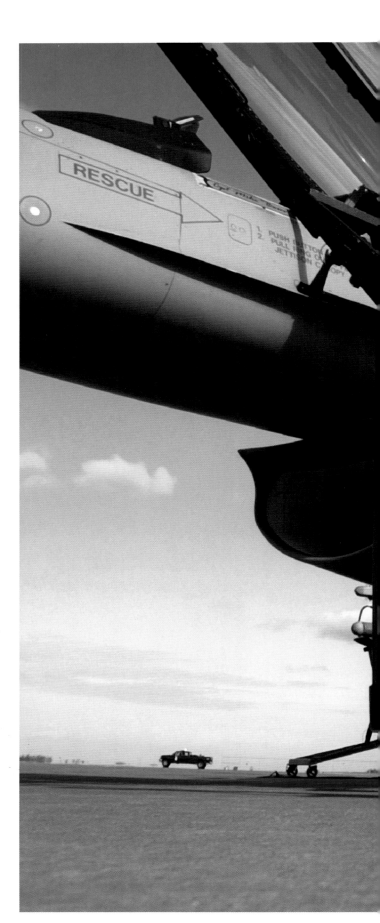

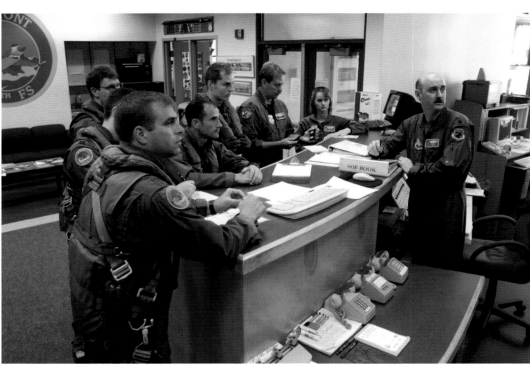

BURLINGTON

On temporary assignment with the Vermont Air National Guard, U.S. Air Force pilot Captain "Sonic" tightens his flight suit before climbing in the cockpit of an F-16.

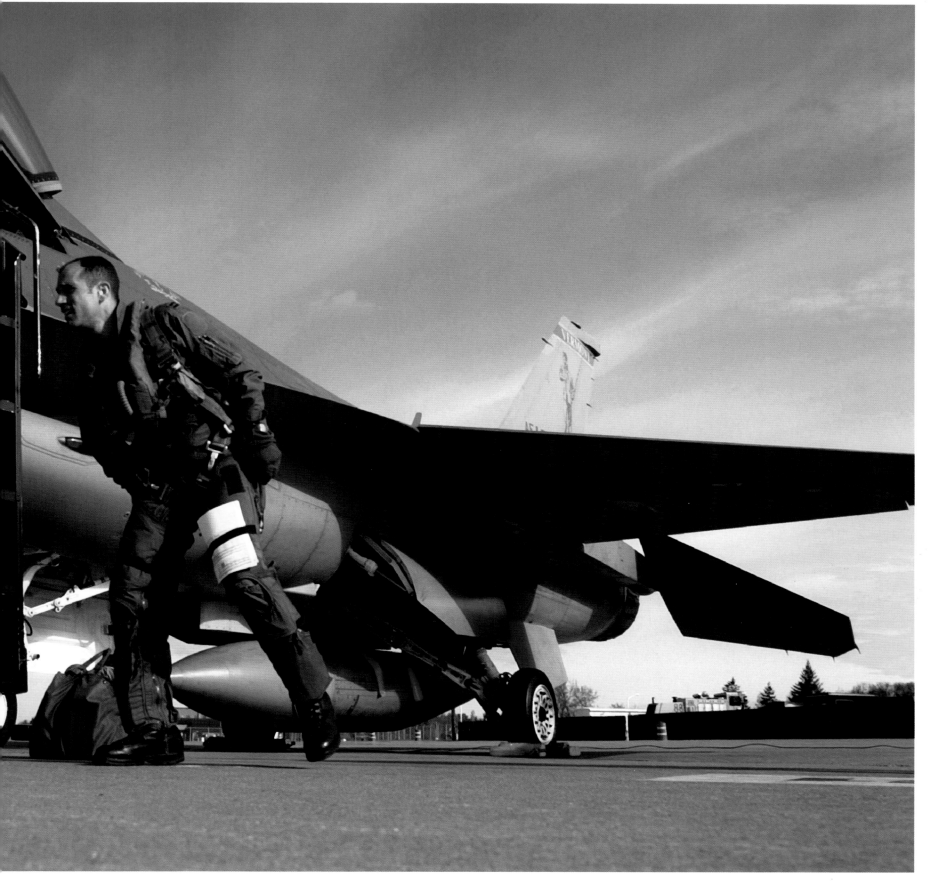

WATERBURY

Buster and WDEV owner Ken Squier cohost the satirical Saturday morning show, "Music to Go to the Dump By," showcasing singers like Spike Jones and Tom Lehrer. According to Squier, the true celebrity is Buster. At a local fundraiser someone bid $300 to eat with the Border collie, while a date with Governor Jim Douglas garnered only $275.
Photo by Jack Rowell

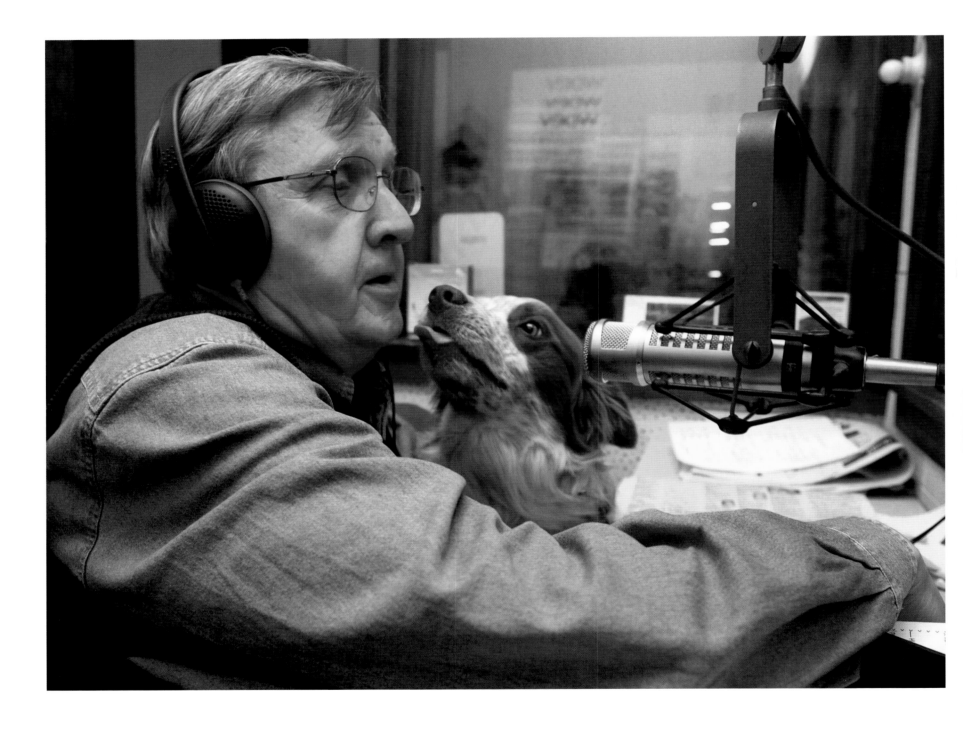

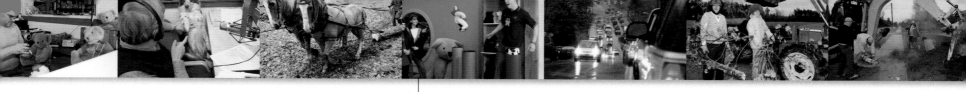

SHELBURNE

Tim Plante, a Bear Ambassador at the Vermont Teddy Bear Factory, tosses Misfit Teddy Bear at the start of a customer tour. Begun as a one-person operation selling at an outdoor market in 1981, the company now occupies a 60,000-square-foot building and employs 280 people. The number of bear species tops 100 and includes Biker Bear and Love Me Tender Elvis Bear.
Photo by Karen Pike,
Karen Pike Photography, Hinesburg

CRAFTSBURY
Barbara Huntington-Massucci has been
rising before dawn every day for 30 years
to run a four-mile circuit through Craftsbury
common. Even when winter temperatures
dip below 20, the second-grade teacher
forces herself to finish the ritual. "If I meet
a challenge first thing in the morning, the
next one doesn't seem so difficult," she says.
Photo by Alden Pellett

Vermont At Play

SHELBURNE

A casual game of T-ball harnesses the energies of young boys on the town parade grounds. A safe entrée to standard ball, T-ball's rules are generous: There are no strikeouts or walks; innings are over when all players have batted.

Photo by Paul O. Boisvert

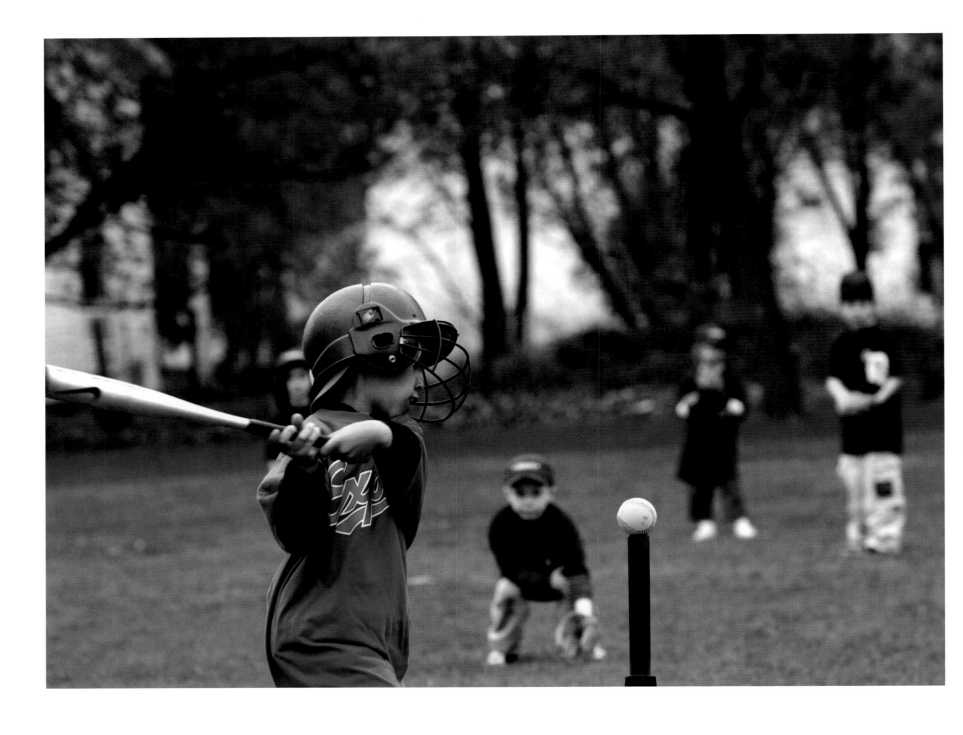

CAMBRIDGE

The pressure's on for the Cambridge Braves' last batter: It's a tie game, bottom of the ninth, with bases loaded. The Little Leaguer keeps his cool and pulls through with a base hit that wins the game, 8–7, over the Eden Eagles.

Photo by Rob Swanson

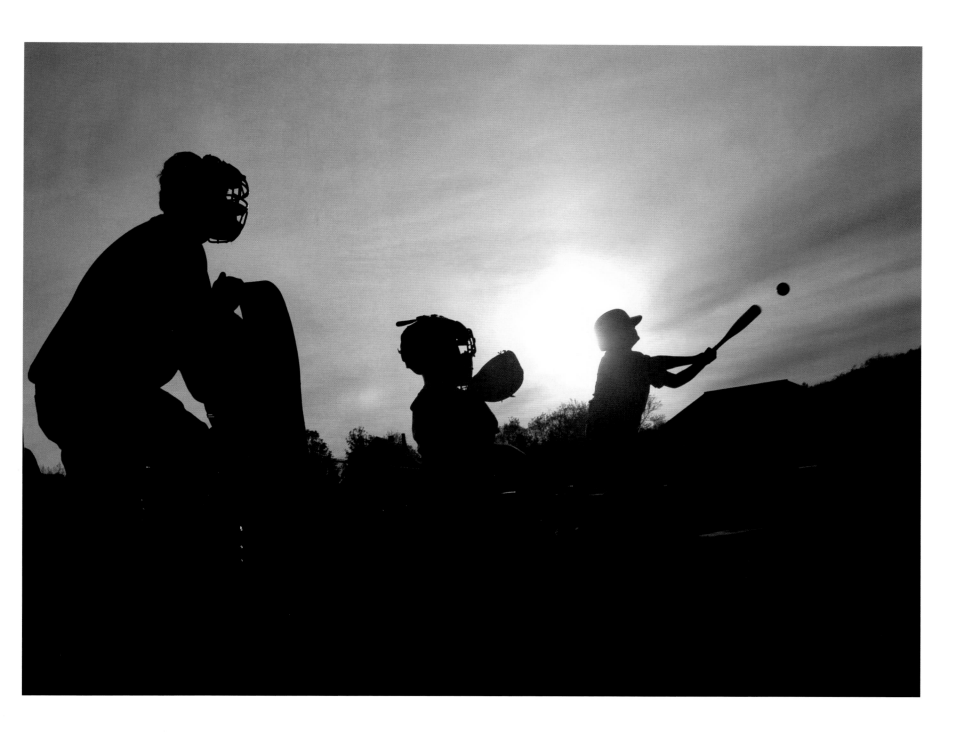

BURLINGTON
With a view of the Adirondacks and Lake Champlain, a boy swings into the sunset at Oakledge Park.
Photo by Richard A. Doran

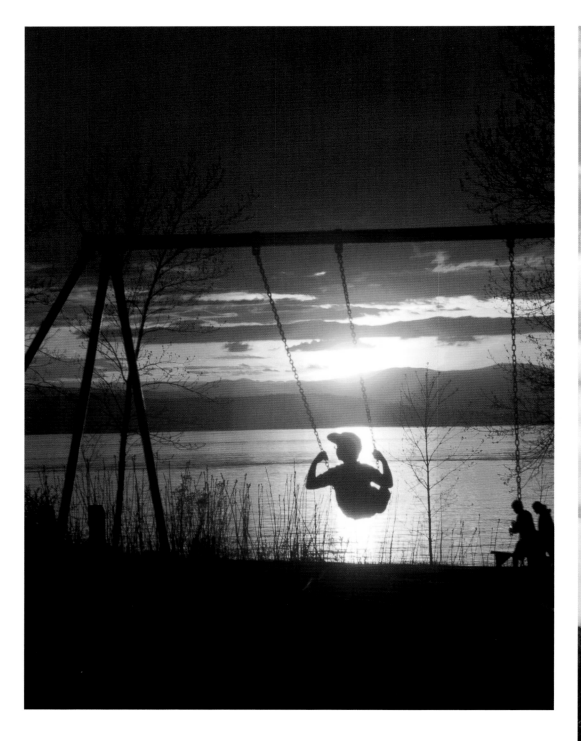

CALAIS
On one of the first warm days of spring, children at Calais elementary school take to the sky.
Photo by Craig Line

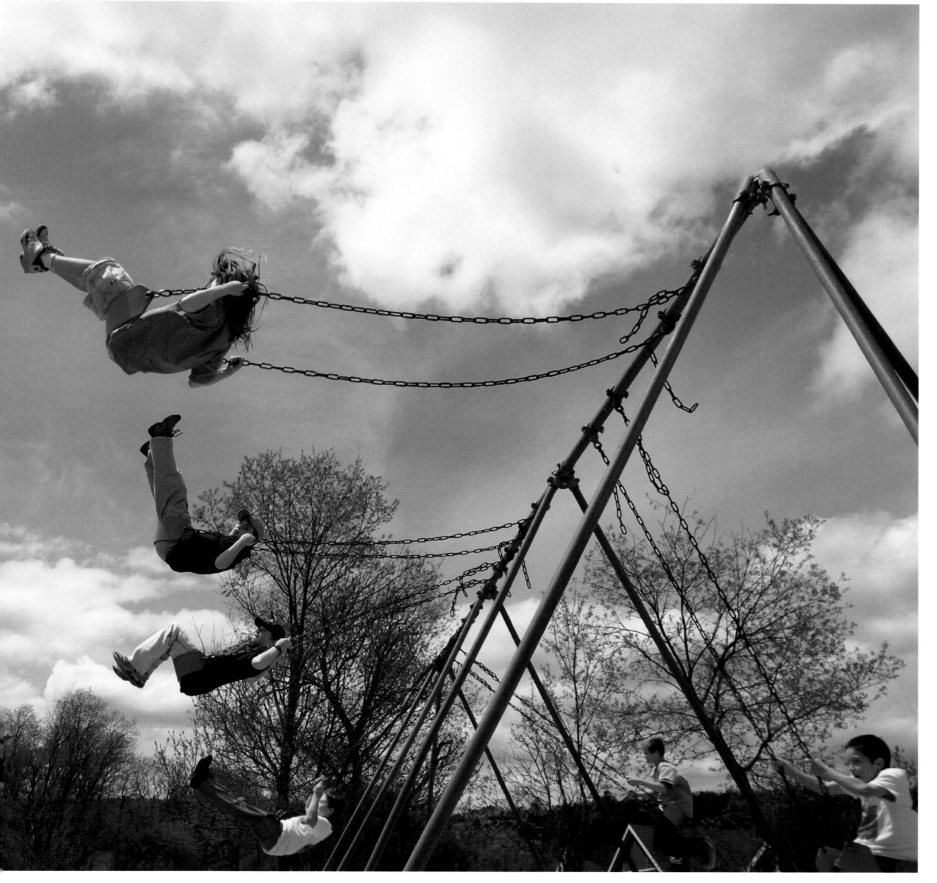

KILLINGTON

Shirtless and fancy-free: Rick Jamgochian attacks the bumps on the black diamond run Superstar. The Middlebury College senior is getting his last fix of spring corn snow before graduating and starting his new job at the Department of Justice in Washington, D.C.
Photo by Dylan Gamache

KILLINGTON

Chris Hamilton powers his way through a patch of moguls. Between April and June, the New York City financial advisor heads up to Killington for what he calls "the best bump skiing in the world."
Photo by Vyto Starinskas, Rutland Herald

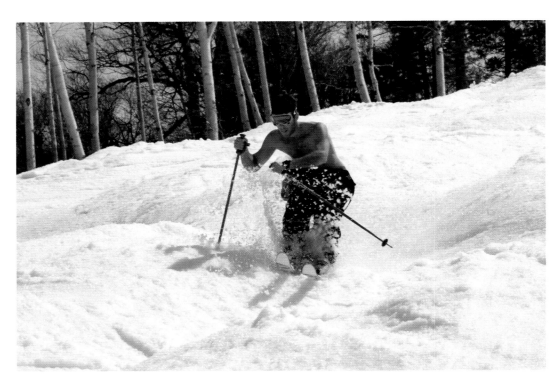

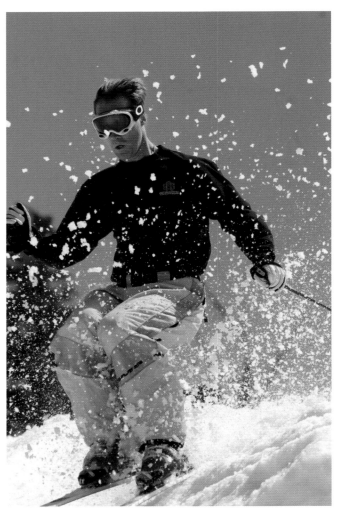

KILLINGTON
Freestylin' Michael Robichaud pulls off an iron cross.
Photo by Vyto Starinskas, Rutland Herald

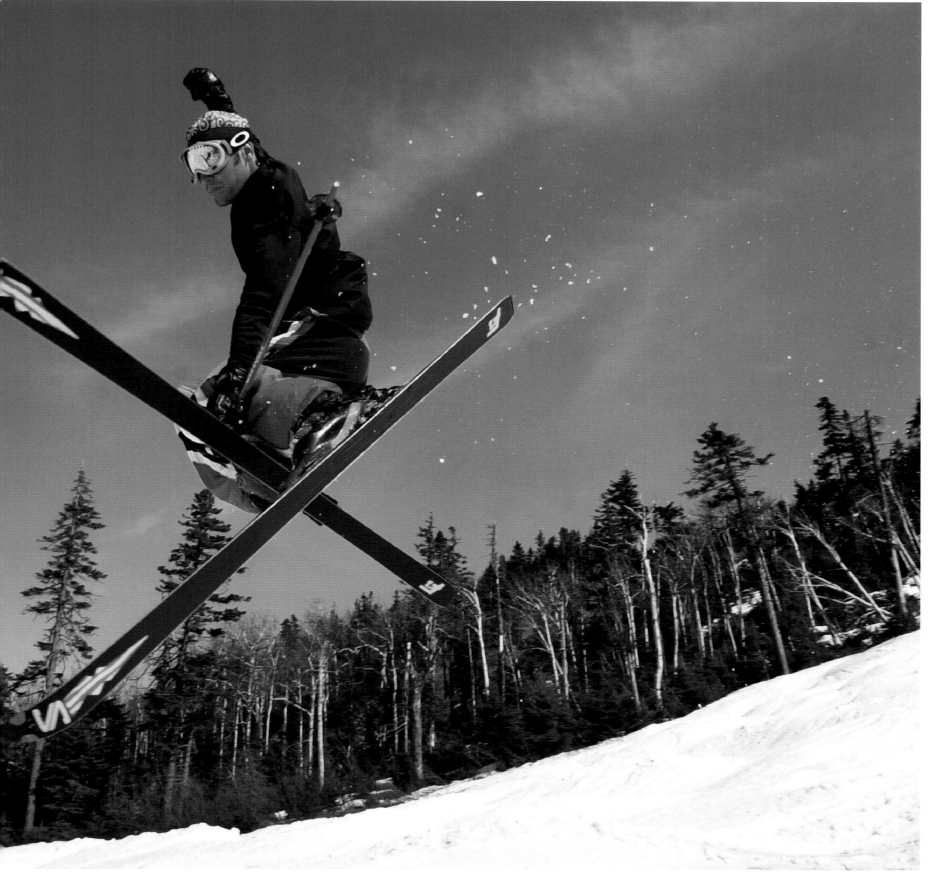

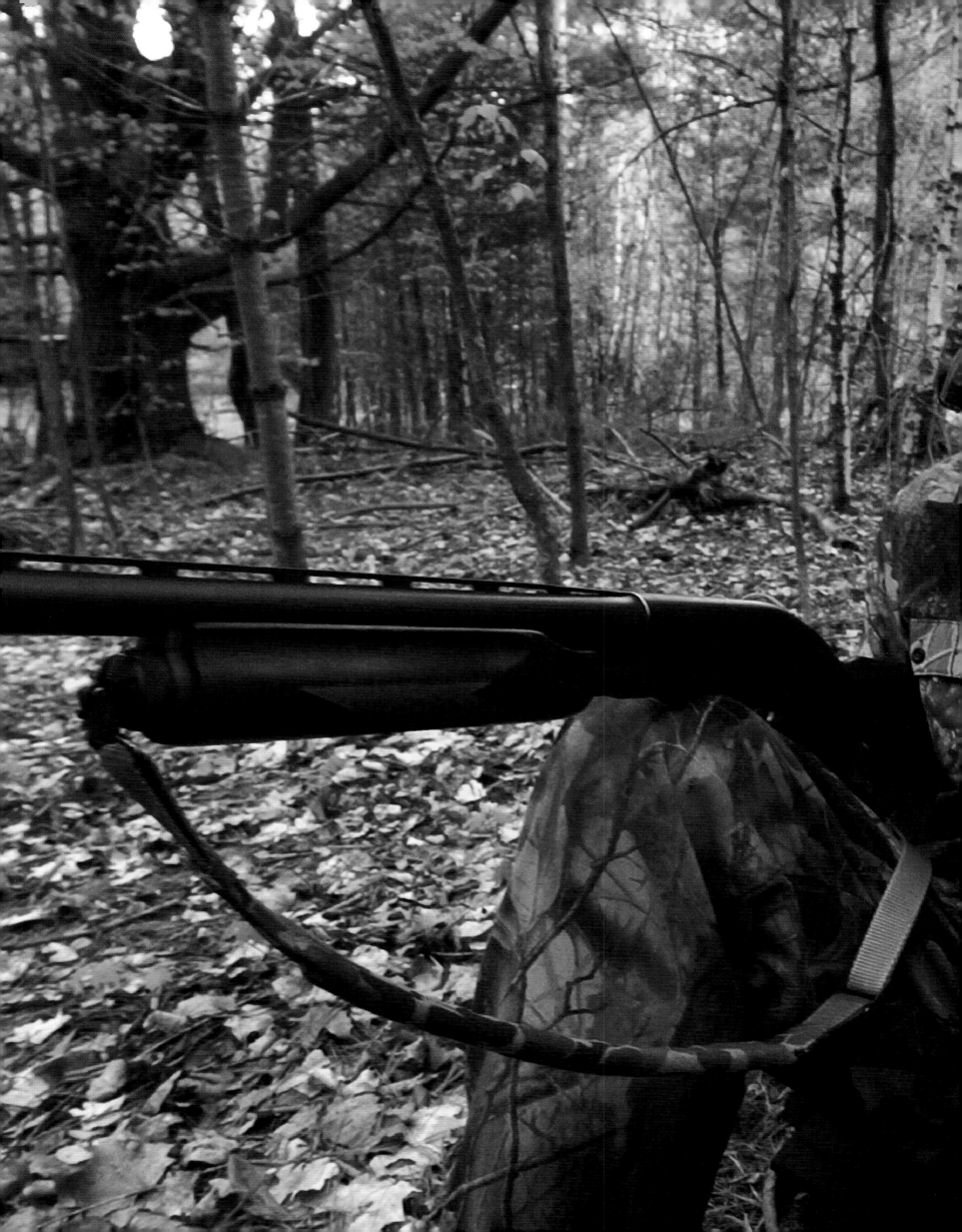

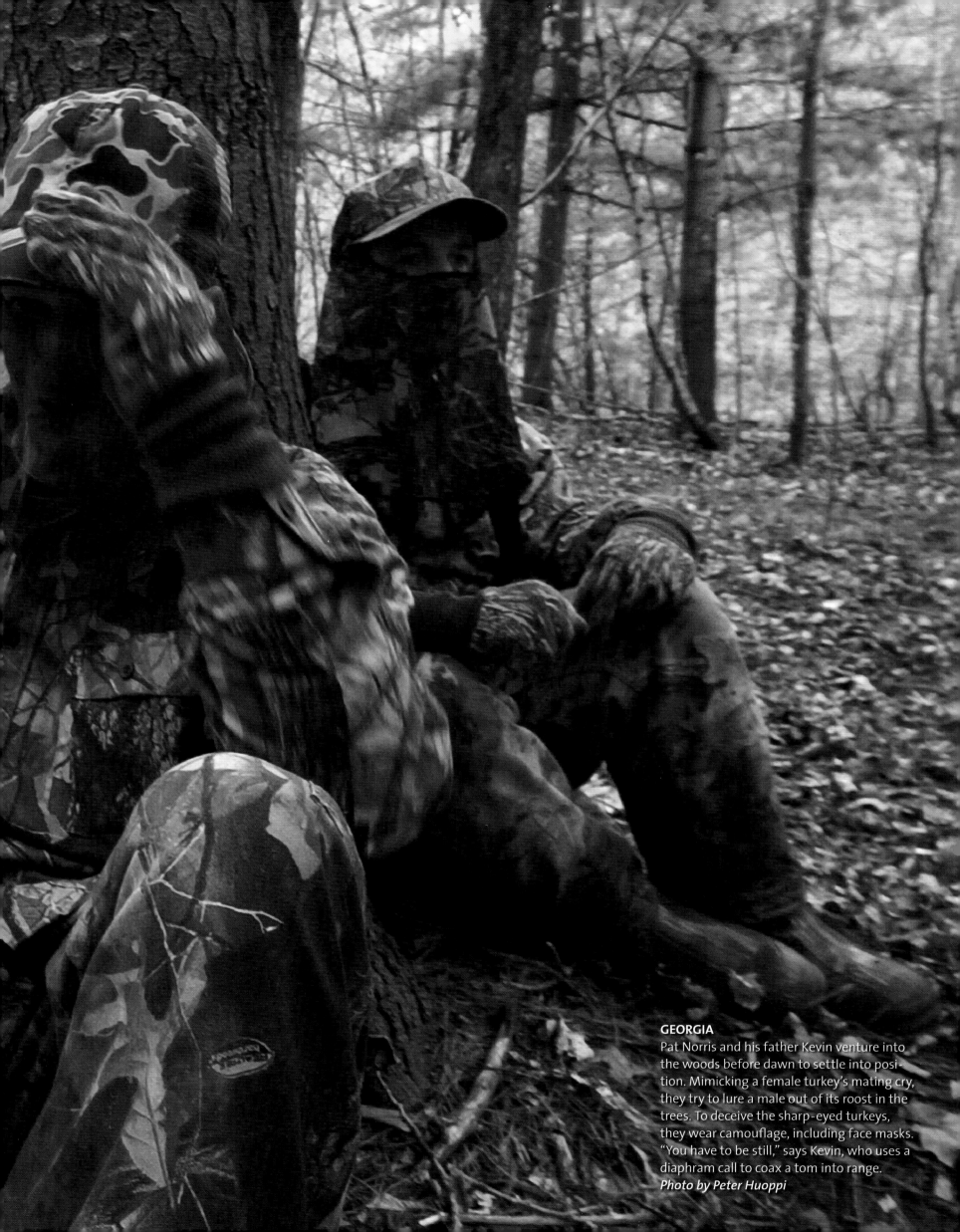

GEORGIA
Pat Norris and his father Kevin venture into the woods before dawn to settle into position. Mimicking a female turkey's mating cry, they try to lure a male out of its roost in the trees. To deceive the sharp-eyed turkeys, they wear camouflage, including face masks. "You have to be still," says Kevin, who uses a diaphram call to coax a tom into range.
Photo by Peter Huoppi

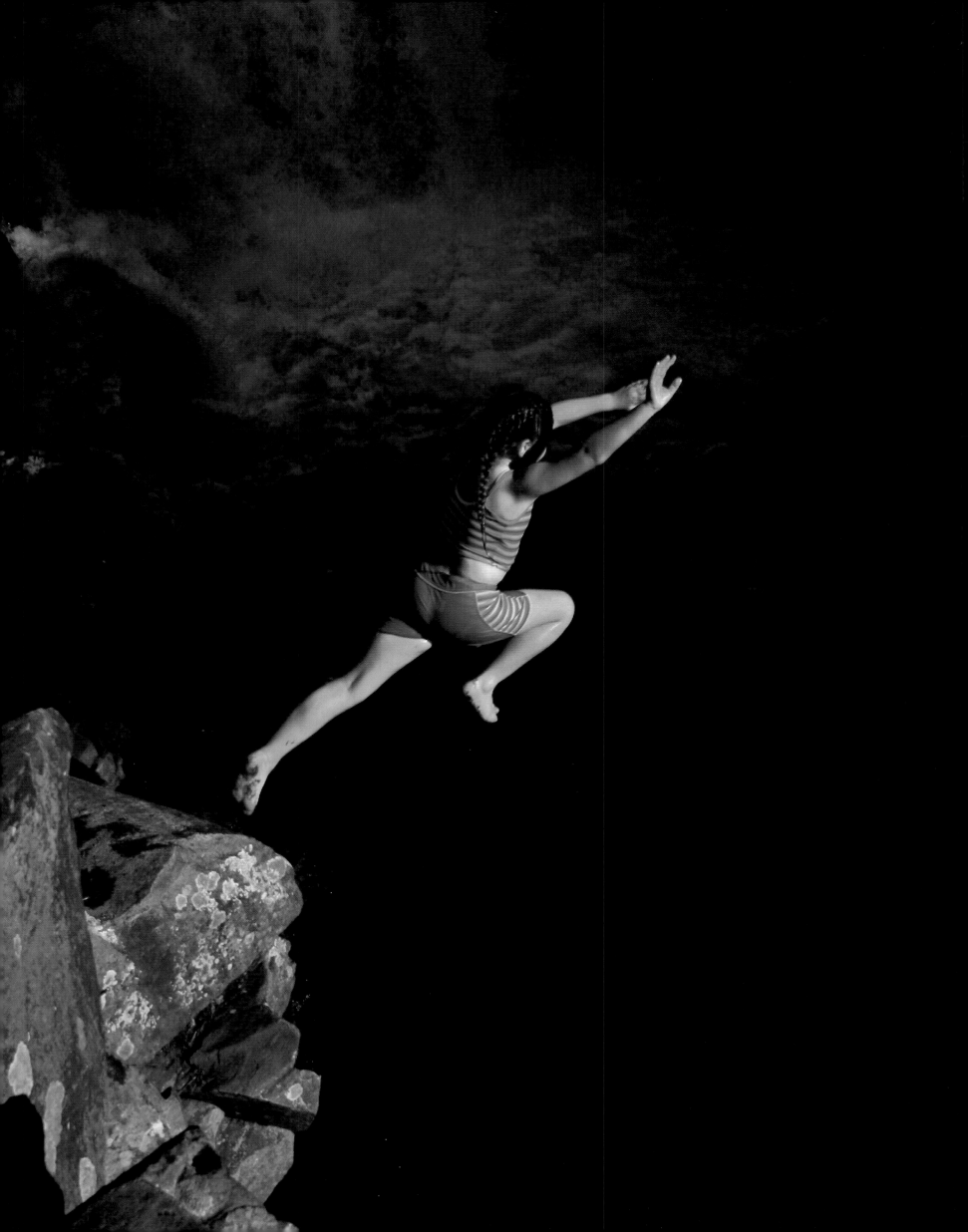

BRISTOL

A true Vermonter, Hannah Gleason didn't think twice about plunging into the 50-degree waters of the New Haven River near Bartlett's Falls.
Photo by Alden Pellett

BURLINGTON

The Petra Cliff Climbing Gym's artificial rock outcroppings, cracks, and arêtes keep Brian Tannler occupied at the U.S. Competition Climbing Association's Regional Championships. The 18-year-old cliffhanger went on to place second.
Photo by Paul Hansen

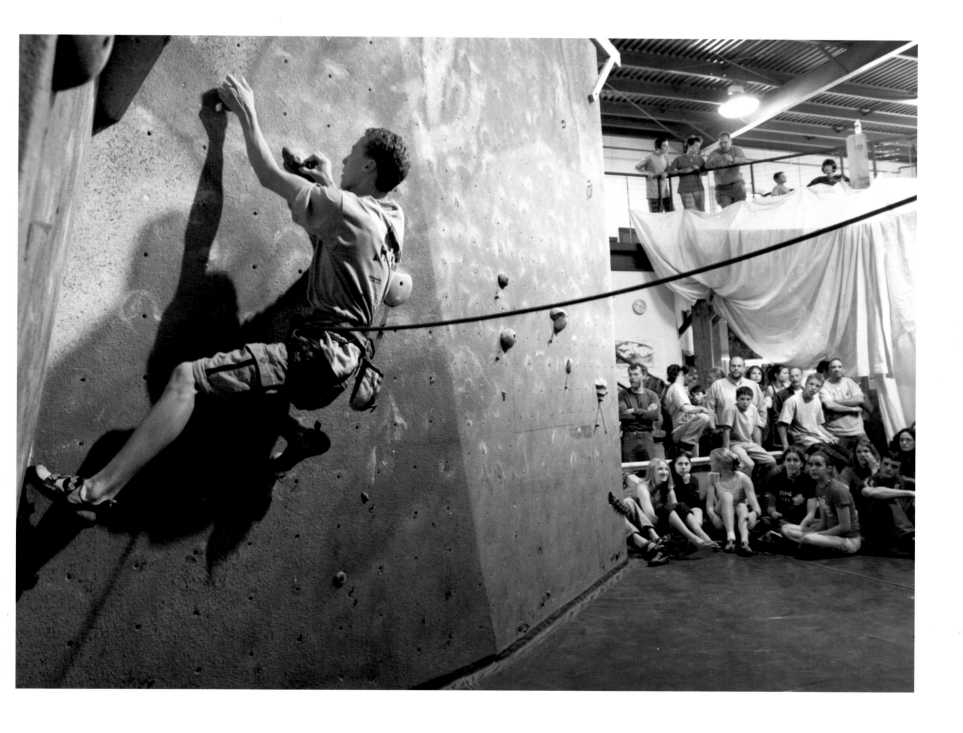

BURLINGTON

Some salsa classes require fancy dress, but the SalsaLina studio invites people to wear whatever feels comfortable. Instructor E. Victoria Moore, twirling with student John Espinoza, teaches beginner and intermediate levels. She also brings in pros from New York City and Boston once a month for advanced workshops.
Photos by Natalie Stultz, Location Photography, Burlington, VT

BURLINGTON

Carolyn Sawyer and Steve McDonald pass each other during a Virginia Reel–type dance at the Champlain Club. The two are members of Ain't Misbehavin', a local swing group that performs at parties and community events.

BURLINGTON

Marjorie Power, a lawyer for the state of Vermont, pairs up with Ben Dana at a monthly contra dance. A devoted contra fan, Power, 61, has lined up seven events she can attend each month, all located within a two-and-a-half-hour drive of her Montpelier home.

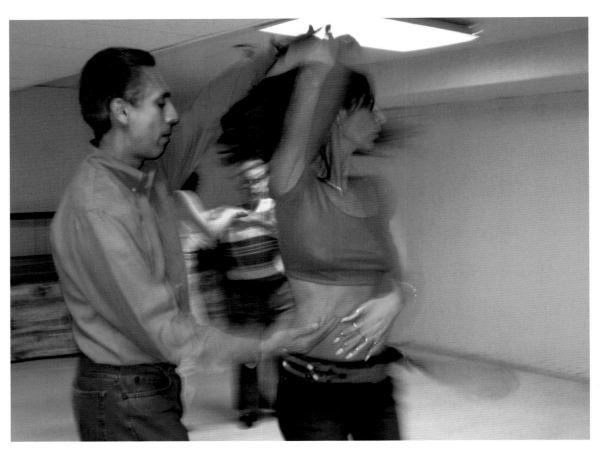

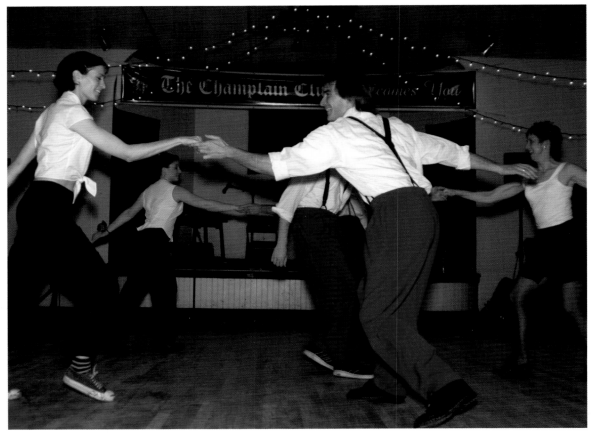

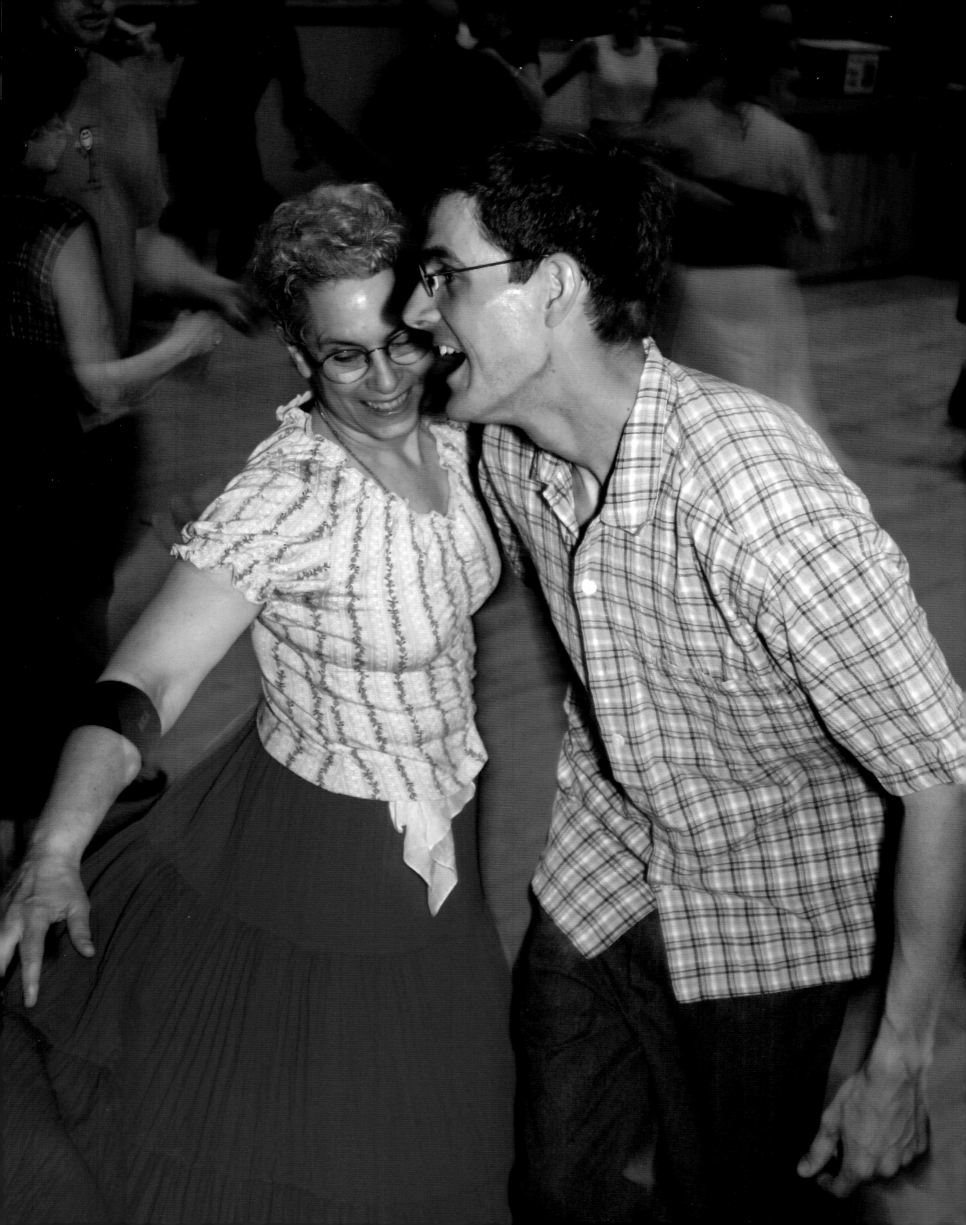

WATERBURY CENTER
The fair way: A foursome finishes up a perfect opening weekend on the 18th green at the Country Club of Vermont. The course overlooks the Green Mountains and Camel's Hump, the second-highest peak in Vermont.
Photo by Peter Miller

MORRISVILLE
A scrap-lumber bonfire in a neighboring yard doesn't faze Don Allen. The golfer focuses on his stroke at the Farm Resort Golf Course's driving range.
Photo by Alden Pellett

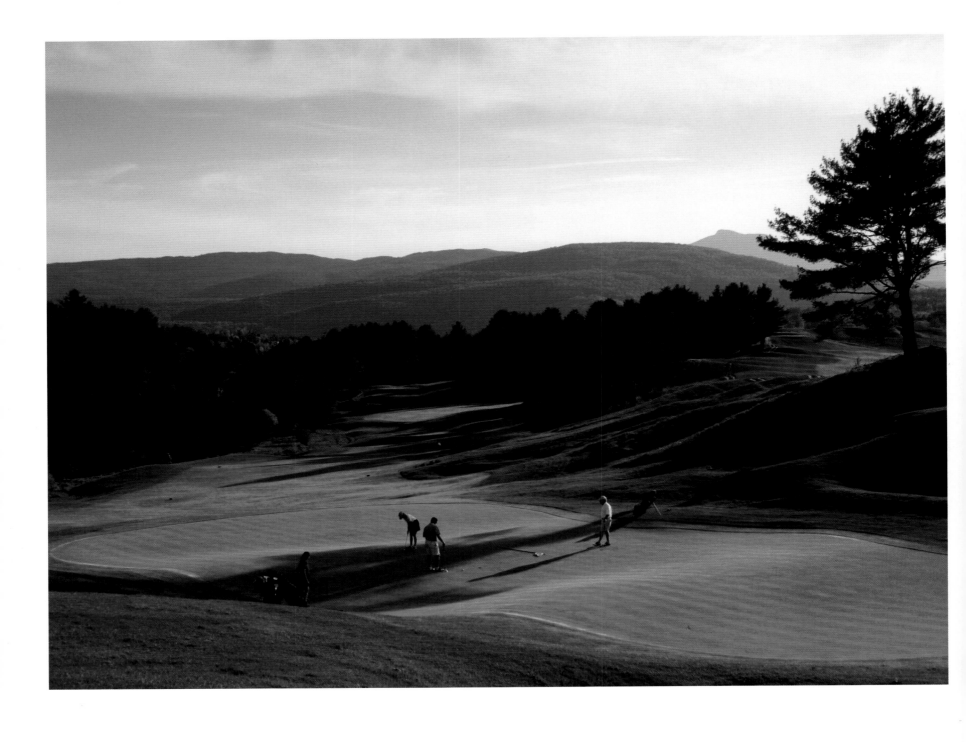

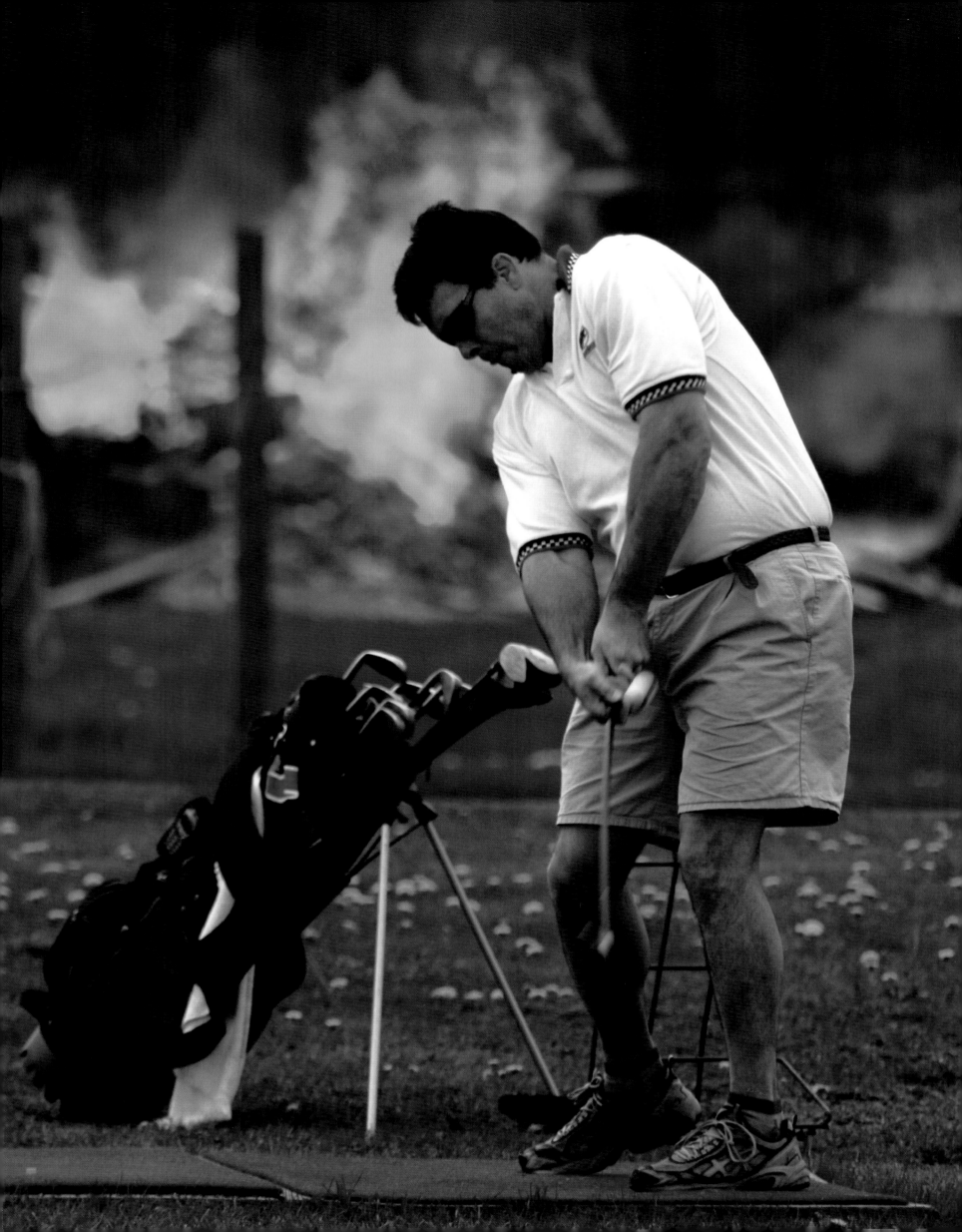

WILLISTON

Competitors in the annual Flower Power moun-
tain bike race charge toward the first turn of the
20-kilometer course at the Catamount Family
Center, site of a former dairy farm. Flower Power
kicks off the summer racing season in northeast-
ern Vermont.

Photos by Glenn Russell,
The Burlington Free Press

WILLISTON

It's all a blur for racer 839, who speeds across a
meadow toward the technical segment of the
course, a mile long stretch of single-track trail
through maple and oak forests.

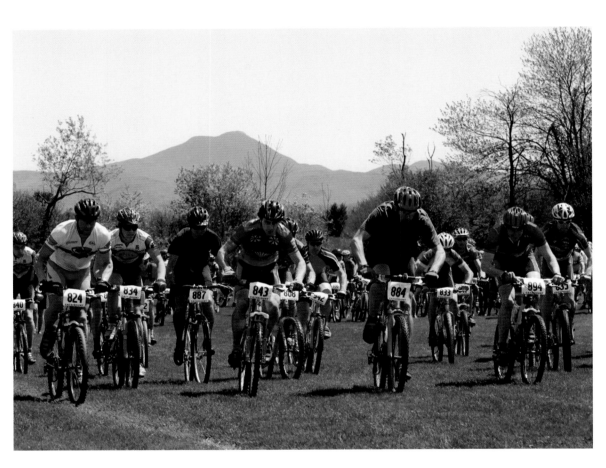

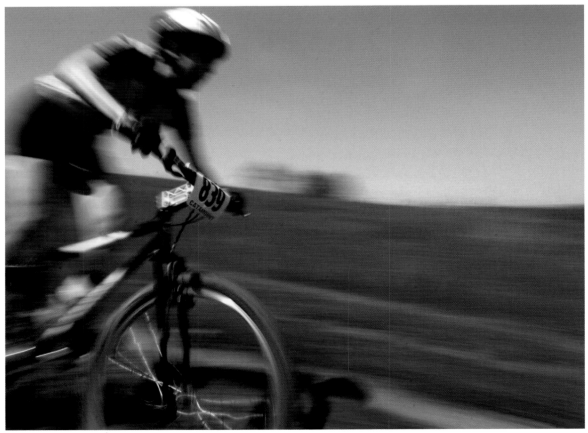

WILLISTON

A little-known African-American Army unit pioneered mountain biking in the late 1800s when they rode primitive stump-jumpers 800 miles from Missoula, Montana, to Yellowstone Park and back again to deliver supplies. A century later, front-wheel suspension and titanium frames have transformed mountain biking into an accessible sport for 4.6 million American riders.

WILLISTON

Balance, grit, and quads of steel help bikers power up the course's rock ledges and boulders. Energy bars and Power Goo help, too: The average mountain biker burns 10 calories per minute of cycling.

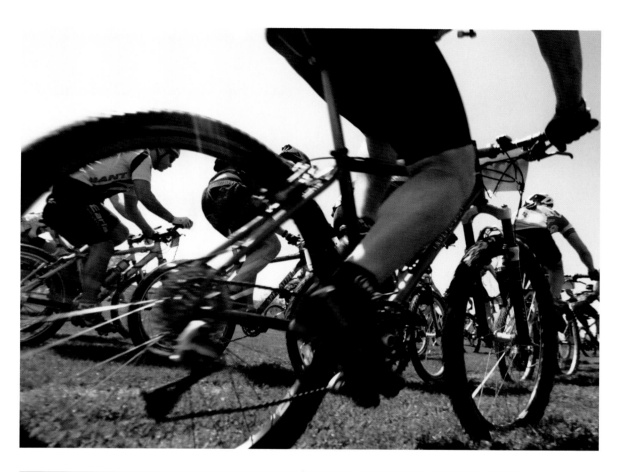

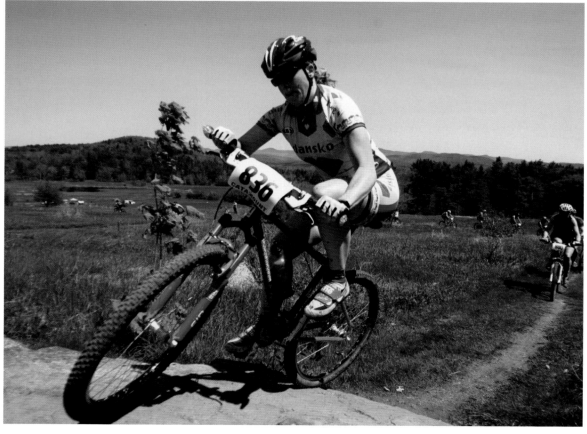

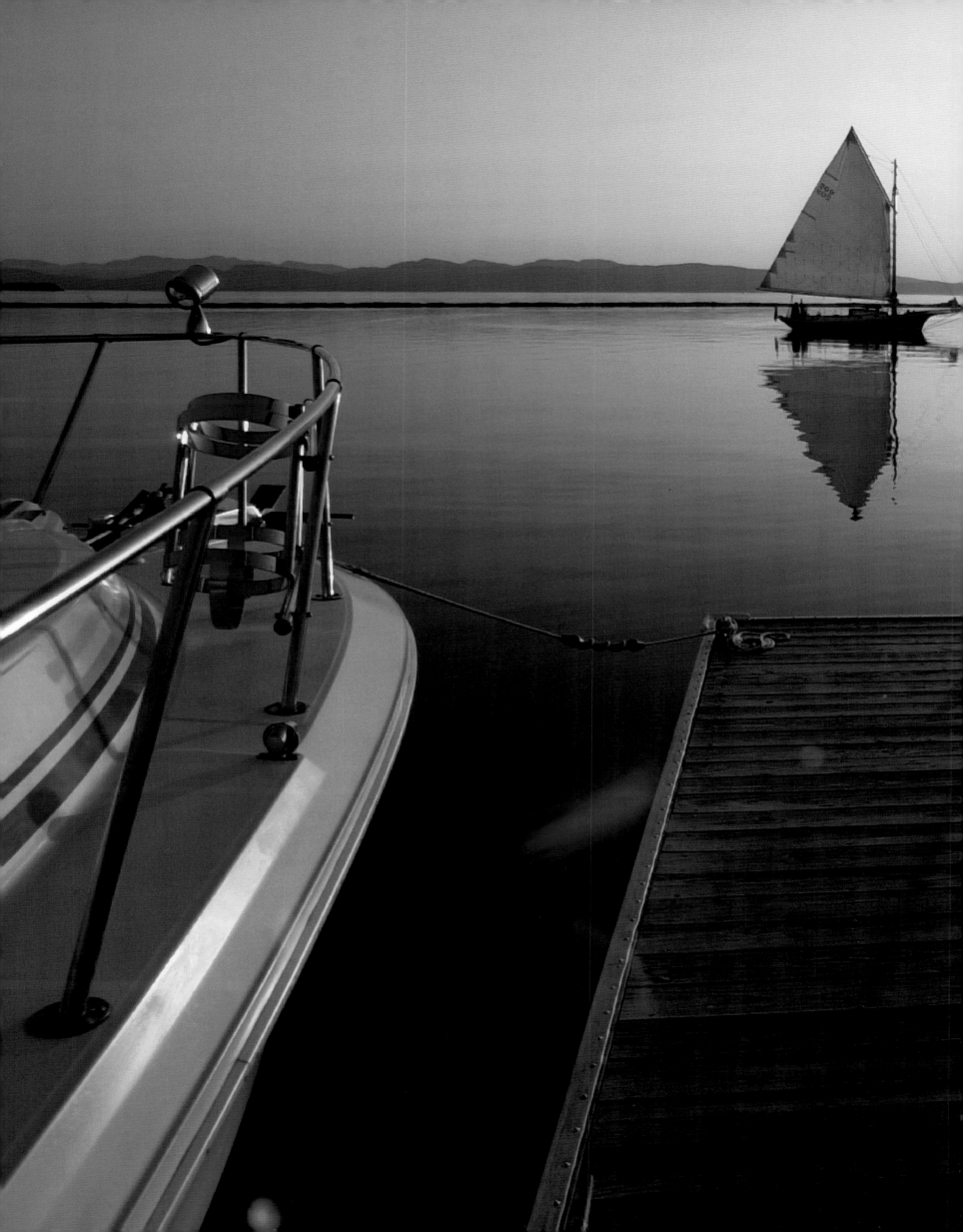

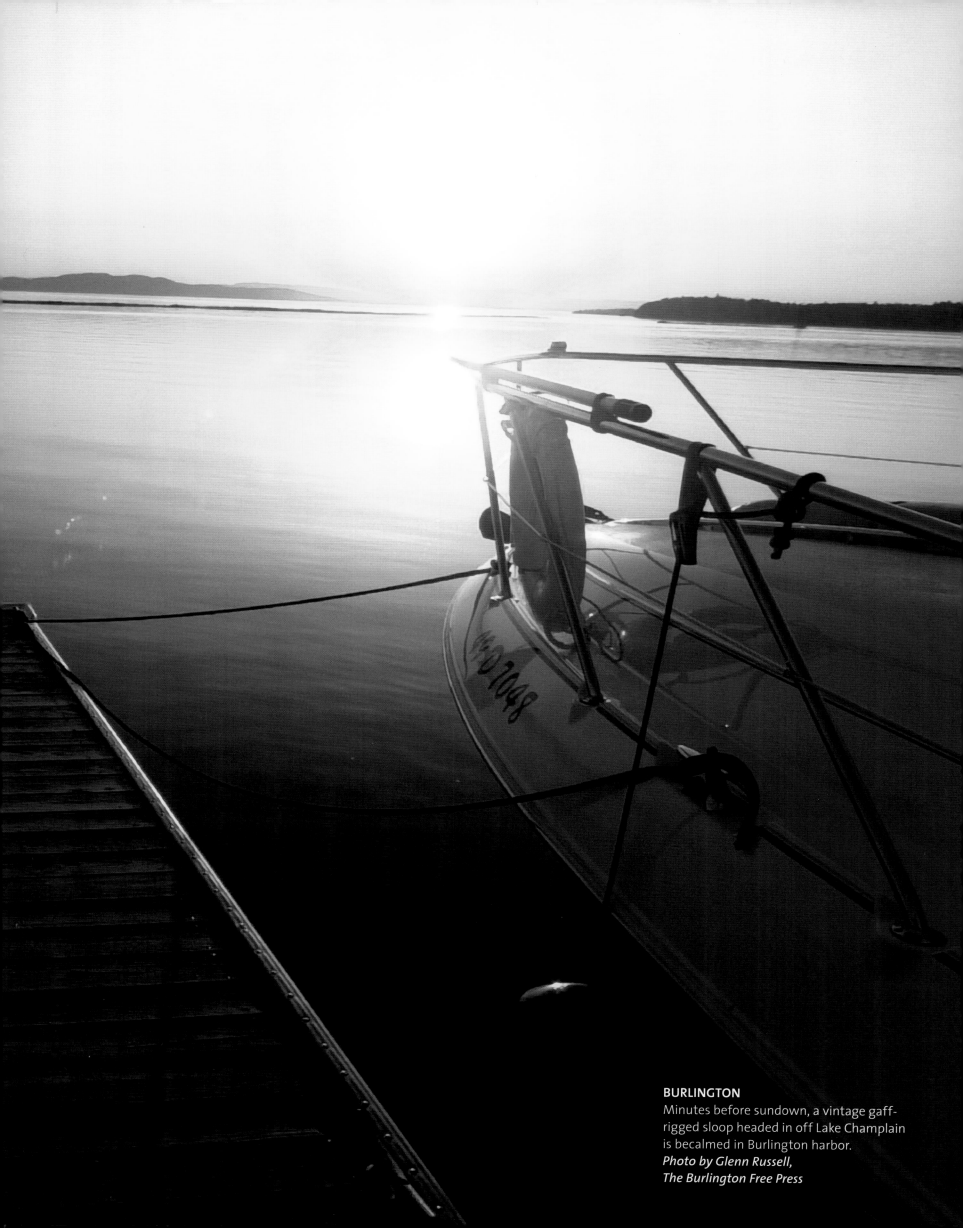

BURLINGTON
Minutes before sundown, a vintage gaff-rigged sloop headed in off Lake Champlain is becalmed in Burlington harbor.
Photo by Glenn Russell,
The Burlington Free Press

BURLINGTON

Waiting expectantly for their rods to quiver with a nibble, anglers on the Burlington pier pay no heed to the storm clouds gathering across Lake Champlain.
Photo by Glenn Russell,
The Burlington Free Press

BERLIN

Dry-fly casting to simulate hatching mayflies, Pat Berry is after rising rainbow or brown trout on the Dog River. "With fly fishing, you get to put a lot of elements together to try to fool the fish," says Berry, a former fishing guide. "It's a lot more exciting than drowning bait."
Photo by Jon Olender

THETFORD

She used to have her own boat, but at 86, Antoinette Shapiro prefers shore fishing these days. It's a good bet she'll hook a few from her friend's bass-stocked pond.
Photo by Jon Gilbert Fox

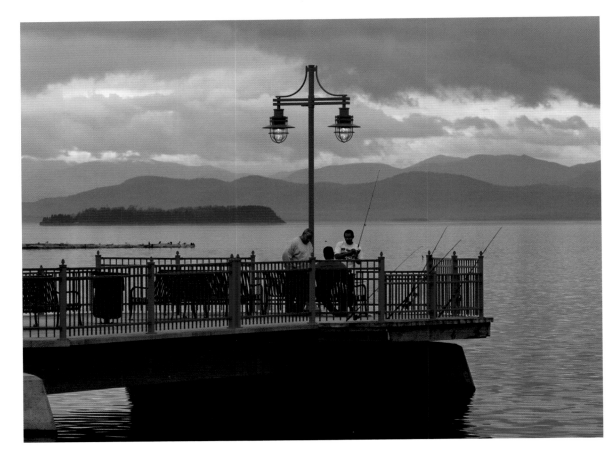

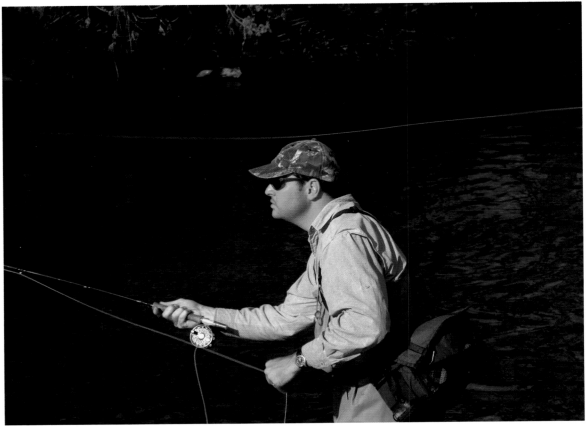

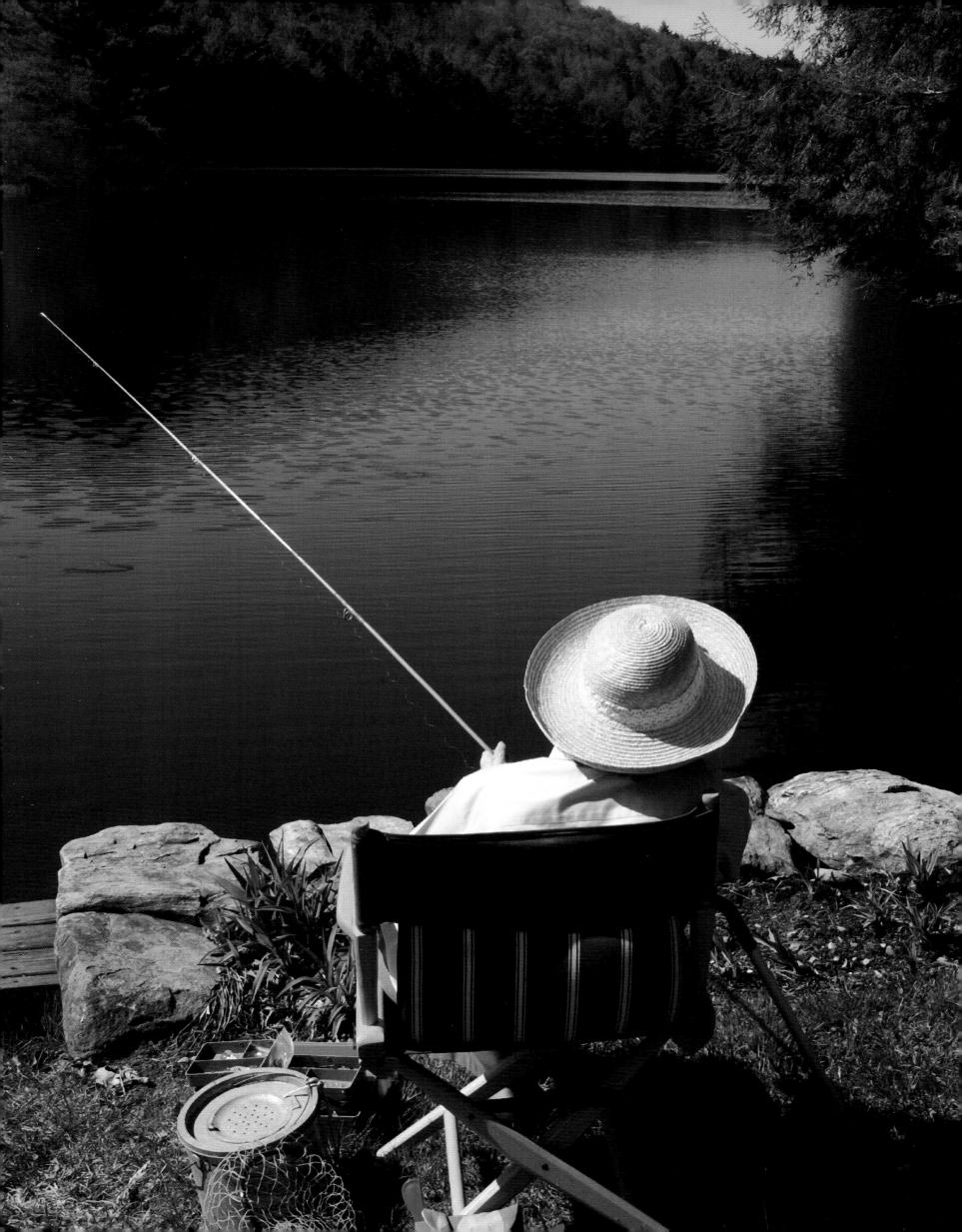

CAMBRIDGE

Hard feelings are left on the pitch at the end of a tough tie game between the South Hero Patriots and the Cambridge Braves under-11 girls' teams. After a round of high fives, the Patriots celebrated the hard-fought draw with ice cream cones at the local parlor.

Photo by Rob Swanson

WEYBRIDGE

Shannon Scioscia, an apprentice at the University of Vermont's Morgan Horse Farm, cools down Veronica after an exercise session. The government ran the farm between 1906 and 1951, and then turned it over to the university. The breed originated in Vermont in 1789 and is the official state animal.

Photo by Natalie Stultz,
Location Photography, Burlington, VT

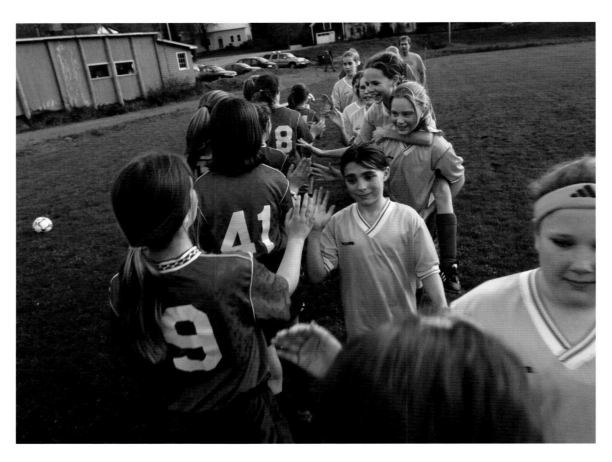

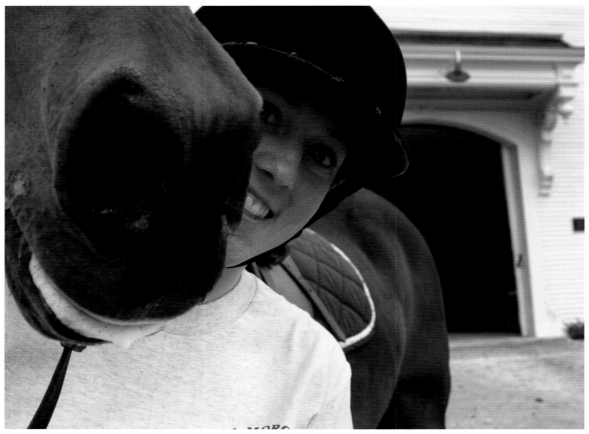

WILLISTON

Mah-jongg enthusiast Jane Greenberg meets four friends from Temple Sinai every Wednesday to play the ancient Chinese game. A cross between dominoes and cards, mah-jongg dates back to the 12th century. All the women in the group learned the game from their mothers, and they're passing it on to their daughters.

Photo by Karen Pike,
Karen Pike Photography, Hinesburg

PROCTOR

Louis Barch is a fixture at the Proctor Country Club and has been for most of the last century. At 93, Barch lugs his vintage 1960s pull cart over the greens several times a week.

Photo by Vyto Starinskas, Rutland Herald

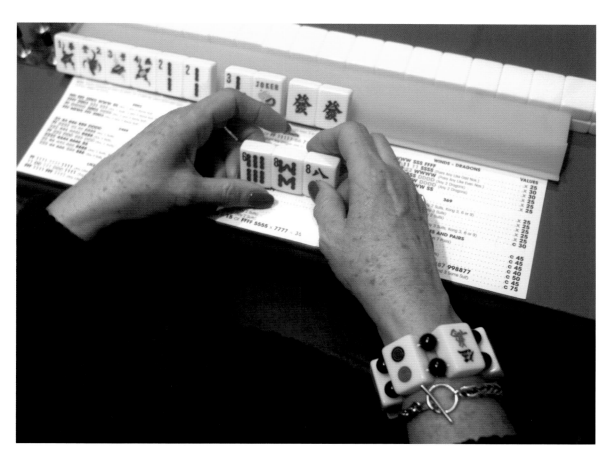

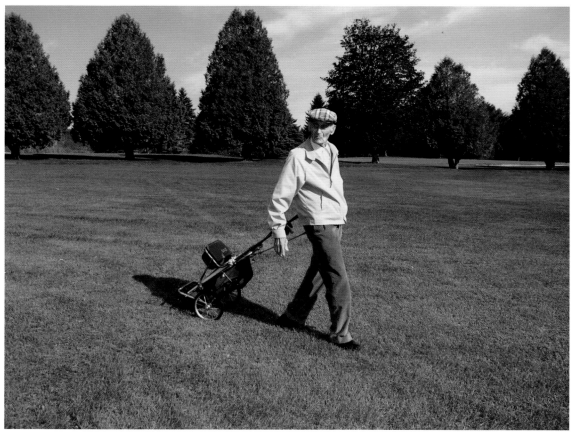

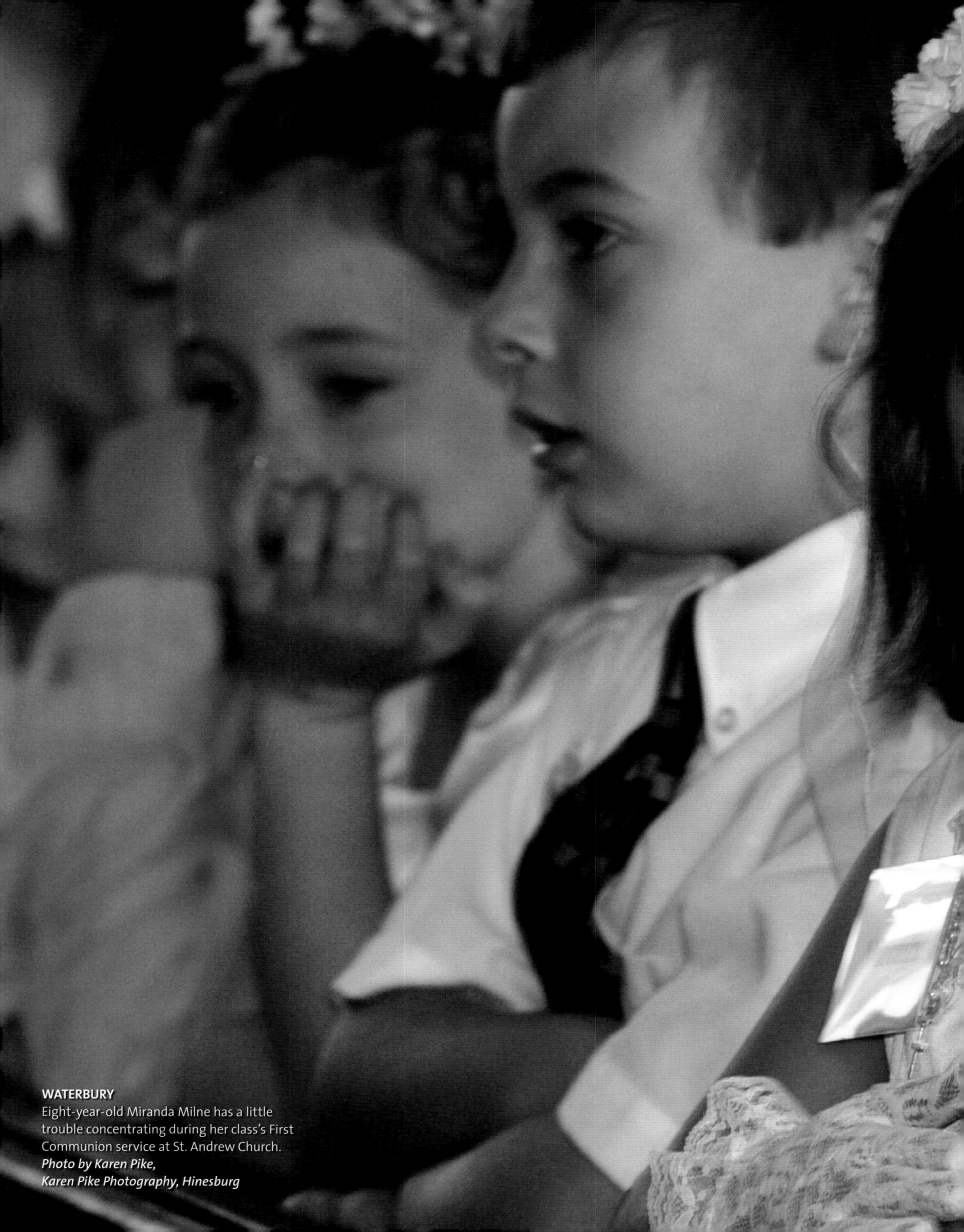

WATERBURY

Eight-year-old Miranda Milne has a little trouble concentrating during her class's First Communion service at St. Andrew Church.
Photo by Karen Pike,
Karen Pike Photography, Hinesburg

Reason To Believe

SOUTH BURLINGTON
During Shabbat service at Temple Sinai, Rabbi James Glazier performs *hagbah*, the ceremonial raising of the Torah scroll before it is read. Founded by 12 families in 1966, the temple now has a congregation of 210 families.
Photos by Karen Pike,
Karen Pike Photography, Hinesburg

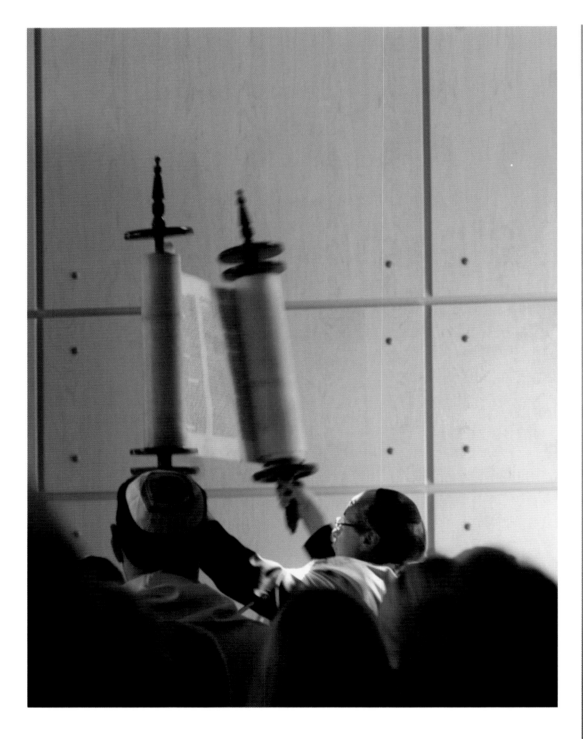

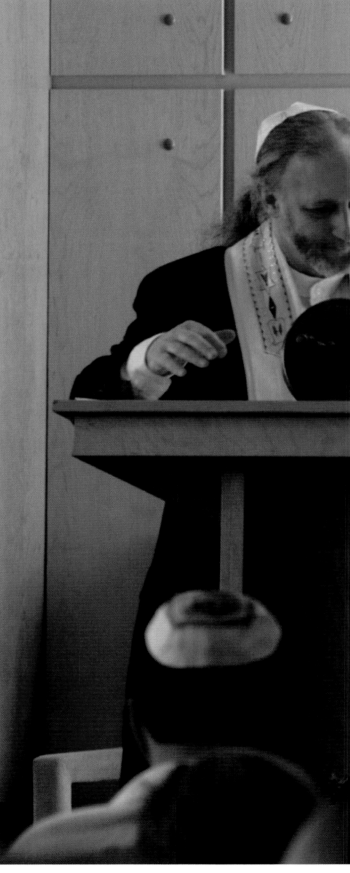

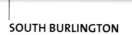

SOUTH BURLINGTON
Jenna Grunvald (center), accompanied by Cantor
Mark Leopold, Rabbi James Glazier, and Religious
School Director Judy Alexander, reads from the
Torah during her Temple Sinai Bat Mitzvah.

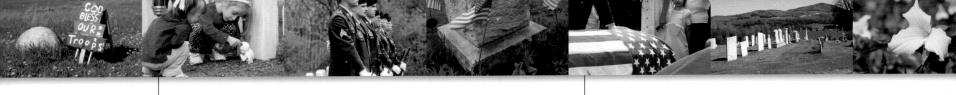

ESSEX JUNCTION

Samantha Parker and Olivia Richland turn their attention to the angels in Fort Ethan Allen Cemetery during the funeral for Richard L. Morgan, Olivia's grandfather and Samantha's great-grandfather.

Photos by Karen Pike,
Karen Pike Photography, Hinesburg

ESSEX JUNCTION

Pastor Roland Ludlam conducts a military funeral service for U.S. Army Lieutenant Colonel (retired) Richard L. Morgan at Fort Ethan Allen Cemetery. Morgan's daughter Karen Sue Bent (black dress) is comforted by daughter Joy Hayes and friend Jane Weiss. Morgan, a native of Vermont, a banker, and an avid harmonica player, served in World War II and the Korean War.

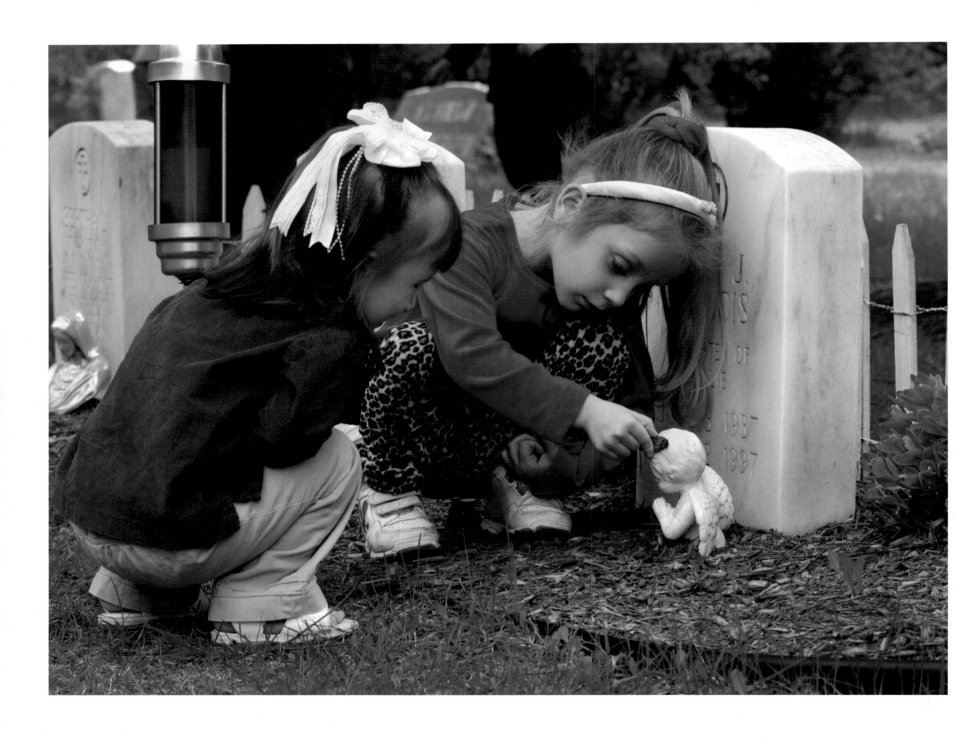

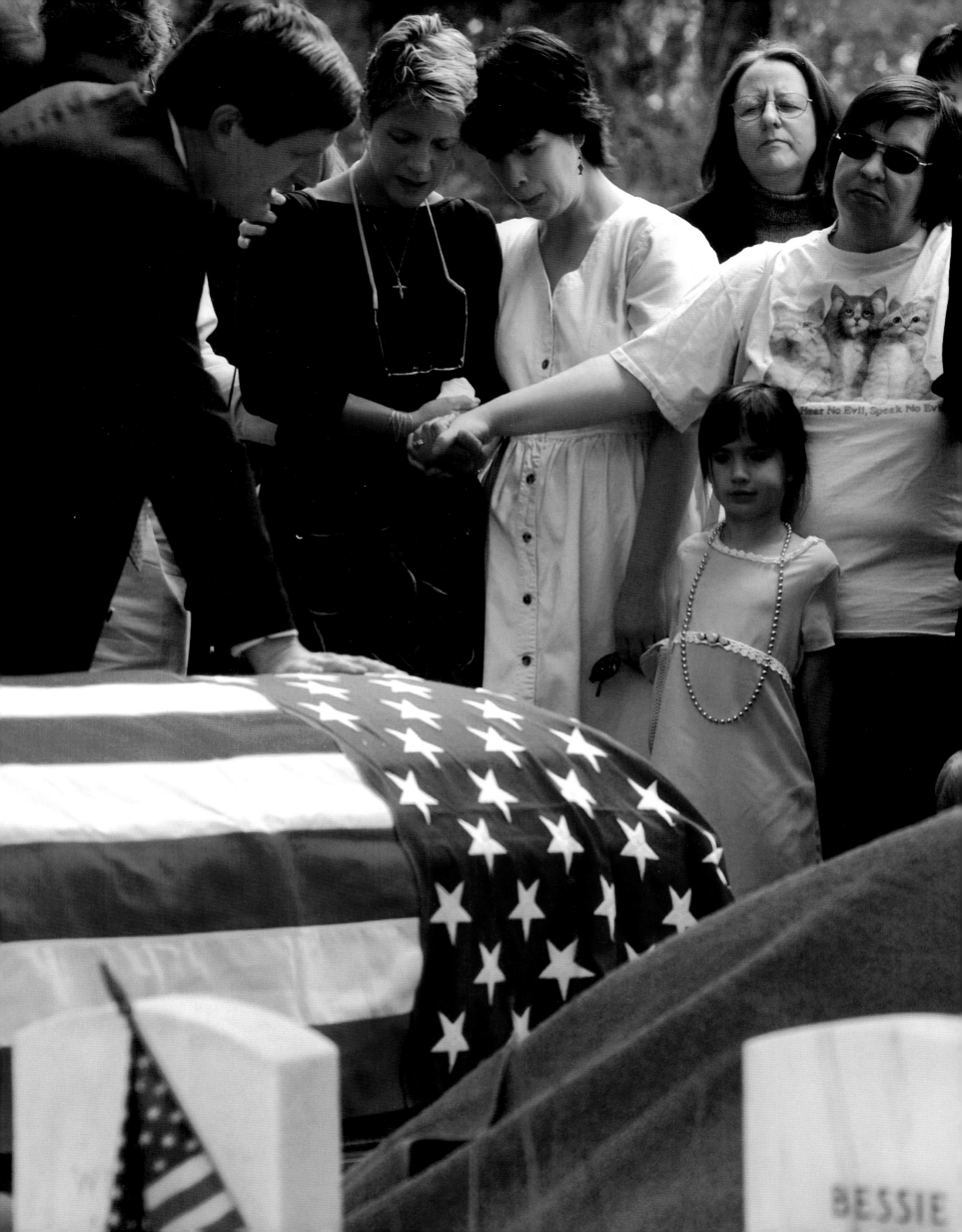

ALBURG

Charlie Emerson of Swanton and Pat Prue of Sheldon admire the chrome and leather detailing on a friend's Harley while stopping at a Route 20 gas station during their caravan to Isle La Motte.
Photos by Rob Swanson

ISLE LA MOTTE

In this quiet town, the annual blessing of motorcycles at Old Stone Methodist Church raises a few eyebrows. Pastor Deborah Laporte started the event, during which she sprinkles holy water on each Harley, to demonstrate the church's commitment to diversity and inclusiveness. "We all have a human bond—that's our take on Christianity," says Laporte.

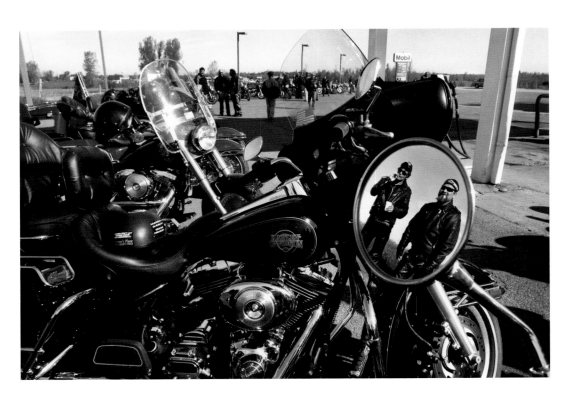

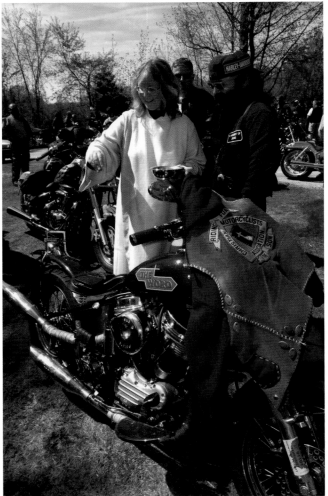

ISLE LA MOTTE

From Canada, New York, and Vermont, motor-heads converge on this 19th-century church for a blessing and then roar off. When the dust settles, the 488-person farming town goes back to milking cows and tending horses.

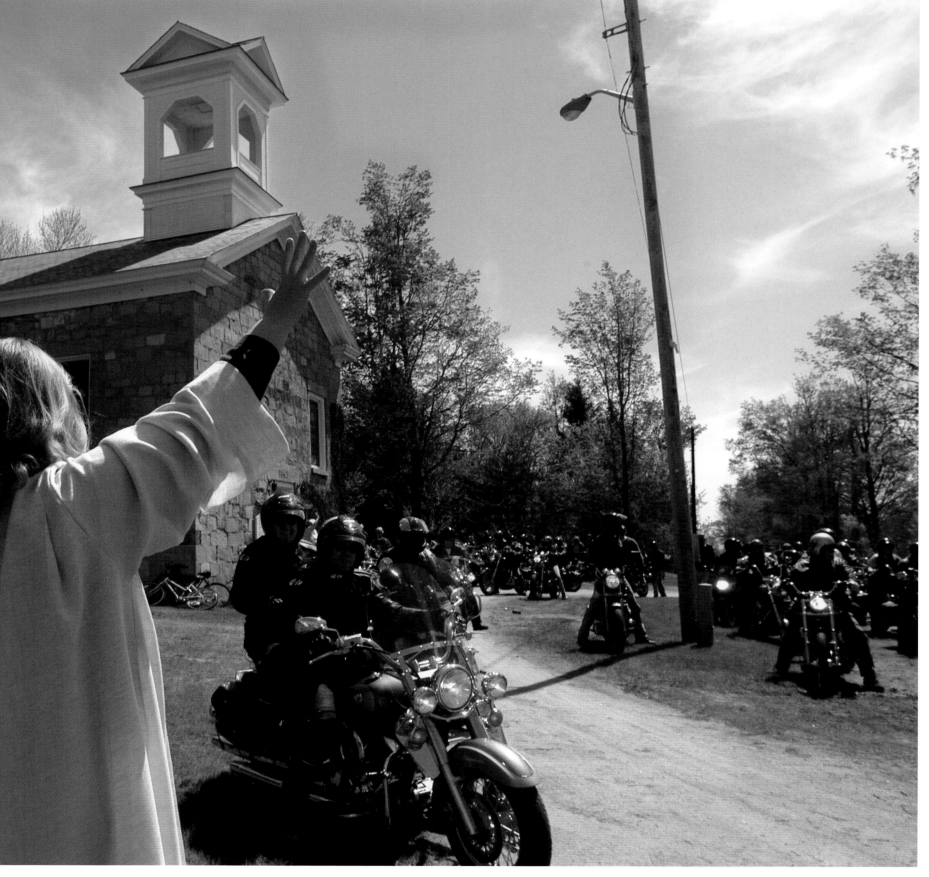

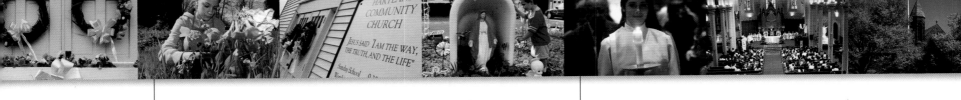

ISLE LA MOTTE

Kelly Lafleury gathers bluebell and tulip blossoms outside the Old Stone Church. Tagging along with friends who attend the church, the 12-year-old made centerpieces and served pancakes to the bikers attending a breakfast there. Behind the long beards and piercings, "they were really nice people," she says.

Photo by Rob Swanson

RUTLAND

Jamie Ravenna lights a path down the aisle at St. Peter's Church during a spring Confirmation ceremony. The devout 10th-grader has been an altar girl since she was 8.

Photo by Vyto Starinskas, Rutland Herald

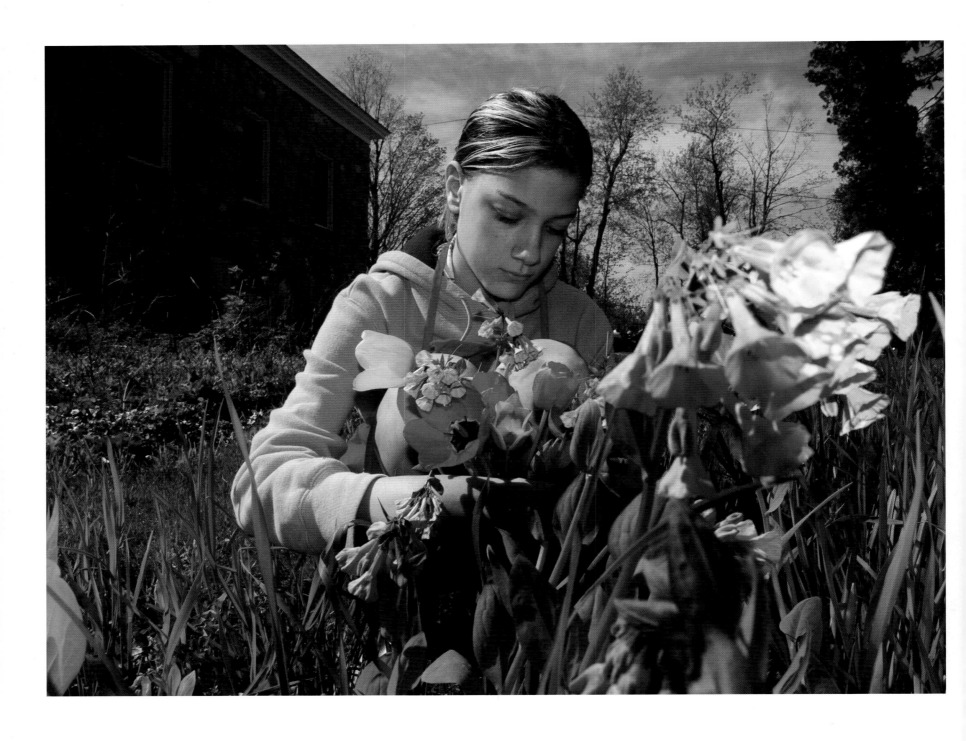

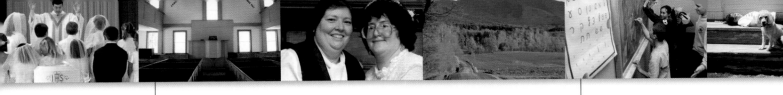

CALAIS

The inscription inside the Old West Church reads: "Remove not the ancient landmark which thy fathers have set." Respecting this order, the town has left the structure as it was first built in 1823. The building, erected by six Protestant denominations to serve as a meeting house and church, is still Calais's primary site for nondenominational services, weddings, and civil unions.
Photo by Craig Line

SOUTH BURLINGTON

At Temple Sinai Religious School, K–12 students study Hebrew, the history of Israel, and Jewish ritual. Fifth-graders Dylan Zane, Samantha Tavlin, and Kevin Weiss practice the Hebrew alphabet.
Photo by Karen Pike,
Karen Pike Photography, Hinesburg

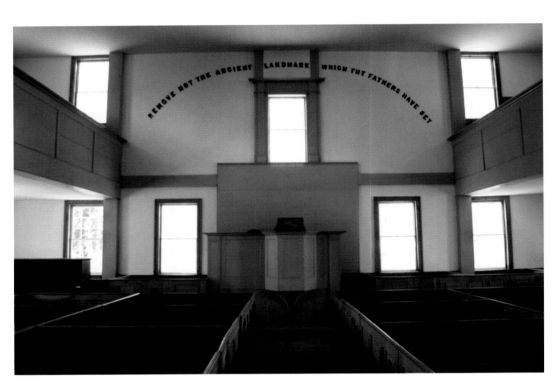

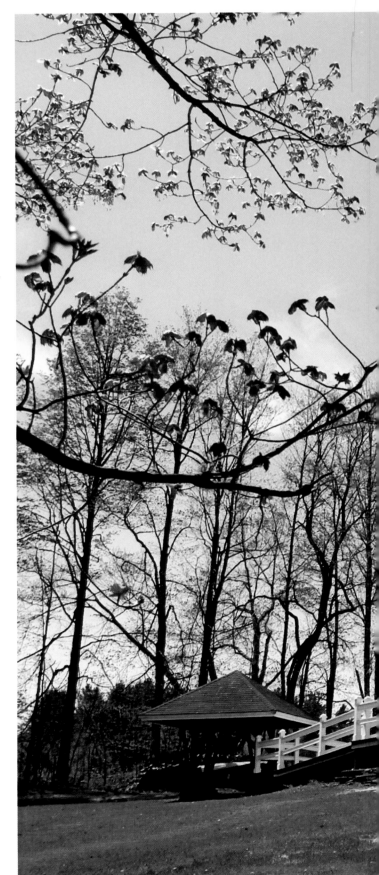

EAST MONTPELIER

The Old Meeting House was built in 1823 in what was then the center of Montpelier. To raise money for its construction, the town sold pews for $24; most people paid with cows, cheese, or grain. Weekly church services are still held here, with about 120 people attending.
Photo by Craig Line

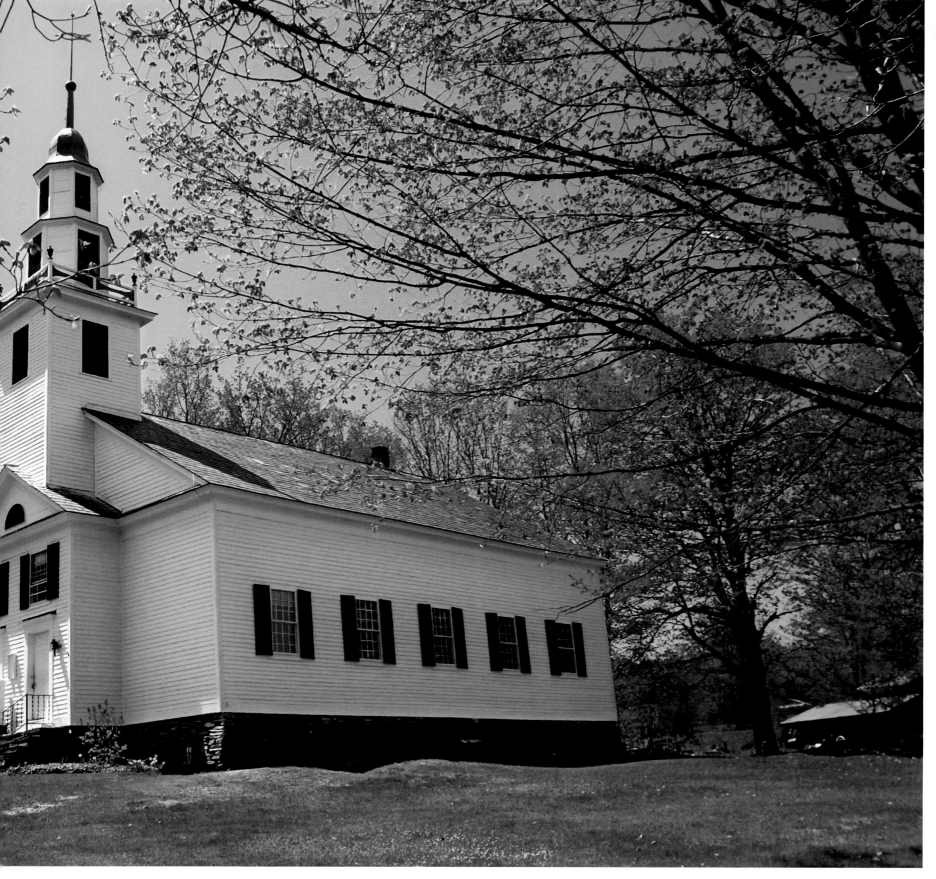

GLOVER
Twins Natasha and Cortney Colbeth have the run of Glover (pop. 966). The surrounding woods beckon them almost as often as the porch at Currier's Market.
Photo by Jack Rowell

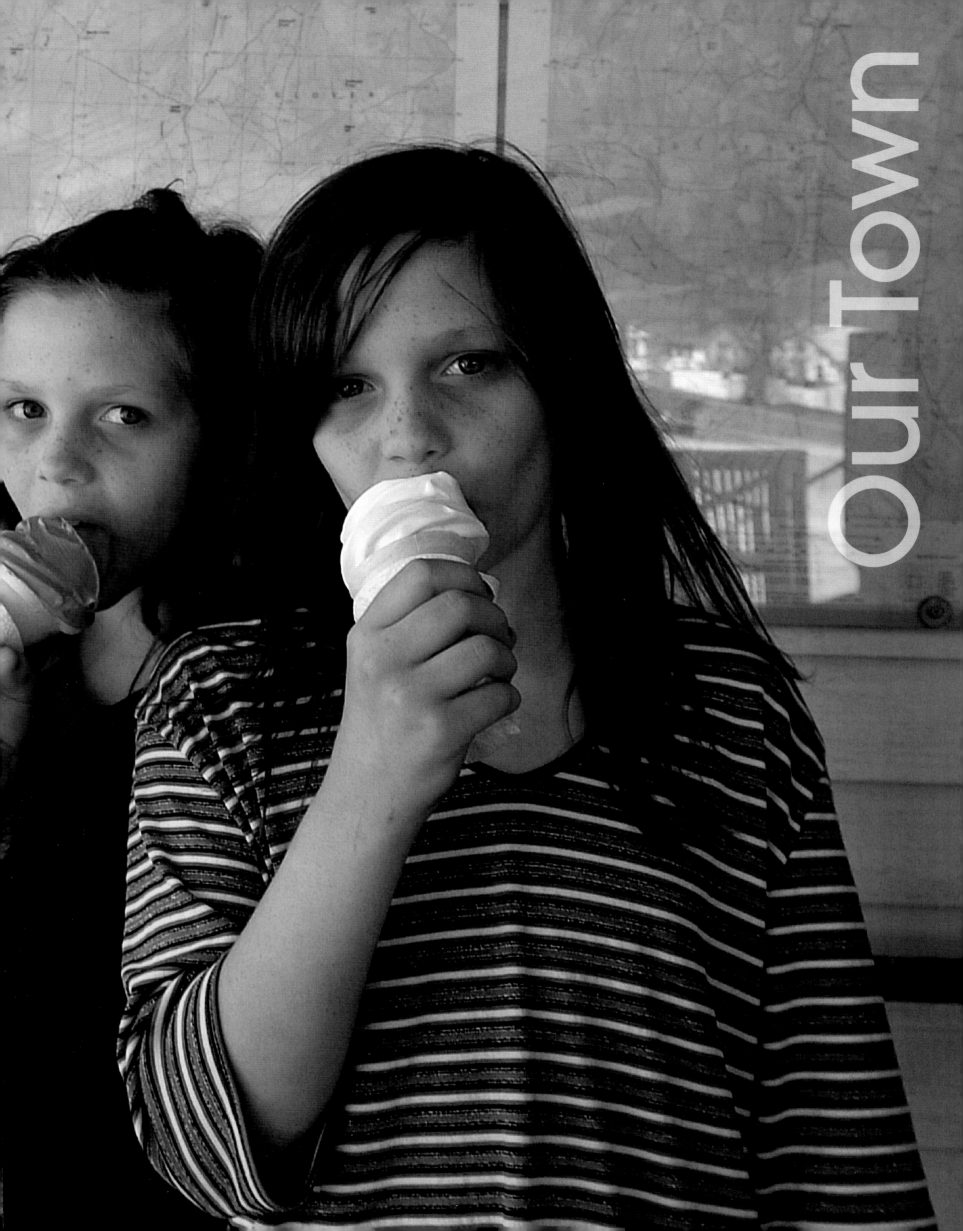

Our Town

Nina Isabelle Line, 7, (front right) consorts with her fellow ballerinas (and nervous parents) just before the troupe dances Prokofiev's "Peter and the Wolf." Nina is one of 300 students in the spring recital at the Vermont Conservatory of Ballet.
Photo by Craig Line

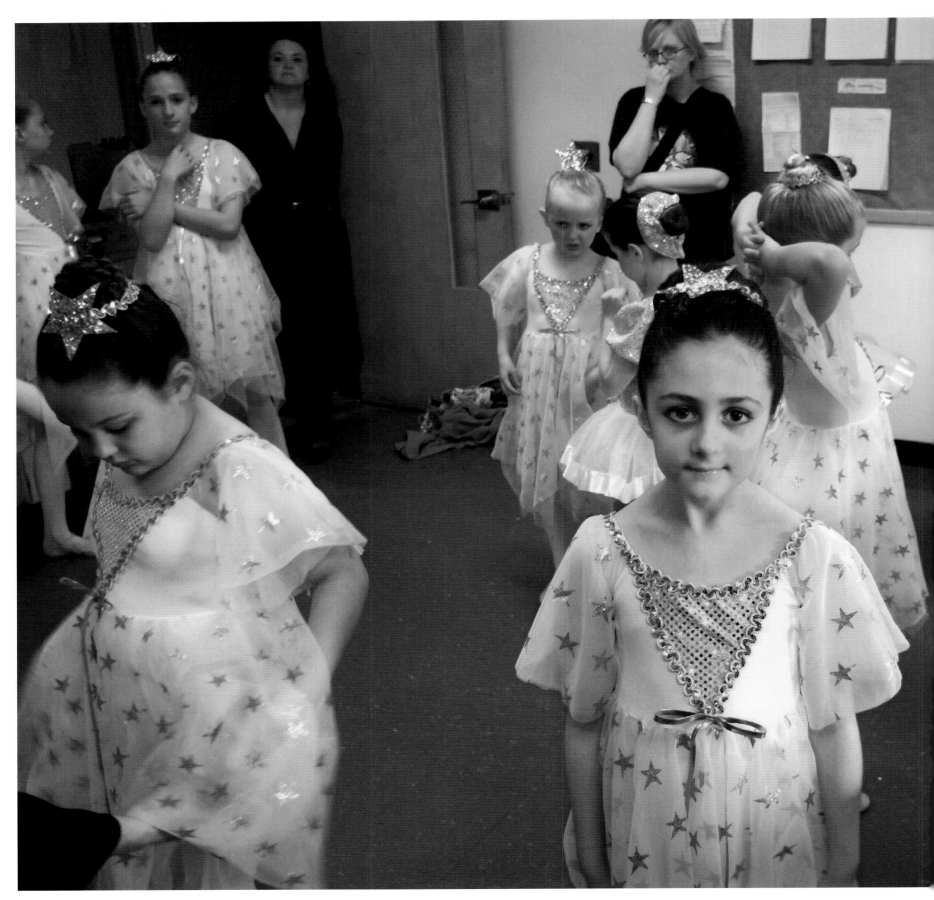

BURLINGTON

Lilly Tobin, a sophomore at Burlington High, likes the character she plays in her school's production of *A Midsummer Night's Dream*. "Hermia's perfect at first...*foxy*. But as the play goes on, she's shaken up. I liked that journey."

Photo by Megan K. Bigelow

BURLINGTON

"But she perforce withholds the loved boy, Crowns him with flowers and makes him all her joy." Sweethearts Tamar Goldberg (who plays Moth) and Sam Punia (Peter Quince) relax in the hall before their scenes in the Burlington High School Drama Club production of Shakespeare's *A Midsummer Night's Dream*.

Photo by Megan K. Bigelow

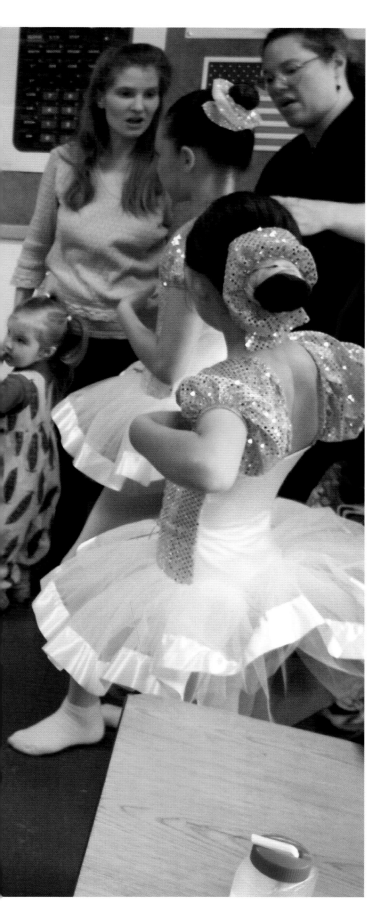

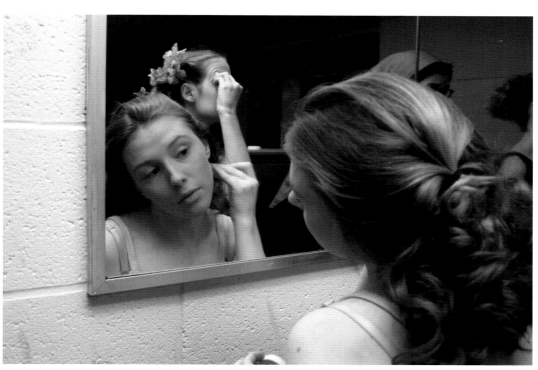

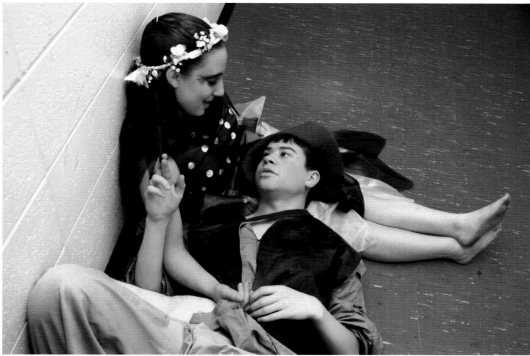

WAITSFIELD
Martin von Trapp took over his family's 150-acre dairy farm near Sugarbush Resort in 1979. Residing just across the road is his father, Werner von Trapp, an original member of the von Trapp family singers and the inspiration for the character of Kurt in *The Sound of Music*.
Photo by Peter Miller

HINESBURG

With its torturous dirt roads and cluster mail-boxes, Hinesburg is a world away from the bustle of Burlington, its neighbor 10 miles north. On Sunset Lane, cows graze by the side of the road and, in winter, residents get about on snowshoes and cross-country skis. The mail carrier prefers the one-stop ease that cluster boxes afford.

Photo by Karen Pike,
Karen Pike Photography, Hinesburg

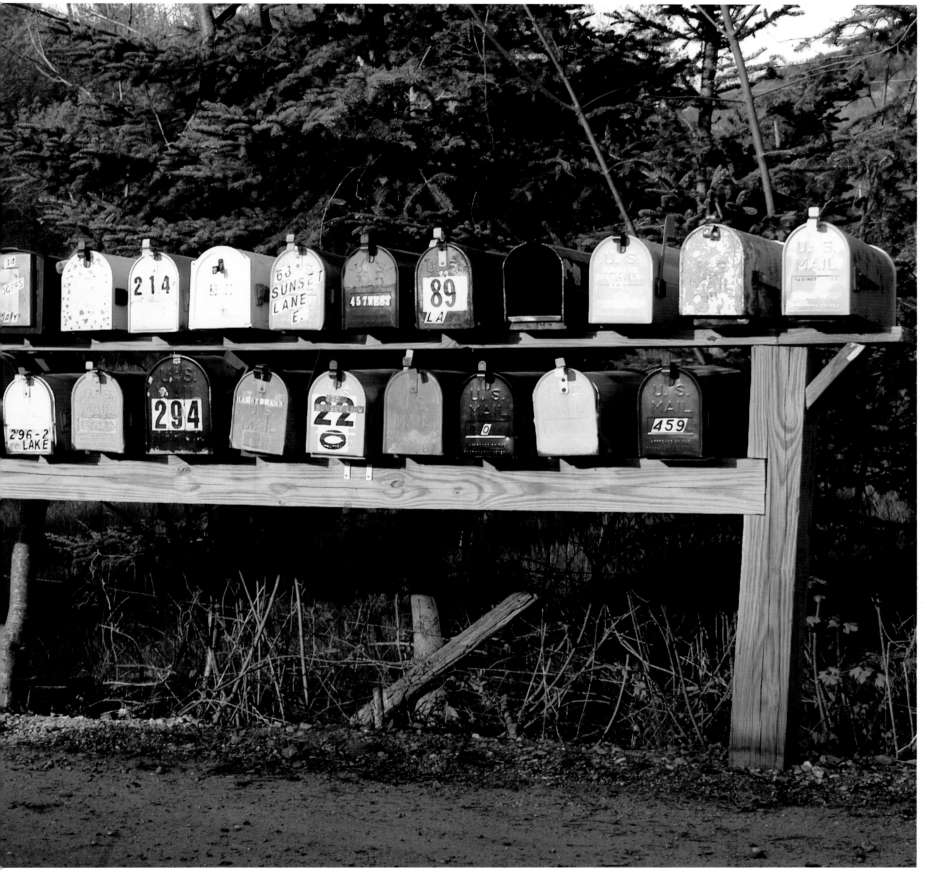

PEACHAM

On the first Tuesday of every March, residents of Peacham (pop. 665) gather for their annual town meeting to elect officials, set the town's tax schedule, and discuss issues of interest to their community. In 2003, the town debated a ban on genetically engineered crops, an antiwar measure, and public works priorities.

Photo by Peter Miller

NORWICH

Local residents turn out for a special election to decide on a school bond measure. These voters share an interstate school district with residents of Hanover, New Hampshire, one of the few such arrangements in the country. Today's vote will determine how much Norwich taxpayers cough up for playing fields, teacher salaries, and school maintenance and whether they opt to relocate or renovate the high school.

Photo by Jon Gilbert Fox

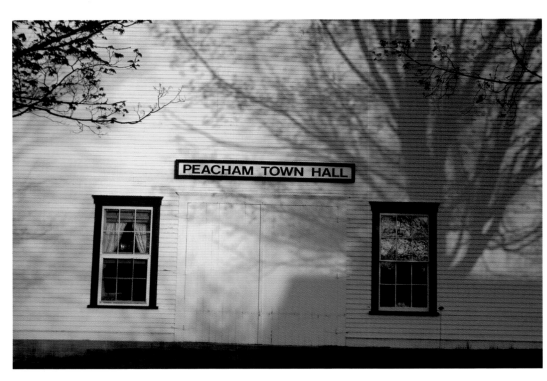

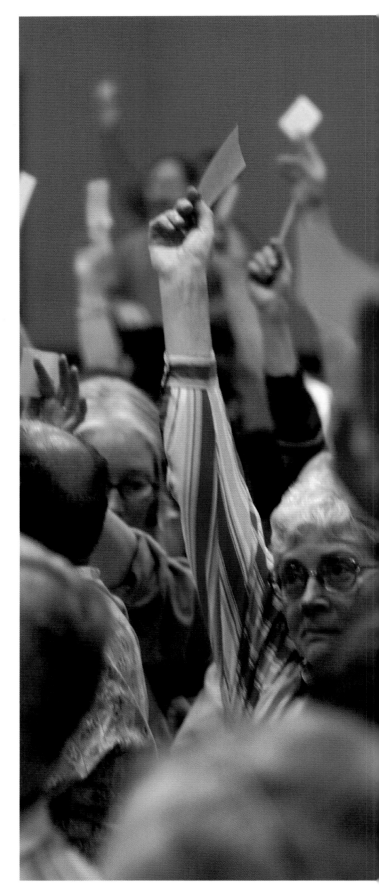

All those in favor say "yea" and hold up their residency cards at a special town meeting, held to decide if the town should do away with open voting and adopt a secret ballot system. For the last time, the townspeople of South Hero vote openly...to do away with open voting.
Photo by Rob Swanson

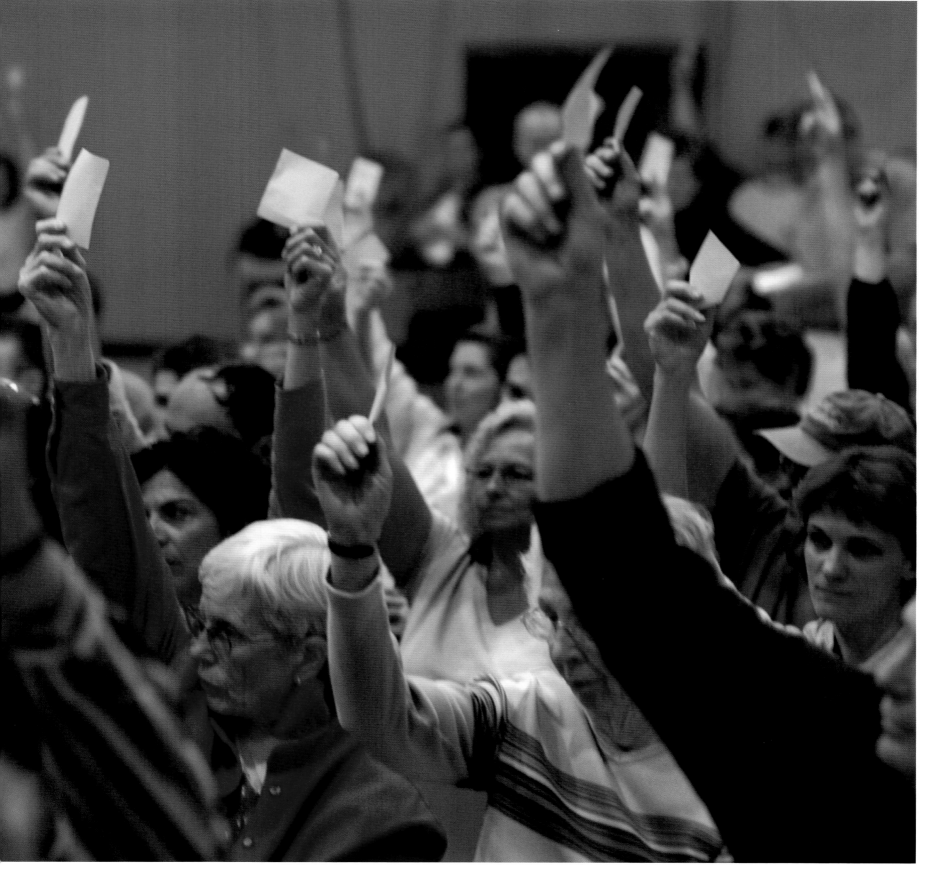

WATERBURY

Ben Cohen and Jerry Greenfield, the two chubbiest kids at their Long Island middle school, became friends after they met in a seventh-grade gym class in 1963. Fourteen years later, the pals took a $5 Penn State correspondence course on ice cream–making, rented an old garage, and started experimenting with cream, sugar, eggs, candy, and ice.
Photos by Peter Miller

WATERBURY

Cone-heads: Visitors line up for a taste of Cherry Garcia, Chunky Monkey, and Karamel Sutra at the Ben & Jerry's Ice Cream Factory. The company, which began as a tiny parlor in downtown Burlington, has become an international empire, selling more than $237 million worth of ice cream in stores worldwide.

WATERBURY

They scream for ice cream: All the way from Thailand, Linda Chayrattanazon and Tar Chatsakunter pilgrimaged to see their favorite flavors (Chunky Monkey and Heath Bar Crunch) being made at the source. The factory and company headquarters is Vermont's no. 1 tourist attraction, enticing 308,000 visitors each year.

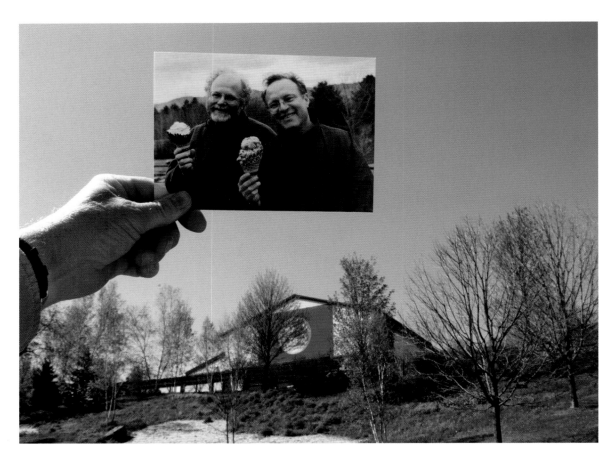

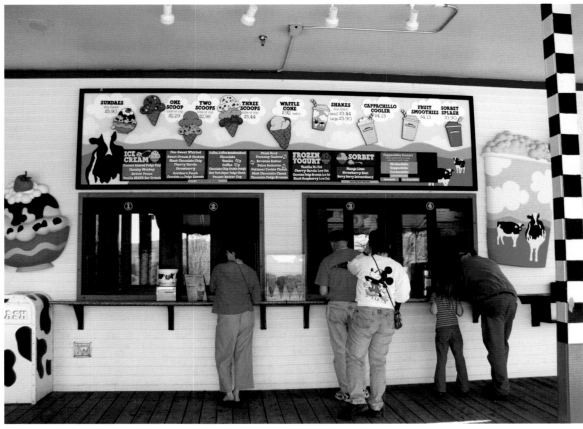

GLOVER
Located in northeast Vermont's big game country, the family-run Currier's Market sells everything from baked goods and bow hunting supplies to postage stamps and lettuce.
Photo by Jack Rowell

BROOKFIELD

A floating bridge first traversed spring-fed Sunset Lake in 1820. About that time, the lake's 3-foot-thick winter ice cap became a commodity valued for its purity and clarity. Ice blocks cut from the lake kept Boston-bound milk cold on the trip east and were then resold in the city.
Photo by Jeb Wallace-Brodeur

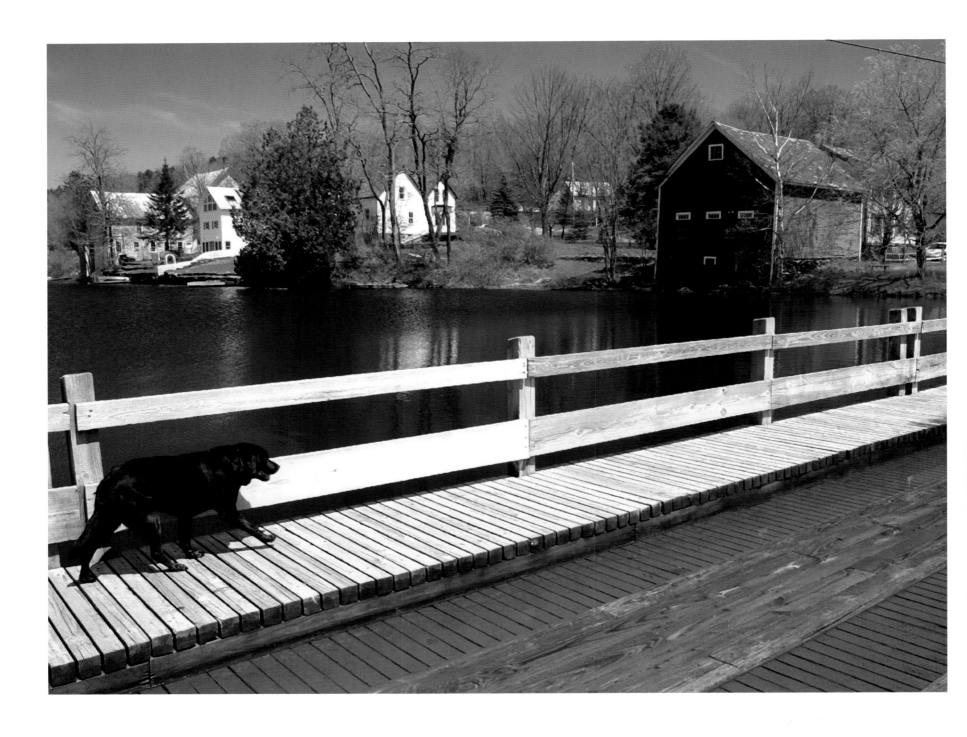

PEACHAM

Classic pastoral scenes like this one along Cabot Road are unobstructed by roadside advertisements, thanks to a law that banned them in 1968. The Green Mountain State is one of only four states— Alaska, Hawaii, and Maine are the others —to liberate their roadsides from billboards.
Photo by Peter Miller

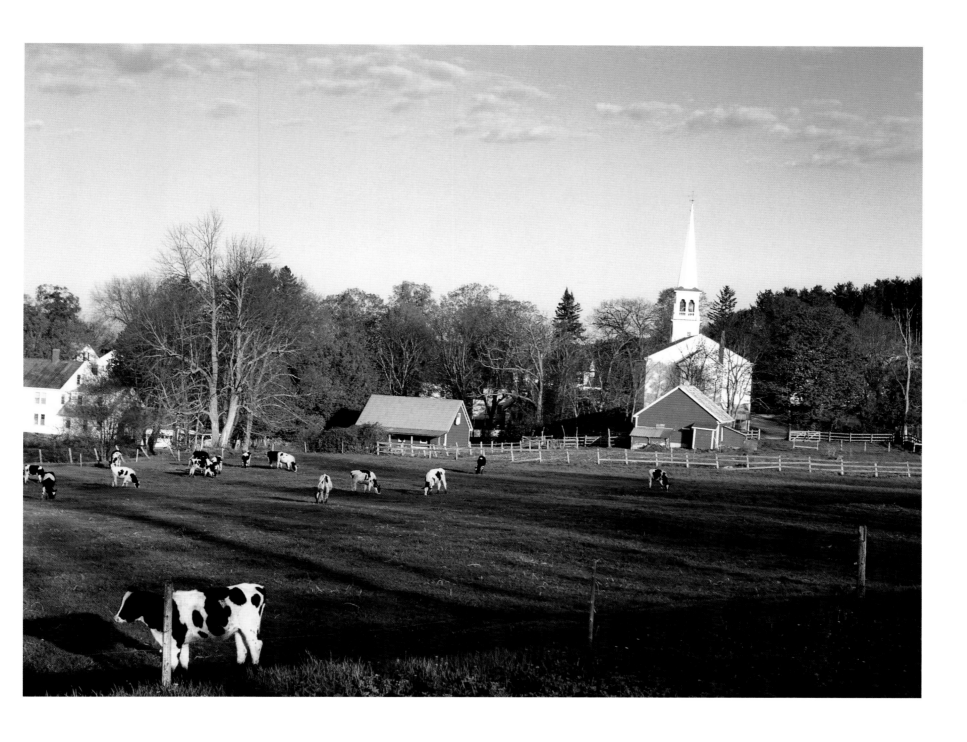

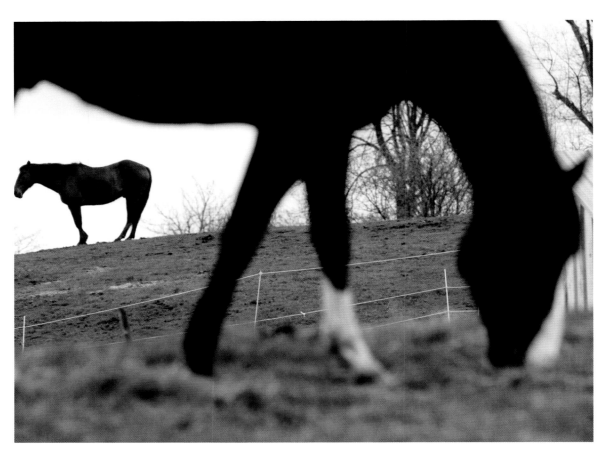

SOUTH HERO

In between dressage lessons and riding competitions, horses at Good Hope Farm stock up on fresh spring grass.
Photo by Rob Swanson

CRAFTSBURY COMMON

Used by the Incas as beasts of burden for more than 4,000 years, llamas have recently become fashionable in the U.S. Vermont has 80 llama farms that raise the camelids as pack animals for wool and as pets.
Photo by Alden Pellett

GRAND ISLE

Day-old filly Tiara of Roses gets imprinted by Tam Cristman, co-owner of this horse breeding farm and riding school. Patting and rubbing the foal helps her get accustomed to human touch and will make it easier to train her as a lesson horse.
Photo by Rob Swanson

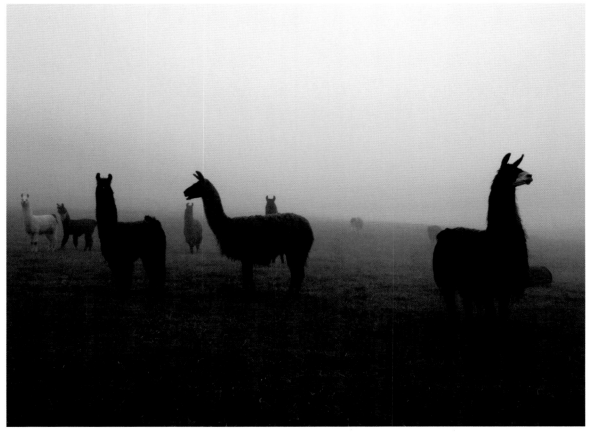

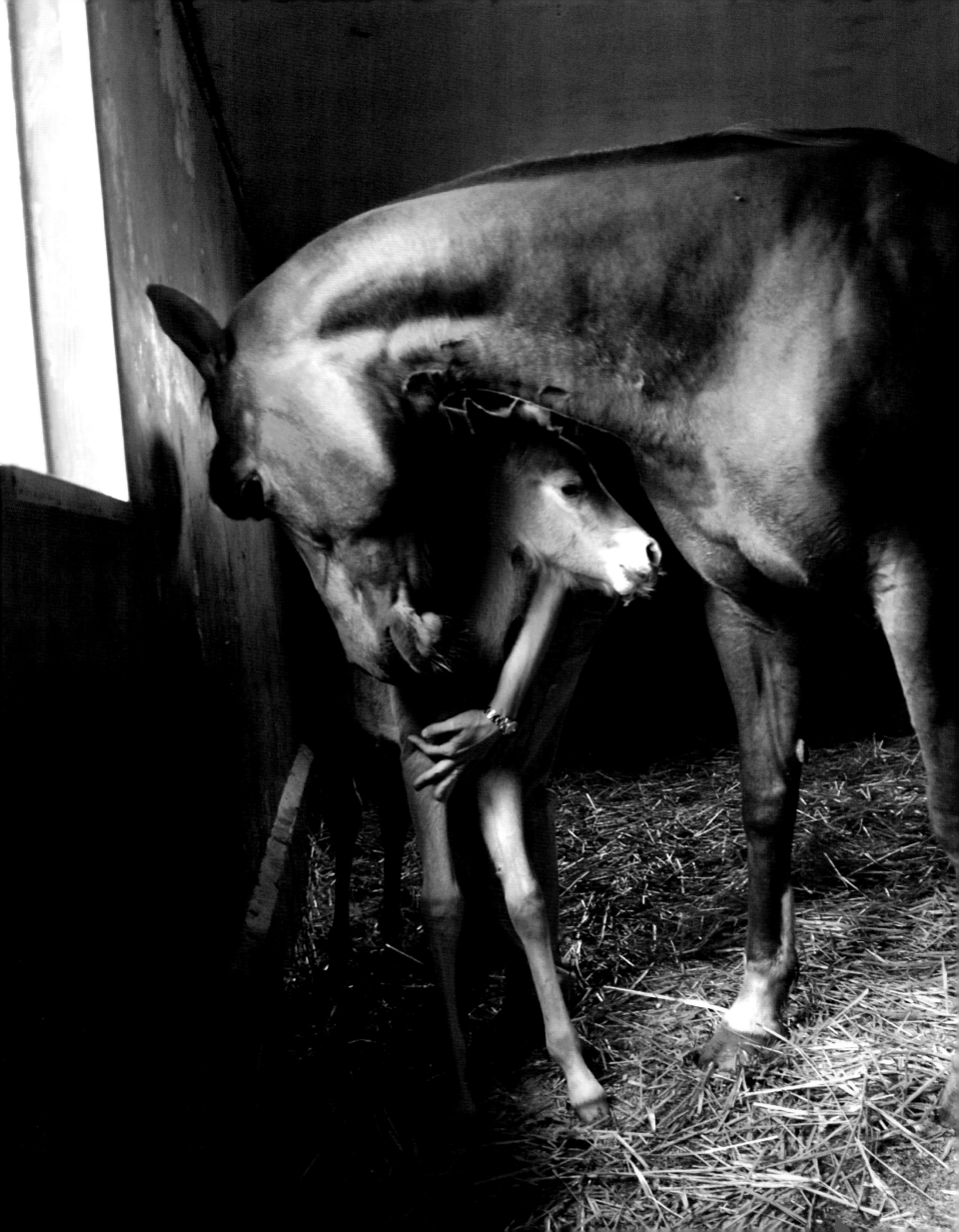

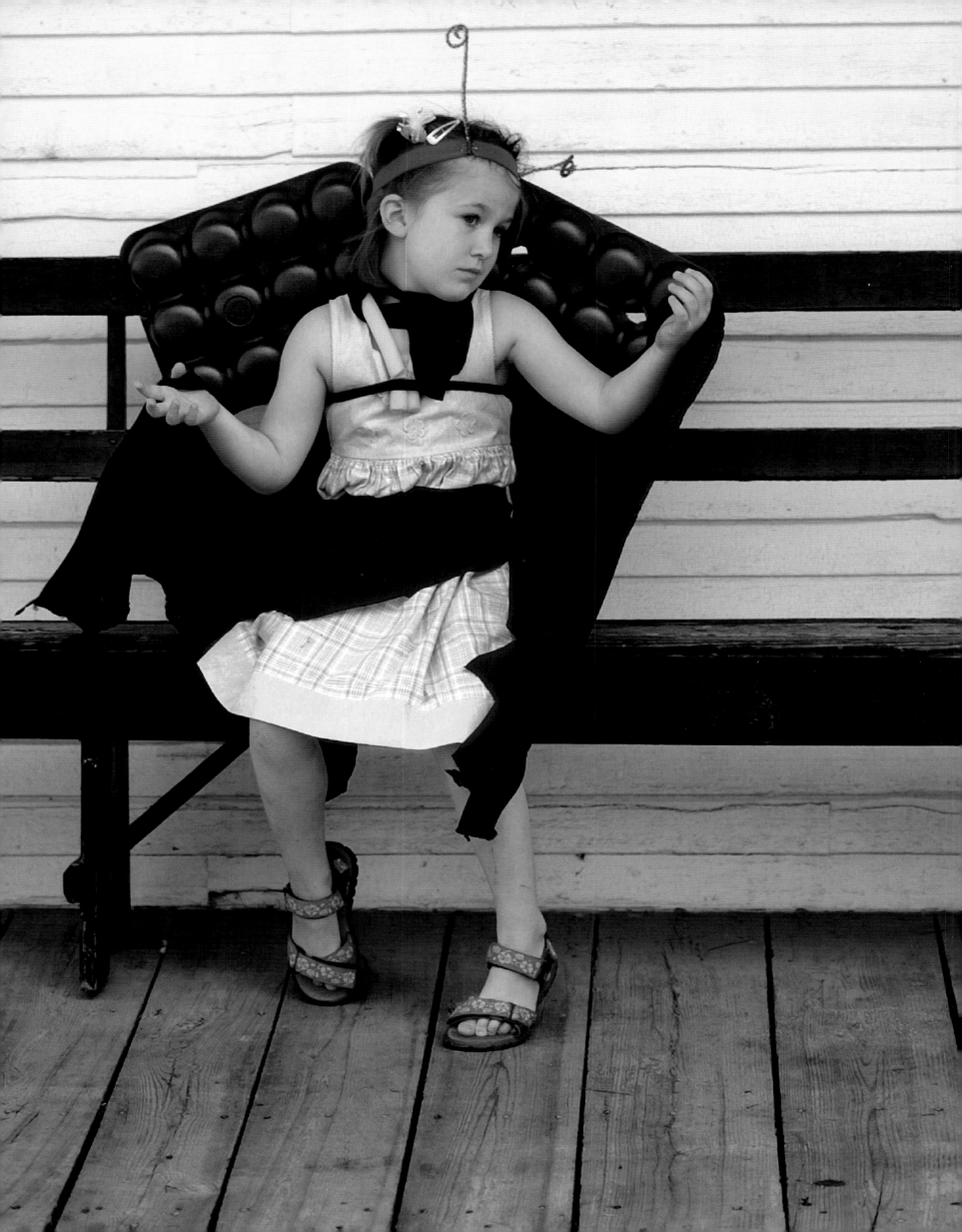

ADAMANT

The first annual Black Fly Festival, with its costume parade, silent auction, and dance, attracts a buggy Ella Thompson and her parents from Montpelier. The goofy fundraiser celebrates the notorious, biting flies that swarm the northern New England town as soon as the weather gets warm.
Photo by Jeb Wallace-Brodeur

ADAMANT

Egg cartons and other materials from the local recycling store make Ceres Porter into an insect creature, ready to buzz at the Black Fly Festival parade.
Photo by Jeb Wallace-Brodeur

GRANVILLE

In unison: At central Vermont's Granville Village School, founded in 1857, Shannon Twitchell, Shawna Brown, and Emily Hewitt learn fingering on their recorders. The one-room schoolhouse has 17 students, from kindergarten through fourth grade.
Photo by Karen Pike,
Karen Pike Photography, Hinesburg

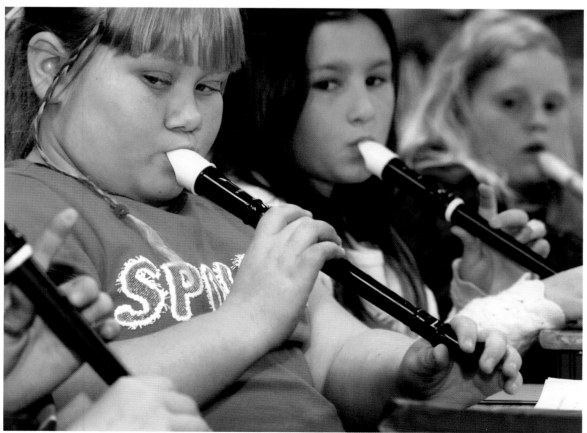

GRAND ISLE

Sixth-grader Dan Brigham does time in a Grand Isle Middle School hallway. After he spoke out of turn one too many times, his language arts teacher exiled him to the 205-student school's lonely corridors for the remainder of class.

Photo by Rob Swanson

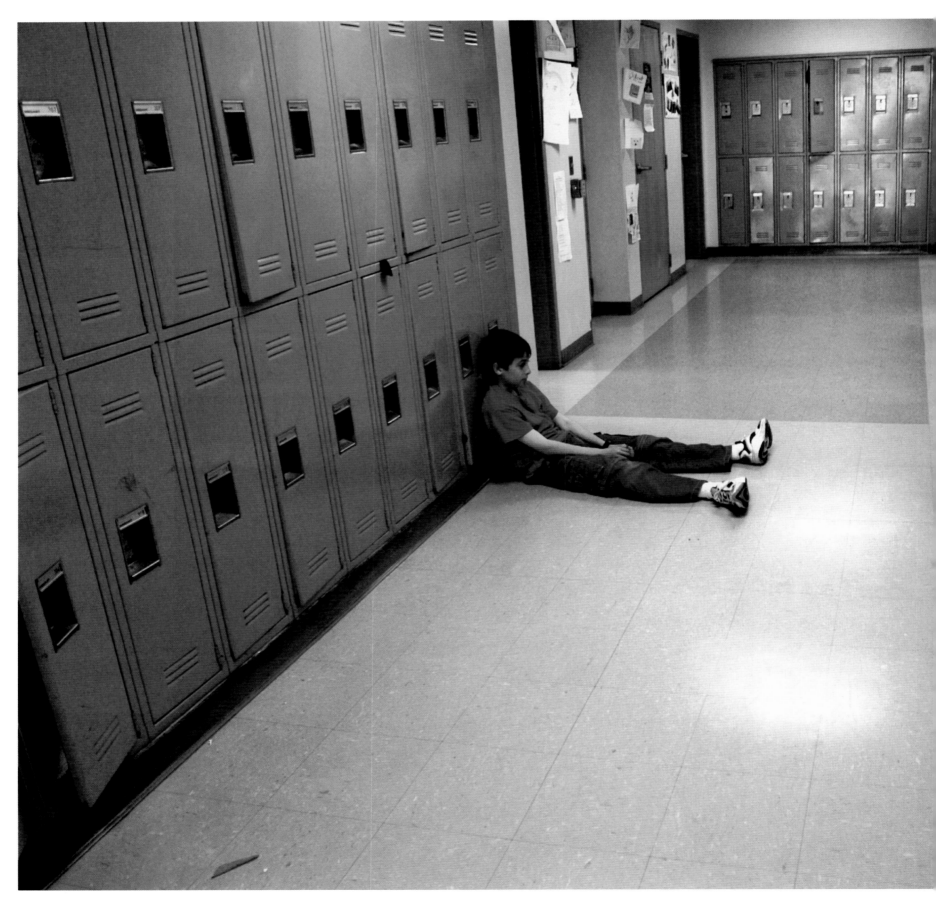

The first-grade class at Calais elementary school sits quietly as teacher Ann Moulton reads aloud. Moulton says one of the biggest changes in her 14 years at the school is the addition of a foreign language requirement. Parents requested that Spanish be added to the school's curriculum.
Photo by Craig Line

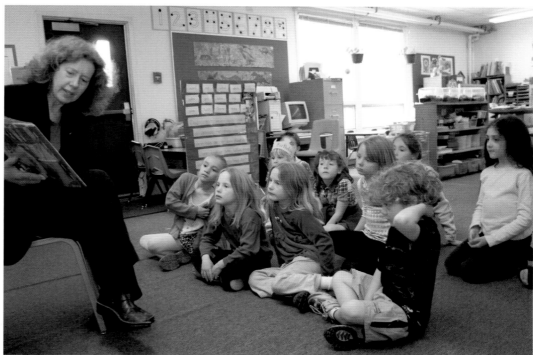

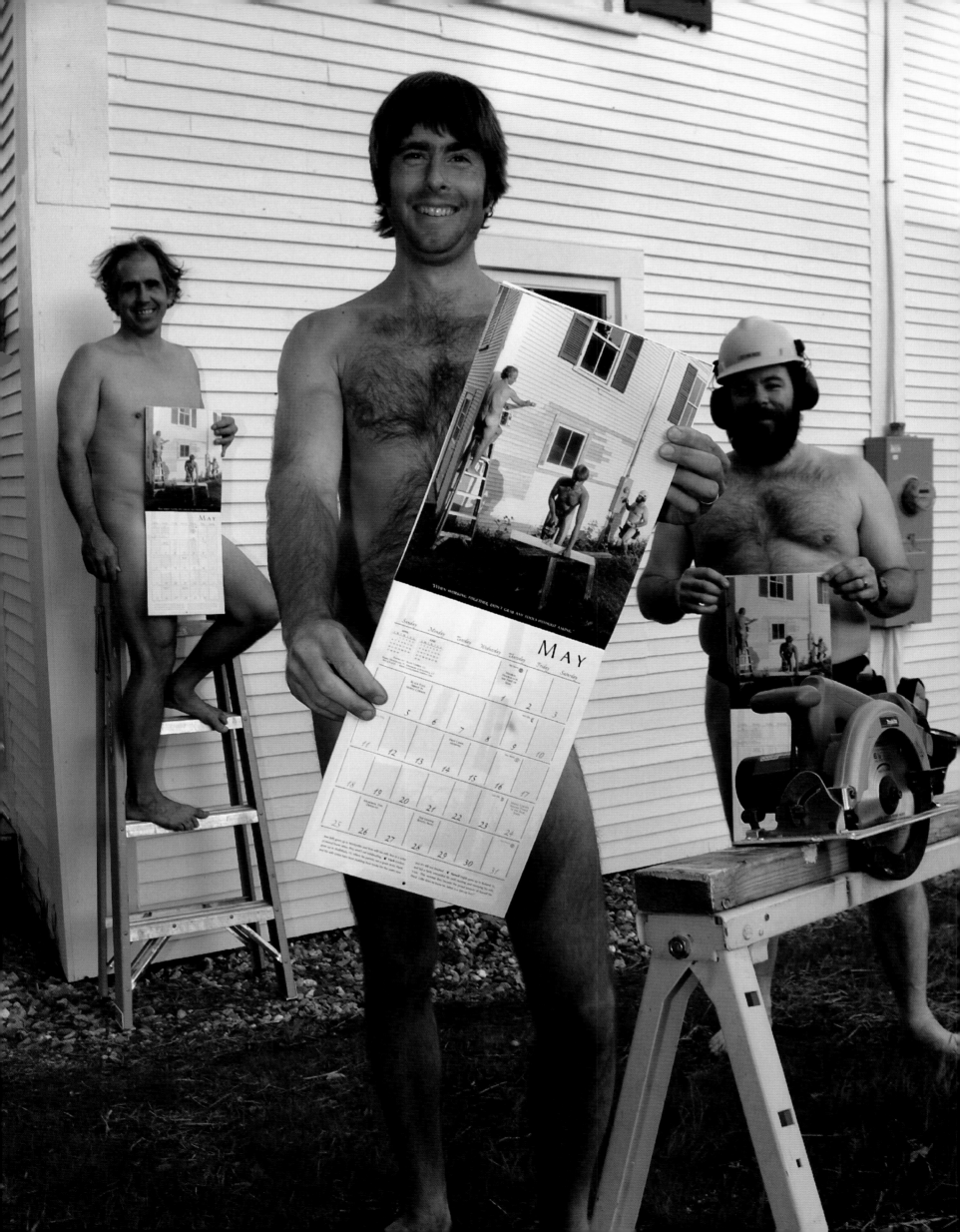

CALAIS

The Full Montpelier: The Men of Maple Corner (10 miles north of Montpelier) bared all to raise money for the upkeep of the Maple Corner Community Center. The calendar generated half a million dollars, but not everyone approved. The Maple Corner Men for Decency posed for their own picture, fully clothed, which was also included in the calendar.

Photo by Craig Line

WILLISTON

Special-needs educator Anne Fortin has been working for four years with Aimee Provost, 20, who suffers from Down's syndrome. "When I first met her, she couldn't do anything. Now she's capable of doing things on her own," says Fortin. Besides teaching Provost basic skills, Fortin drives her to various activities and to her clerical job at the Shelburne Police Department.

Photo by Megan K. Bigelow

NORTH HERO

Residents of the Champlain Islands call themselves the "frozen chosen" because of their fierce winters. One place they head when the weather turns warm is the waterfront patio at Hero's Welcome.

Photo by Paul O. Boisvert

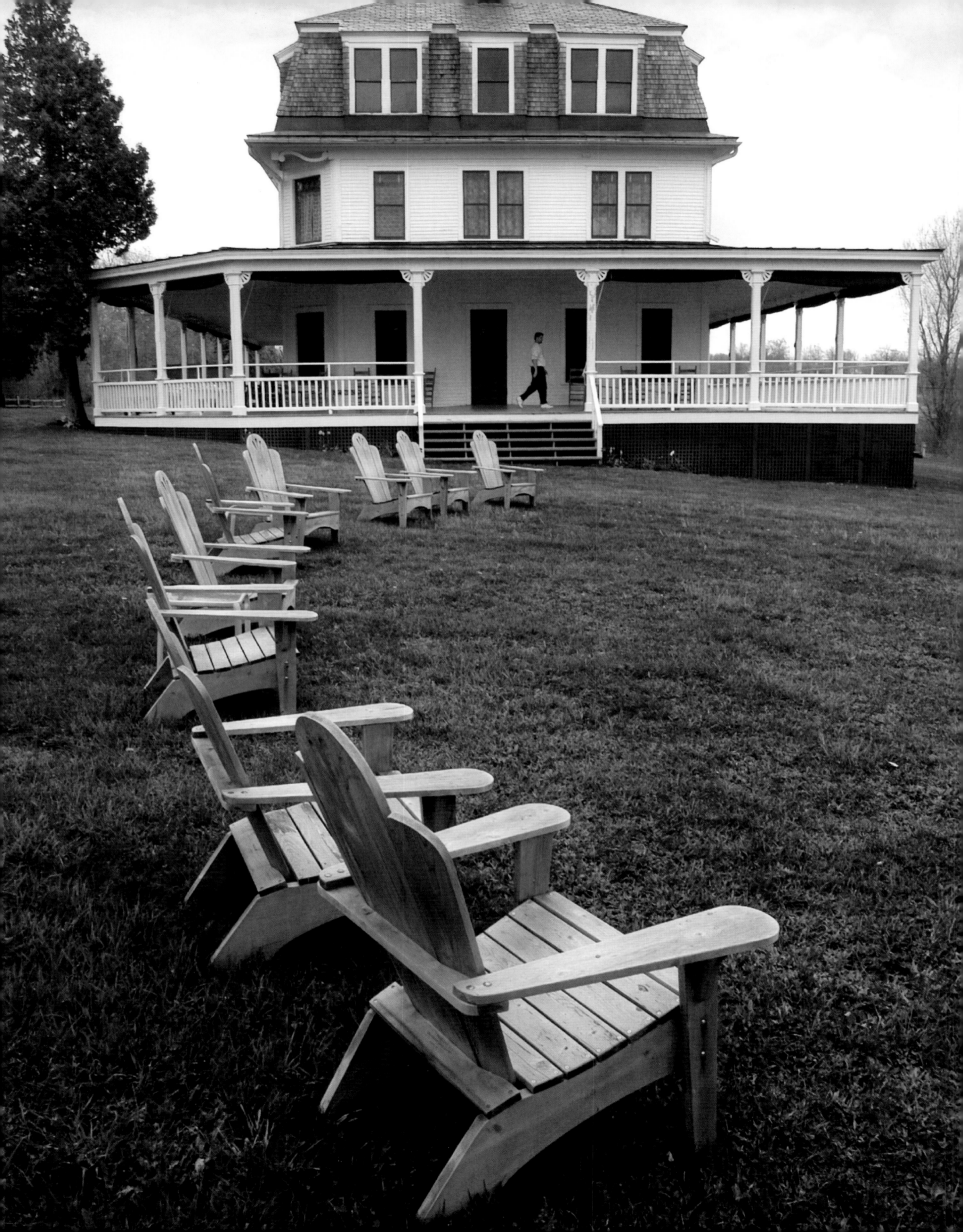

GRAND ISLE

Weekend croquet tournaments on the front lawn once amused wealthy New England vacationers at the Grand Isle Lake House. Built in 1903, the inn's wrap-around porch was the scene of bridge parties and shuffleboard. Today, the Preservation Trust of Vermont owns the property and rents it out for weddings and business retreats.

Photo by Rob Swanson

NEWFANE

Near the Windham County Courthouse (1825), a statue memorializes those who died in the Civil War and World War I. Accompanying their names are these lines from Theodore O'Hara's poem: "On Fame's eternal camping-ground / Their silent tents are spread, / And Glory guards, with solemn round, / The bivouac of the dead."

Photo by Craig Line

MONTPELIER

The 1859 Vermont State House is the third building to become the seat of government for Vermont. The 1808 wooden building on State Street was replaced in 1836 with a granite structure, which was gutted by fire 21 years later. The current building, made of Barre granite, has a copper dome, first covered in gold leaf in 1907.

Photo by Jeb Wallace-Brodeur

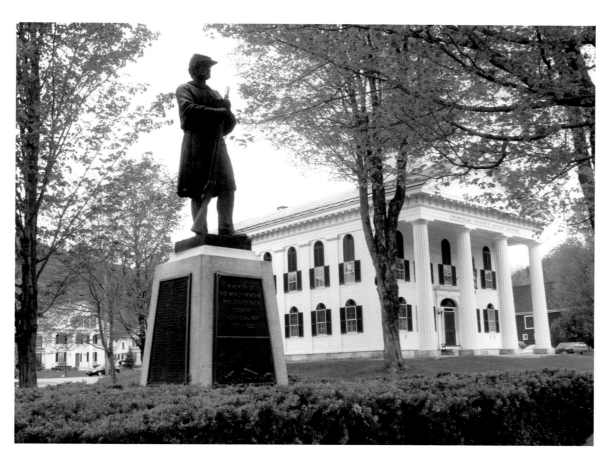

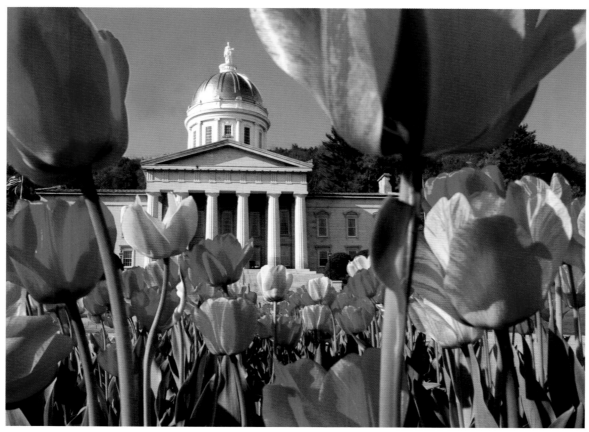

LEICESTER

Queen Connie, the Bug-toting, 19-foot, 16-ton, concrete gorilla at Pioneer Auto Sales on Route 7, was commissioned by Pioneer Auto's owner Joan Cameron O'Neil in 1985. O'Neil started her dealership in 1969 out of frustration: As a woman, she was not allowed to sell on the floor.

Photo by Peter Huoppi

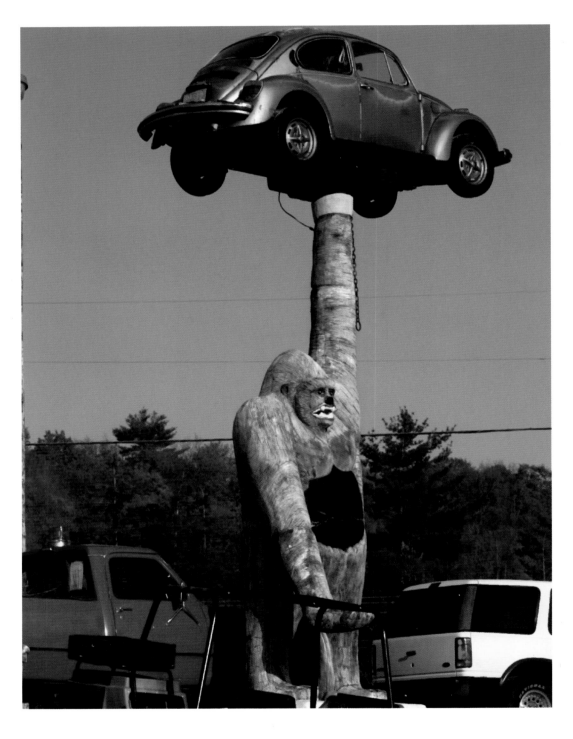

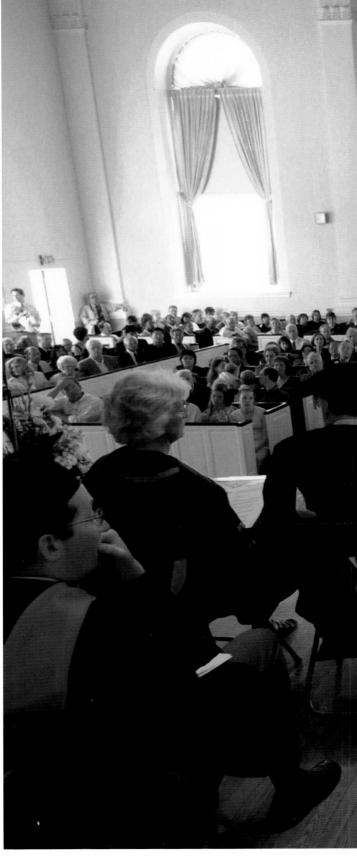

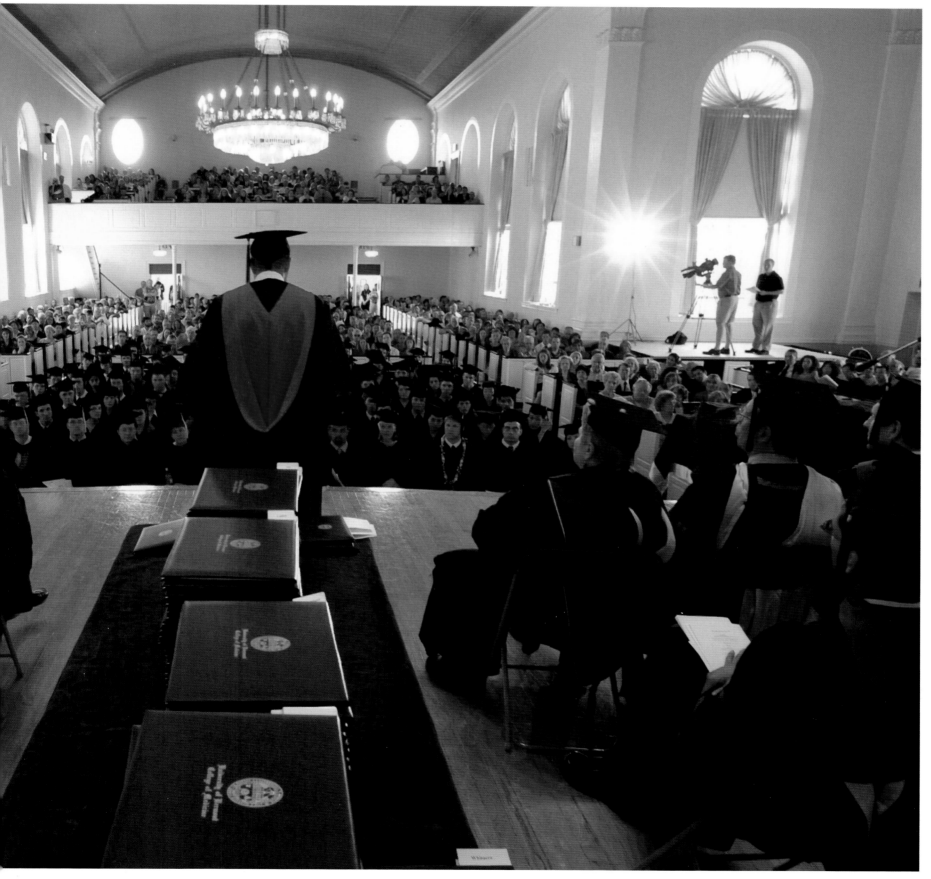

FAIRLEE

At one of the two motel/drive-in movie theatres in the country, Jacob Marchant sells tickets to customers who came to watch *The Lord of the Rings*. The Fairlee Drive-In's 12 motel rooms are wired for sound and have "picture windows" for unobstructed views of the big screen.

Photo by Jon Gilbert Fox

WHITE RIVER JUNCTION
As its name implies, White River Junction (pop. 2,570) on the Connecticut River has always been a significant crossroad for travelers. Two interstate highways, 89 and 91, intersect there. And 23 buses—bound for New York City, Montreal, Boston, Albany, and so on—pull in to this Vermont Transit Company station daily.
Photo by Megan K. Bigelow

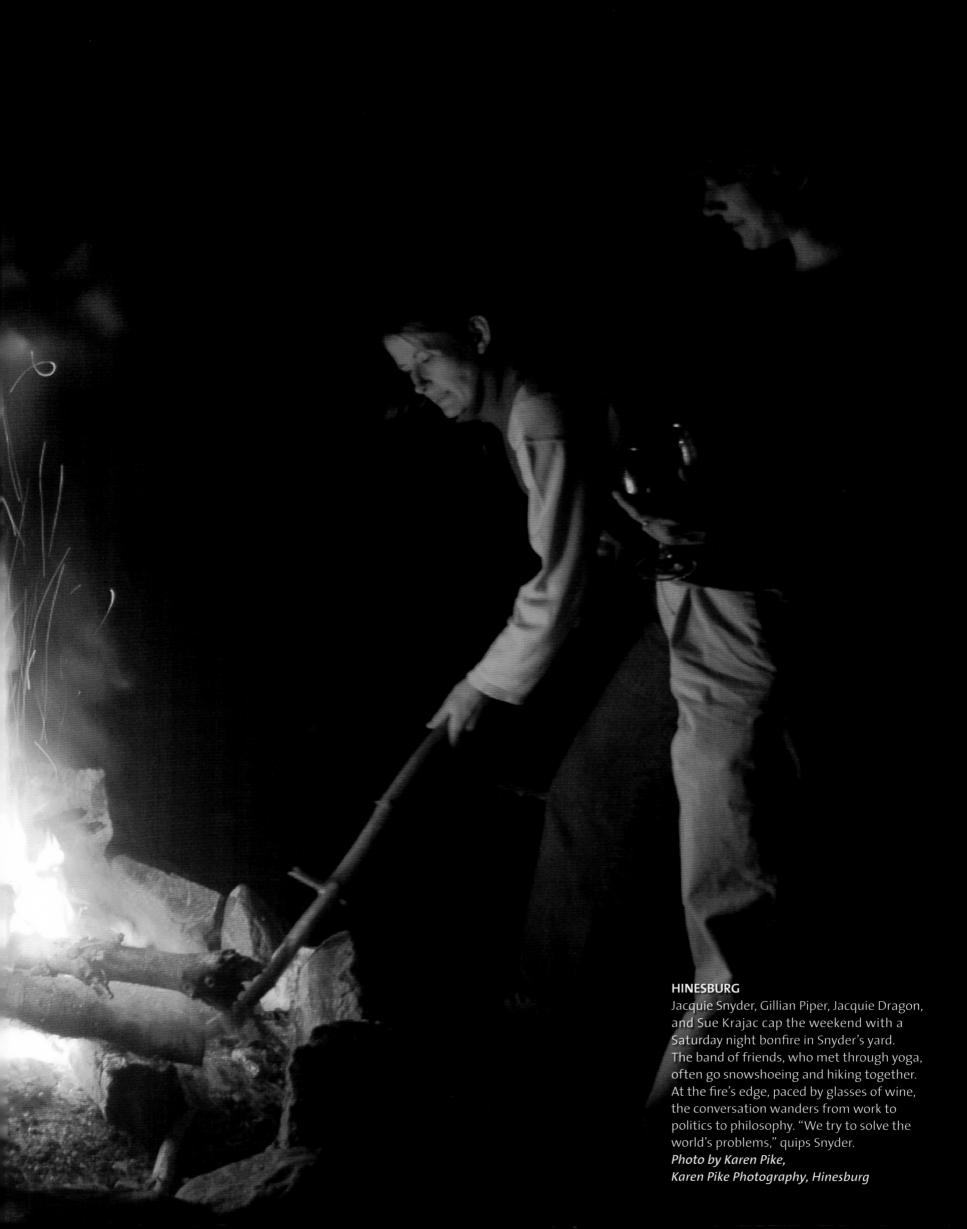

HINESBURG

Jacquie Snyder, Gillian Piper, Jacquie Dragon, and Sue Krajac cap the weekend with a Saturday night bonfire in Snyder's yard. The band of friends, who met through yoga, often go snowshoeing and hiking together. At the fire's edge, paced by glasses of wine, the conversation wanders from work to politics to philosophy. "We try to solve the world's problems," quips Snyder.

Photo by Karen Pike,
Karen Pike Photography, Hinesburg

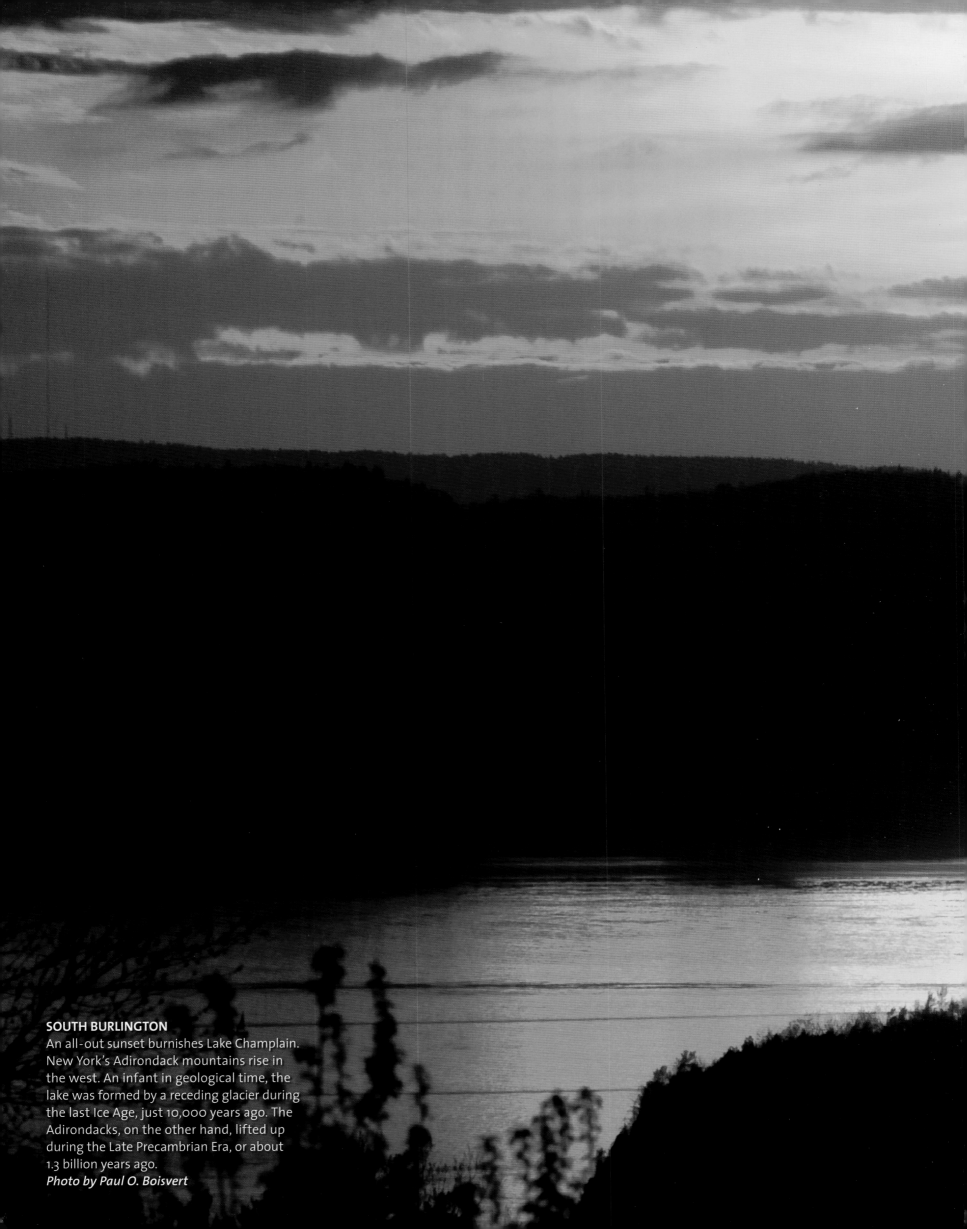

SOUTH BURLINGTON
An all-out sunset burnishes Lake Champlain.
New York's Adirondack mountains rise in
the west. An infant in geological time, the
lake was formed by a receding glacier during
the last Ice Age, just 10,000 years ago. The
Adirondacks, on the other hand, lifted up
during the Late Precambrian Era, or about
1.3 billion years ago.
Photo by Paul O. Boisvert

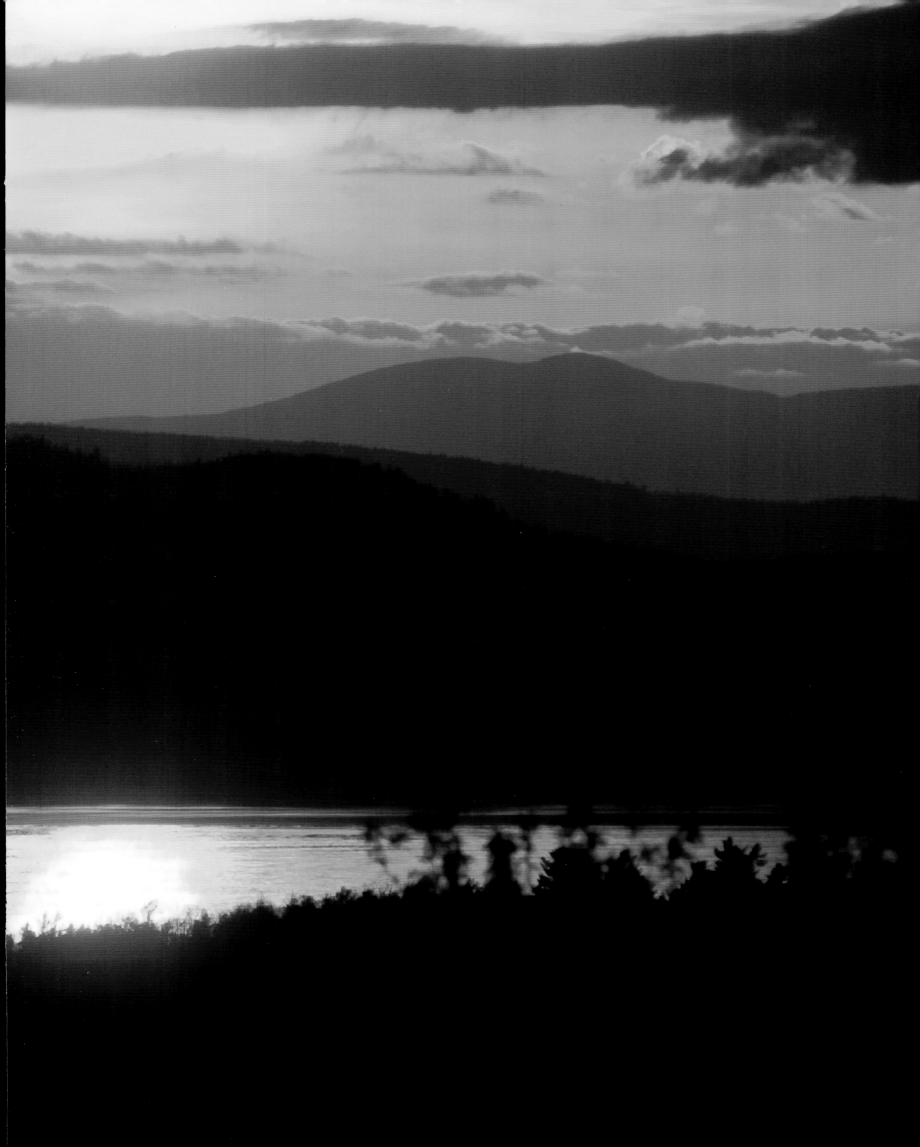

The week of May 12-18, 2003, more than 25,000 professional and amateur photographers spread out across the nation to shoot over a million digital photographs with the goal of capturing the essence of daily life in America.

The professional photographers were equipped with Adobe Photoshop and Adobe Album software, Olympus C-5050 digital cameras, and Lexar Media's high-speed compact flash cards.

The 1,000 professional contract photographers plus another 5,000 stringers and students sent their images via FTP (file transfer protocol) directly to the *America 24/7* website. Meanwhile, thousands of amateur photographers uploaded their images to Snapfish's servers.

At *America 24/7*'s Mission Control headquarters, located at CNET in San Francisco, dozens of picture editors from the nation's most prestigious publications culled the images down to 25,000 of the very best, using Photo Mechanic by Camera Bits. These photos were transferred into Webware's ActiveMedia Digital Asset Management (DAM) system, which served as a central image library and enabled the designers to track, search, distribute, and reformat the images for the creation of the 51 books, foreign language editions, web and magazine syndication, posters, and exhibitions.

Once in the DAM, images were optimized (and in some cases resampled to increase image resolution) using Adobe Photoshop. Adobe InDesign and Adobe InCopy were used to design and produce the 51 books, which were edited and reviewed in multiple locations around the world in the form of Adobe Acrobat PDFs. Epson Stylus printers were used for photo proofing and to produce large-format images for exhibitions. The companies providing support for the *America 24/7* project offer many of the essential components for anyone building a digital darkroom. We encourage you to

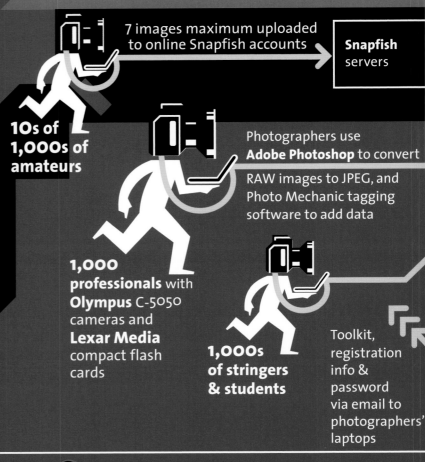

SHOOT

7 images maximum uploaded to online Snapfish accounts → **Snapfish** servers

10s of 1,000s of amateurs

Photographers use **Adobe Photoshop** to convert RAW images to JPEG, and Photo Mechanic tagging software to add data

1,000 professionals with **Olympus** C-5050 cameras and **Lexar Media** compact flash cards

1,000s of stringers & students

Toolkit, registration info & password via email to photographers' laptops

Printer ← **InDesign** layouts output via **Acrobat** to PDF format

5 graphic design and production teams

51 books: one national, 50 states

Produced by 24/7 Media, published by DK Publishing

50 state posters designed by 50 AIGA member firms

24/7

DESIGN & PUBLISH

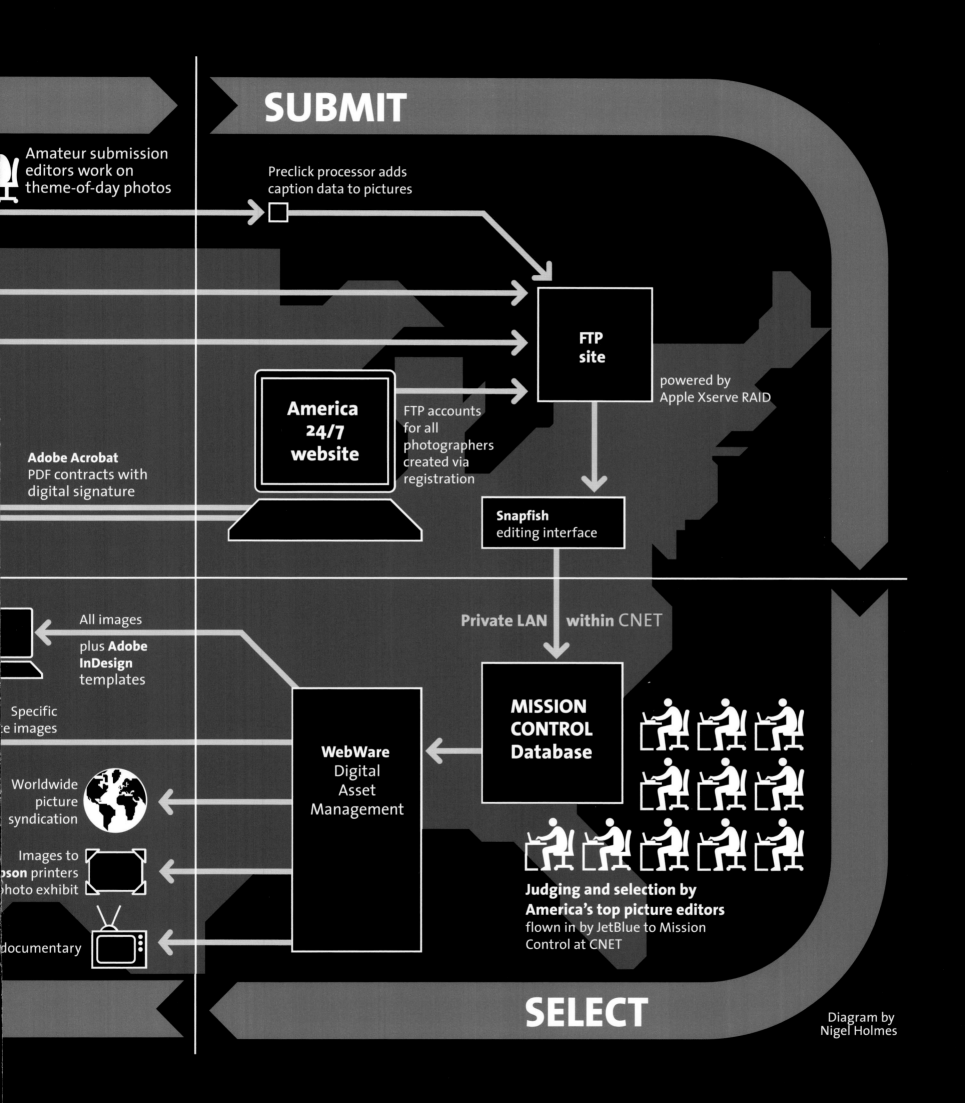

SUBMIT

Amateur submission editors work on theme-of-day photos

Preclick processor adds caption data to pictures

FTP site

powered by Apple Xserve RAID

America 24/7 website

FTP accounts for all photographers created via registration

Adobe Acrobat PDF contracts with digital signature

Snapfish editing interface

All images

plus **Adobe InDesign** templates

Specific e images

Private LAN within CNET

WebWare Digital Asset Management

MISSION CONTROL Database

Worldwide picture syndication

Images to son printers hoto exhibit

Judging and selection by America's top picture editors flown in by JetBlue to Mission Control at CNET

documentary

SELECT

Diagram by Nigel Holmes

About Our Sponsors

America 24/7 gave digital photographers of all levels the opportunity to share their visions of what it means to live in the United States. This project was made possible by a digital photography revolution that is dramatically changing and improving picture-taking for professionals and amateurs alike. And an Adobe product, Photoshop®, has been at the center of this sea change.

Adobe's products reflect our customers' passion for the creative process, be it the photographer, graphic designer, layout artist, or printer. Adobe is the Publishing and Imaging Software Partner for *America 24/7* and products such as Adobe InDesign®, Photoshop, Acrobat®, and Illustrator® were used to produce this stunning book in a matter of weeks. We hope that our software has helped do justice to the mythic images, contributed by well-known photographers and the inspired hobbyist.

Adobe is proud to be a lead sponsor of *America 24/7*, a project that celebrates the vibrancy of the American spirit: the same spirit that helped found Adobe and inspires our employees and customers to deliver the very best.

Bruce Chizen
President and CEO
Adobe Systems Incorporated

Olympus, a global technology leader in designing precision healthcare solutions and innovative consumer electronics, is proud to be the official digital camera sponsor of *America 24/7*. The opportunity to introduce Americans from coast to coast to the thrill, excitement, and possibility of digital photography makes the vision behind this book a perfect fit for Olympus, a leader in digital cameras since 1996.

For most people, the essence of digital photography is best grasped through firsthand experience with the technology, which is precisely what *America 24/7* is about. We understand that direct experience is the pathway to inspiration, and welcome opportunities like this sponsorship to bring the power of the digital experience into the lives of people everywhere. To Olympus, *America 24/7* offers a platform to help realize a core mission: to deliver and make accessible the power of the digital experience to millions of American photographers, amateurs, and professionals alike.

The 1,000 professional photographers contracted to shoot on the America 24/7 project were all equipped with Olympus C-5050 digital cameras. Like all Olympus products, the C-5050 is offered by a company well known for designing, manufacturing, and servicing products used by professionals to perform their work, every day. Olympus is a customer-centric company committed to working one-to-one with a diverse group of professionals. From biomedical researchers who use our clinical microscopes, to doctors who perform life-saving procedures with our endoscopes, to professional photographers who use cameras in their daily work, Olympus is a trusted brand.

The digital imaging technology involved with *America 24/7* has enabled the soul of America to be visually conveyed, not just by professional observers, but by the American public who participated in this project—the very people who collectively breath life into this country's existence each day.

We are proud to be enabling so many photographers to capture the pictures on these pages that tell the story of who we are as a nation. From sea to shining sea, digital imagery allows us to connect to one another in ways we never dreamed possible.

At Olympus, our ideas have proliferated as rapidly as technology has evolved. We have channeled these visions into breakthrough products and solutions to meet the demands of our changing world-products like microscopes, endoscopes, and digital voice recorders, supported by the highly regarded training, educational, and consulting services we offer our customers.

Today, 83 years after we introduced our first microscope, we remain as young, as curious, and as committed as ever.

Lexar Media has grown from the digital photography revolution, which is why we are proud to have supplied the digital memory cards used in the America 24/7 project. Lexar Media's high-performance memory cards utilize our unique and patented controller coupled with high-speed flash memory from Samsung, the world's largest flash memory supplier. This powerful combination brings out the ultimate performance of any digital camera.

Photographers who demand the most from their equipment choose our products for their advanced features like write speeds up to 40X, Write Acceleration technology for enabled cameras, and Image Rescue, which recovers previously deleted or lost images. Leading camera manufacturers bundle Lexar Media digital memory cards with their cameras because they value its performance and reliability.

Lexar Media is at the forefront of digital photography as it transforms picture-taking worldwide, and we will continue to be a leader with new and innovative solutions for professionals and amateurs alike.

Snapfish, which developed the technology behind the *America 24/7* amateur photo event, is a leading online photo service, with more than 5 million members and 100 million photos posted online. Snapfish enables both film and digital camera owners to share, print, and store their most important photo memories, at prices that cannot be equaled. Digital camera users upload photos into a password-protected online album for free. Users can also order film-quality prints on professional photographic paper for as low as 25¢. Film camera users get a full set of prints, plus online sharing and storage, for just $2.99 per roll.

Founded in 1995, eBay created a powerful platform for the sale of goods and services by a passionate community of individuals and businesses. On any given day, there are millions of items across thousands of categories for sale on eBay. eBay enables trade on a local, national and international basis with customized sites in markets around the world.

Through an array of services, such as its payment solution provider PayPal, eBay is enabling global e-commerce for an ever-growing online community.

JetBlue Airways is proud to be *America 24/7's* preferred carrier, flying photographers, photo editors, and organizers across the United States.

Winner of Condé Nast Traveler's Readers' Choice Awards for Best Domestic Airline 2002, JetBlue provides friendly service and low fares for travelers in 22 cities in nine states across America.

On behalf of JetBlue's 5,000 crew members, we're excited to be involved in this remarkable project, and for the opportunity to serve American travelers each and every day, coast to coast, 24/7.

DIGITAL POND

Digital Pond has been a leading creator of large graphic displays for museums, corporations, trade shows, retail environments and fine art since 1992.

We were proud to bring together our creative, print and display capabilities to produce signage and displays for mission control, critical retouching for numerous key images for the book, and art galleries for the New York Public Library and Bryant Park.

The Pond's team and SplashPic® Online service enabled us to nimbly design, produce and install over 200 large graphic panels in two NYC locations within the truly "24/7" production schedule of less than ten days.

WebWare Corporation is pleased to be a major sponsor of the America 24/7 project. We take pride in being part of a groundbreaking adventure that is stretching the boundaries—and the imagination—in digital photography, digital asset management, publishing, news, and global events.

Our ActiveMedia Enterprise™ digital asset management software is the "nerve center" of *America 24/7*, the central repository for managing, sharing, and collaborating on the project's photographs. From photo editors and book publishers to 24/7's media relations and marketing personnel, ActiveMedia provides the application support that links all facets of the project team to the content worldwide.

WebWare helps Global 2000 firms securely manage, reuse, and distribute media assets locally or globally. Its suite of ActiveMedia software products provide powerful media services platforms for integrating rich media into content management systems marketing and communication portals; web publishing systems; and e-commerce portals.

Google's mission is to organize the world's information and make it universally accessible and useful.

With our focus on plucking just the right answer from an ocean of data, we were naturally drawn to the America 24/7 project. The book you hold is a compendium of images of American life distilled from thousands of photographs and infinite possibilities. Are you looking for emotion? Narrative? Shadows? Light? It's all here, thanks to a multitude of photographers and writers creating links between you, the reader, and a sea of wonderful stories. We celebrate the connections that constitute the human experience and are pleased to help engender them. And we're pleased to have been a small part of this project, which captures the results of that interaction so vividly, so dynamically, and so dramatically.

Special thanks to additional contributors: FileMaker, Apple, Camera Bits, LaCie, Now Software, Preclick, Outpost Digital, Xerox, Microsoft, WoodWing Software, net-linx Publishing Solutions, and Radical Media. The Savoy Hotel, San Francisco; The Pan Pacific, San Francisco; Four Seasons Hotel, San Francisco; and The Queen Anne Hotel. Photography editing facilities were generously hosted by CNET Networks, Inc.

Participating Photographers

Coordinator: Karen Pike, Karen Pike Photography, Hinesburg

Megan K. Bigelow
Paul O. Boisvert
Richard A. Doran
Jon Gilbert Fox
Dylan Gamache
Geoff Hansen
Paul Hansen
Stefan Hard
Peter Huoppi
Craig Line
S Mease
Peter Miller
Sarah Montgomery
Jon Olender
Alden Pellett
Karen Pike, Karen Pike Photography, Hinesburg

Kathy Pintair
Alison Redlich
Adam Riesner
Sara Riley
Jack Rowell
Glenn Russell, *The Burlington Free Press*
Jordan Silverman Photography, www.jordansilverman.com
Vyto Starinskas, *Rutland Herald*
Natalie Stultz, Location Photography, Burlington
Rob Swanson
Mark Tafoya
Toby Talbot
Jeb Wallace-Brodeur
Chas Weaver

Thumbnail Picture Credits

Credits for thumbnail photographs are listed by the page number and are in order from left to right.

Stefan Hard
Toby Talbot
Toby Talbot

65 Stefan Hard
Toby Talbot
Toby Talbot
Stefan Hard
Stefan Hard
Stefan Hard
Toby Talbot

66 Alison Redlich
Geoff Hansen
Jack Rowell
Karen Pike, Karen Pike Photography, Hinesburg
Karen Pike, Karen Pike Photography, Hinesburg
Jordan Silverman Photography,
www.jordansilverman.com
Tom Pollak, Teal City Media

67 Karen Pike, Karen Pike Photography, Hinesburg
Jack Rowell
Jeb Wallace-Brodeur
Karen Pike, Karen Pike Photography, Hinesburg
Richard A. Doran
Paul O. Boisvert
Paul O. Boisvert

70 Jack Rowell
Jeb Wallace-Brodeur
Paul O. Boisvert
Jeb Wallace-Brodeur
Paul O. Boisvert
Megan K. Bigelow
Jeb Wallace-Brodeur

71 Paul O. Boisvert
Megan K. Bigelow
Paul O. Boisvert
Rob Swanson
Jeb Wallace-Brodeur
Megan K. Bigelow
Paul O. Boisvert

72 Craig Line
Richard A. Doran
Natalie Stultz, Location Photography, Burlington, VT
Craig Line
Paul Hansen
Natalie Stultz, Location Photography, Burlington, VT
Natalie Stultz, Location Photography, Burlington, VT

73 Natalie Stultz, Location Photography,
Burlington, VT
Natalie Stultz, Location Photography, Burlington, VT
Natalie Stultz, Location Photography, Burlington, VT
Paul Hansen
Craig Line
Paul Hansen
Tom Pollak, Teal City Media

74 Geoff Hansen
Dylan Gamache
Dylan Gamache
Geoff Hansen
Vyto Starinskas, Rutland Herald
Paul O. Boisvert
Dylan Gamache

75 Megan K. Bigelow
Vyto Starinskas, Rutland Herald
L.J. Corliss
Dwight John Gies
Vyto Starinskas, Rutland Herald
Natalie Stultz, Location Photography, Burlington, VT
Geoff Hansen

79 Alden Pellett
Alden Pellett
Dwight John Gies
Alden Pellett
Paul Hansen
Alden Pellett
Paul Hansen

80 Natalie Stultz, Location Photography,
Burlington, VT
Natalie Stultz, Location Photography, Burlington, VT
Natalie Stultz, Location Photography, Burlington, VT
Natalie Stultz, Location Photography, Burlington, VT
Natalie Stultz, Location Photography, Burlington, VT
Natalie Stultz, Location Photography, Burlington, VT
Natalie Stultz, Location Photography, Burlington, VT

82 Jack Rowell
Peter Miller
Jack Rowell
Vyto Starinskas, *Rutland Herald*
Alden Pellett
Vyto Starinskas, *Rutland Herald*
Paul O. Boisvert

84 Craig Line
Glenn Russell, *The Burlington Free Press*
Craig Line
Paul O. Boisvert
Glenn Russell, *The Burlington Free Press*
Glenn Russell, *The Burlington Free Press*
Glenn Russell, *The Burlington Free Press*

85 Paul O. Boisvert
Glenn Russell, The Burlington Free Press
Paul O. Boisvert
Glenn Russell, *The Burlington Free Press*
Glenn Russell, *The Burlington Free Press*
Paul O. Boisvert
Tom Pollak, Teal City Media

88 Jon Olender
Glenn Russell, *The Burlington Free Press*
Jon Olender
Jon Olender
Jon Olender
Jon Gilbert Fox
Karen Pike, Karen Pike Photography, Hinesburg

90 Stefan Hard
Rob Swanson
Jon Gilbert Fox
Karen Pike, Karen Pike Photography, Hinesburg
Natalie Stultz, Location Photography, Burlington, VT
Natalie Stultz, Location Photography, Burlington, VT
Natalie Stultz, Location Photography, Burlington, VT

91 Tom Pollak, Teal City Media
Karen Pike, Karen Pike Photography, Hinesburg
Natalie Stultz, Location Photography, Burlington, VT
Jon Gilbert Fox
Vyto Starinskas, *Rutland Herald*
Tom Pollak, Teal City Media
Tom Pollak, Teal City Media

94 Glenn Russell, *The Burlington Free Press*
Karen Pike, Karen Pike Photography, Hinesburg
Peter Miller
Richard A. Doran
Vyto Starinskas, *Rutland Herald*
Glenn Russell, *The Burlington Free Press*
Richard A. Doran

95 Jeb Wallace-Brodeur
Vyto Starinskas, *Rutland Herald*
Richard A. Doran
Tom Pollak, Teal City Media
Karen Pike, Karen Pike Photography, Hinesburg
Jeb Wallace-Brodeur
Karen Pike, Karen Pike Photography, Hinesburg

96 Peter Miller
Karen Pike, Karen Pike Photography, Hinesburg
Karen Pike, Karen Pike Photography, Hinesburg
Jon Gilbert Fox
Karen Pike, Karen Pike Photography, Hinesburg
Peter Miller
Paul O. Boisvert

98 Richard A. Doran
Rob Swanson
Geoff Hansen
Craig Line

Rob Swanson
Geoff Hansen
Rob Swanson

99 Rob Swanson
Jack Rowell
Rob Swanson
Paul O. Boisvert
Rob Swanson
Richard A. Doran
Rob Swanson

100 Jon Gilbert Fox
Rob Swanson
Jon Gilbert Fox
Rob Swanson
Vyto Starinskas, *Rutland Herald*
Vyto Starinskas, *Rutland Herald*
Richard A. Doran

102 Karen Pike, Karen Pike Photography, Hinesburg
Craig Line
Karen Pike, Karen Pike Photography, Hinesburg
Paul O. Boisvert
Karen Pike, Karen Pike Photography, Hinesburg
Craig Line
Jon Gilbert Fox

103 Karen Pike, Karen Pike Photography, Hinesburg
Karen Pike, Karen Pike Photography, Hinesburg
Peter Miller
Karen Pike, Karen Pike Photography, Hinesburg
Craig Line
Paul O. Boisvert
Karen Pike, Karen Pike Photography, Hinesburg

106 Darlene Bordwell, Ambient Light Photography
Craig Line
Megan K. Bigelow
Darlene Bordwell, Ambient Light Photography
Craig Line
Darlene Bordwell, Ambient Light Photography
Megan K. Bigelow

107 Darlene Bordwell, Ambient Light Photography
Megan K. Bigelow
Jon Gilbert Fox
Natalie Stultz, Location Photography, Burlington, VT
Megan K. Bigelow
Paul O. Boisvert
Megan K. Bigelow

108 Jack Rowell
Craig Line
Peter Miller
Jeb Wallace-Brodeur
Natalie Stultz, Location Photography, Burlington, VT
Craig Line
Jon Gilbert Fox

109 Karen Pike, Karen Pike Photography, Hinesburg
Jack Rowell
Karen Pike, Karen Pike Photography, Hinesburg
Karen Pike, Karen Pike Photography, Hinesburg
L.J. Corliss
Natalie Stultz, Location Photography, Burlington, VT
L.J. Corliss

110 Rob Swanson
Peter Miller
Rob Swanson
Jon Gilbert Fox
Jon Gilbert Fox
Rob Swanson
Jeb Wallace-Brodeur

111 Rob Swanson
Jeb Wallace-Brodeur
Richard A. Doran
Jon Gilbert Fox
Rob Swanson
Stefan Hard
Rob Swanson

112 Jack Rowell
Peter Miller
Peter Miller

Peter Miller
Peter Miller
Peter Miller
Peter Miller

116 Craig Line
Craig Line
Jeb Wallace-Brodeur
Craig Line
Craig Line
Craig Line

117 Jack Rowell
Craig Line
Jeb Wallace-Brodeur
Peter Miller
Jeb Wallace-Brodeur
Paul O. Boisvert
Toby Talbot

118 Rob Swanson
Rob Swanson
Paul O. Boisvert
Alden Pellett
Peter Miller
Rob Swanson
Paul O. Boisvert

121 Karen Pike, Karen Pike Photography, Hinesburg
Jeb Wallace-Brodeur
Jeb Wallace-Brodeur
Jeb Wallace-Brodeur
Karen Pike, Karen Pike Photography, Hinesburg
Karen Pike, Karen Pike Photography, Hinesburg
Jeb Wallace-Brodeur

122 Jeb Wallace-Brodeur
Rob Swanson
Jeb Wallace-Brodeur
Natalie Stultz, Location Photography, Burlington, VT
Jon Gilbert Fox
Craig Line
Jeb Wallace-Brodeur

123 Natalie Stultz, Location Photography,
Burlington, VT
Jeb Wallace-Brodeur
Rob Swanson
Jeb Wallace-Brodeur
Craig Line
Jeb Wallace-Brodeur
Jeb Wallace-Brodeur

125 Jack Rowell
Craig Line
Megan K. Bigelow
Megan K. Bigelow
Rob Swanson
Paul O. Boisvert
Toby Talbot

127 Paul O. Boisvert
Rob Swanson
Richard A. Doran
Craig Line
Paul O. Boisvert
Jeb Wallace-Brodeur
Paul O. Boisvert

128 Jon Gilbert Fox
Peter Huoppi
Adam Riesner
Adam Riesner
Alison Redlich
Adam Riesner
Karen Pike, Karen Pike Photography, Hinesburg

129 Jon Gilbert Fox
Natalie Stultz, Location Photography, Burlington, VT
Richard A. Doran
Paul O. Boisvert
Adam Riesner
Richard A. Doran
Rob Swanson

Staff

The *America 24/7* series was imagined years ago by our friend Oscar Dystel, a publishing legend whose vision and enthusiasm have been a source of great inspiration.

We also wish to express our gratitude to our truly visionary publisher, DK.

Rick Smolan, Project Director
David Elliot Cohen, Project Director

Administrative
Katya Able, Operations Director
Gina Privitere, Communications Director
Chuck Gathard, Technology Director
Kim Shannon, Photographer Relations Director
Erin O'Connor, Photographer Relations Intern
Leslie Hunter, Partnership Director
Annie Polk, Publicity Manager
John McAlester, Website Manager
Alex Notides, Office Manager
C. Thomas Hardin, State Photography Coordinator

Design
Brad Zucroff, Creative Director
Karen Mullarkey, Photography Director
Judy Zimola, Production Manager
David Simoni, Production Designer
Mary Dias, Production Designer
Heidi Madison, Associate Picture Editor
Don McCartney, Production Designer
Diane Dempsey Murray, Production Designer
Jan Rogers, Associate Picture Editor
Bill Shore, Production Designer and Image Artist
Larry Nighswander, Senior Picture Editor
Bill Marr, Sarah Leen, Senior Picture Editors
Peter Truskier, Workflow Consultant
Jim Birkenseer, Workflow Consultant

Editorial
Maggie Canon, Managing Editor
Curt Sanburn, Senior Editor
Teresa L. Trego, Production Editor
Lea Aschkenas, Writer
Olivia Boler, Writer
Korey Capozza, Writer
Beverly Hanly, Writer
Bridgett Novak, Writer
Alison Owings, Writer
Fred Raker, Writer
Joe Wolff, Writer
Elise O'Keefe, Copy Chief
Daisy Hernández, Copy Editor
Jennifer Wolfe, Copy Editor

Infographic Design
Nigel Holmes

Literary Agent
Carol Mann, The Carol Mann Agency

Legal Counsel
Barry Reder, Coblentz, Patch, Duffy & Bass, LLP
Phil Feldman, Coblentz, Patch, Duffy & Bass, LLP
Gabe Perle, Ohlandt, Greeley, Ruggiero & Perle, LLP
Jon Hart, Dow, Lohnes & Albertson, PLLC
Mike Hays, Dow, Lohnes & Albertson, PLLC
Stephen Pollen, Warshaw Burstein, Cohen, Schlesinger & Kuh, LLP
Rick Pappas

Accounting and Finance
Rita Dulebohn, Accountant
Robert Powers, Calegari, Morris & Co. Accountants
Eugene Blumberg, Blumberg & Associates
Arthur Langhaus, KLS Professional Advisors Group, Inc.

Picture Editors
J. David Ake, Associated Press
Caren Alpert, formerly *Health* magazine
Simon Barnett, *Newsweek*
Caroline Couig, *San Jose Mercury News*
Mike Davis, formerly *National Geographic*
Michel duCille, *Washington Post*
Deborah Dragon, *Rolling Stone*
Victor Fisher, formerly Associated Press
Frank Folwell, *USA Today*
MaryAnne Golon, *Time*
Liz Grady, formerly *National Geographic*
Randall Greenwell, *San Francisco Chronicle*
C. Thomas Hardin, formerly *Louisville Courier-Journal*
Kathleen Hennessy, *San Francisco Chronicle*
Scot Jahn, *U.S. News & World Report*
Steve Jessmore, *Flint Journal*
John Kaplan, University of Florida
Kim Komenich, *San Francisco Chronicle*
Eliane Laffont, *Hachette Filipacchi Media*
Jean-Pierre Laffont, *Hachette Filipacchi Media*
Andrew Locke, MSNBC
Jose Lopez, *The New York Times*
Maria Mann, formerly AFP
Bill Marr, formerly *National Geographic*
Michele McNally, *Fortune*
James Merithew, *San Francisco Chronicle*
Eric Meskauskas, *New York Daily News*
Maddy Miller, *People* magazine
Michelle Molloy, *Newsweek*
Dolores Morrison, *New York Daily News*
Karen Mullarkey, formerly *Newsweek, Rolling Stone, Sports Illustrated*
Larry Nighswander, Ohio University School of Visual Communication
Jim Preston, *Baltimore Sun*
Sarah Rozen, formerly *Entertainment Weekly*
Mike Smith, *The New York Times*
Neal Ulevich, formerly Associated Press

Website and Digital Systems
Jeff Burchell, Applications Engineer

Television Documentary
Sandy Smolan, Producer/Director
Rick King, Producer/Director
Bill Medsker, Producer

Video News Release
Mike Cerre, Producer/Director

Digital Pond
Peter Hogg
Kris Knight
Roger Graham
Philip Bond
Frank De Pace
Lisa Li

Senior Advisors
Jennifer Erwitt, Strategic Advisor
Tom Walker, Creative Advisor
Megan Smith, Technology Advisor
Jon Kamen, Media and Partnership Advisor
Mark Greenberg, Partnership Advisor
Patti Richards, Publicity Advisor
Cotton Coulson, Mission Control Advisor

Executive Advisors
Sonia Land
George Craig
Carole Bidnick

Advisors
Chris Anderson
Samir Arora
Russell Brown
Craig Cline
Gayle Cline
Harlan Felt
George Fisher
Phillip Moffitt
Clement Mok
Laureen Seeger
Richard Saul Wurman

DK Publishing
Bill Barry
Joanna Bull
Therese Burke
Sarah Coltman
Christopher Davis
Todd Fries
Dick Heffernan
Jay Henry
Stuart Jackman
Stephanie Jackson
Chuck Lang
Sharon Lucas
Cathy Melnicki
Nicola Munro
Eunice Paterson
Andrew Welham

Colourscan
Jimmy Tsao
Eddie Chia
Richard Law
Josephine Yam
Paul Koh
Chee Cheng Yeong
Dan Kang

Chief Morale Officer
Goose, the dog